W9-DFG-231

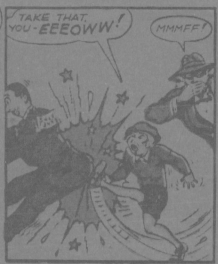
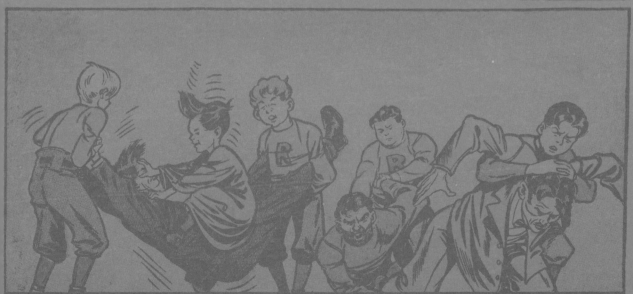

QUIRK BOOKS

TITLE THE LEAGUE — SIDEKICKS
MONTH OCT.

Dedicated to Michael,
companion of the Red Bee.
It's finally your time to shine!

Copyright © 2018 by Jon Morris
All rights reserved. Except as authorized under U.S. copyright law, no part of this
book may be reproduced in any form without written permission from the publisher.
Library of Congress Cataloging in Publication Number: 2017960599
ISBN: 978-1-68369-076-4
Printed in China
Typeset in Plantin, Futura, and Ed Gothic
Designed by Elissa Flanigan
Production management by John J. McGurk

All illustrations in this book are copyrighted by their respective copyright holders
(according to the original copyright or publication date as printed in the comics) and
are reproduced for historical purposes. Any omission or incorrect information should
be transmitted to the author or publisher, so it can be rectified in any future edition
of this book. All DC Comics characters, related logos, and indicia are trademarked
and copyrighted by DC Comics Inc. All Marvel Comics characters, related logos,
and indicia are trademarked and copyrighted by Marvel comics Inc. All Dell Comics
characters, related logos, and indicia are trademarked and copyrighted by Dell
Comics Inc. All Harvey Comics characters, related logos, and indicia are trademarked
and copyrighted by Harvey Comics Inc. All Archie Comics characters, related logos,
and indicia are trademarked and copyrighted by Archie comics Inc.

Quirk Books
215 Church Street
Philadelphia, PA 19106
quirkbooks.com
10 9 8 7 6 5 4 3 2 1

THE LEAGUE OF
REGRETTABLE
SIDEKICKS

BY JON MORRIS

QUIRK BOOKS

PHILADELPHIA

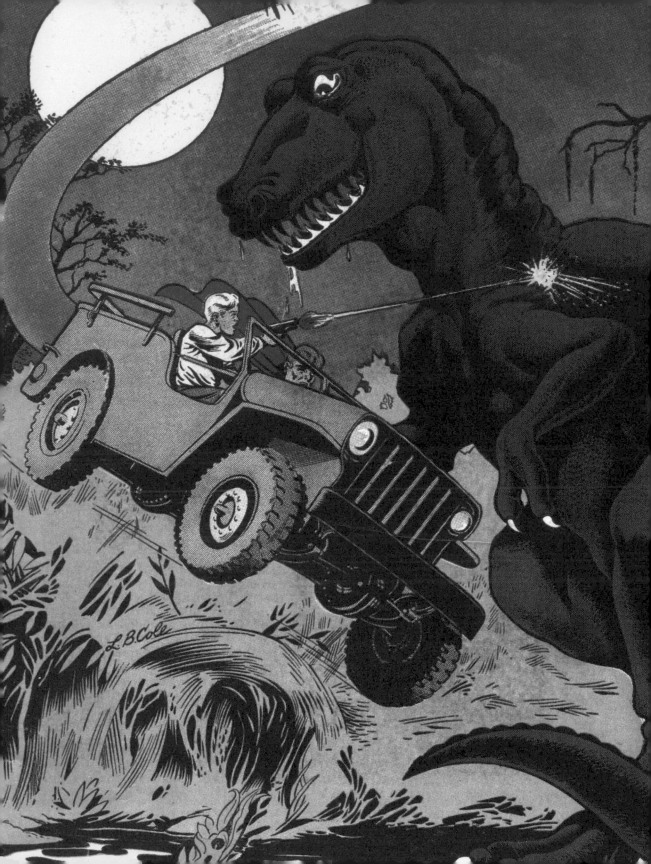

INTRODUCTION 8
PART 1: THE GOLDEN AGE 11

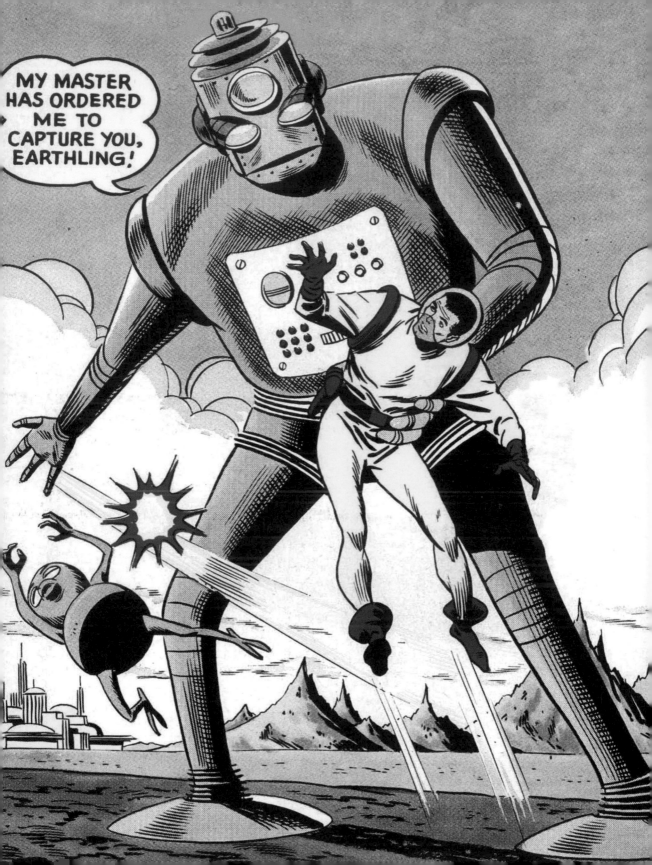

PART 2: THE SILVER AGE 137

PART 3: THE MODERN AGE 193

ACKNOWLEDGMENTS 255

INTRODUCTION

WHAT WOULD A SUPERHERO BE without a plucky, pint-sized partner? What would a villain be with no obedient underlings? What would the landscape of superhero comics look like if there were no sidekicks—or their felonious equivalents, henchpersons?

The answer to this last question is: "Roughly the same." Nothing requires heroes to pick up a junior partner, or villains to acquire a minion or two. Many high-profile comic book characters do well without them. Nevertheless, sidekicks bring something different to the average super-powered grudge match between good and evil. Sometimes it's humor, sometimes it's vulnerability, sometimes it's merely someone with whom the lead character can share a confidence or two. As superfluous as they may seem at first glance, sidekicks serve a valuable role in

their senior partners' stories.

They also serve a long tradition. The pulp magazines, radio shows, and dime novels that preceded comics produced a veritable army of underlings and assistants. The Lone Ranger and Green Hornet had Tonto and Kato; the Shadow had his sprawling network of secret operatives. Fu Manchu commanded the Si-Fan assassins. And the concept goes back even further, into literature and mythology: Don Quixote's Sancho Panza; Robin Hood's Merry Men; even the hairy wild man Enkidu of the Gilgamesh myth. If anything, comics were late to the game when it came to including these characters in stories.

Belated as they may have been, comics take that existing concept and crank the weirdness volume up to eleven. Beyond traditional cos-

tumed kid partners, the assistant heroes and adjunct villains covered in this volume range in age from childhood to dotage; they include men, women, children, animals, robot, and . . . *other*. Some sport colorful costumes, others make do with street clothes. They are wards, junior partners, peers, and pals, but they are also fiends, creeps, and monstrous menaces. Sidekicks might be pets, imps, romantic partners, troublesome relatives, and all sorts of unlikely underlings.

Of course, not every creation hits a home run. Many of the junior crime busters, super-pets, underlings, and goons-for-hire you'll meet in these pages are poorly thought out, mistimed, or generally offensive. But so many more were worthy, if weird, ideas just executed in the wrong place or time. At the very least,

they are all fascinating snapshots of what might have been. So, as with the other books in this series, please be aware that the term *regrettable* is used loosely and with affection.

Few sidekicks graduate to solo status. For every Winter Soldier (formerly Captain America's sidekick Bucky) or Nightwing (once Batman's boy partner Robin), there are a few hundred Peeps, Zooks, Ungghs, Blargos, Monster Men, Gaggies, Ittys, Klonsbons, Bingos, and Dandies who spend their entire career in another character's shadow. Accordingly, within these pages, let's celebrate the second bananas on their own merits. They never enjoyed top billing, but they can at least enjoy this fleeting moment in the sun.

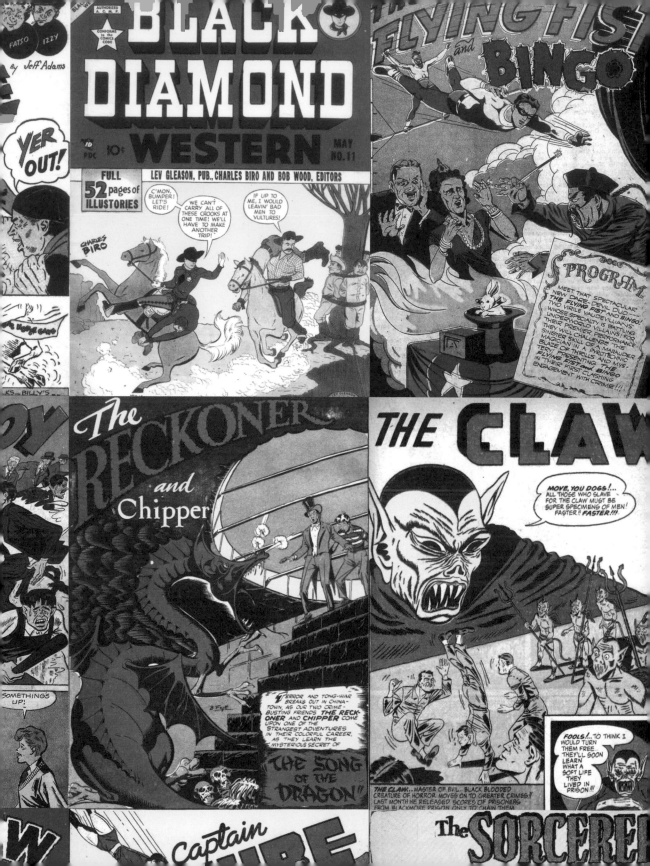

THE GOLDEN AGE
1938-1949

AS WITH MANY TRENDS IN mainstream comics, it is Batman who is generally credited with launching the tradition of costumed kid sidekicks. The debut of Robin the Boy Wonder in 1940 opened the floodgates to literally hundreds of other junior superheroes—a new category in the expansive history of the sidekick.

But sidekicks were a presence even before Robin swung onto the scene. Superman's creators, Jerry Siegel and Joe Shuster, partnered their roughneck detective Slam Bradley with a comical, would-be Sherlock-style sleuth Shorty Morgan (1937). They also created the mystical Dr. Occult and his adept assistant, Rose (1935). Meanwhile, Bob Kane spent part of his pre-Batman days drawing the funny animal adventures of Peter Pupp, accompanied by his sidekick Tinymite

(1938). Likewise, the bad guys filled their staffing needs, generally preferring insidious monsters, robots, and thugs to the individual sidekick.

The annals of Golden Age sidekickery were awash with not just costumed kids but also with middle-aged men (largely of the working-class variety) and even elderly grandfather types. Heroes were backed by spirits, imps, genies, and mythological gods. Not to mention dogs, cats, parrots, hawks, tigers, lions, chimps, monkeys, gorillas, and every other type of animal.

The buoyant energy of the Golden Age of comics owed much to the fact that both the medium and the superhero genre were brand-new. It was a period of pure invention, and a spectrum of sidekicks was just part of the plenitude.

NOTE: Not everyone agrees on the exact limits of these comicbookdom epochs, but the debut of Superman is generally considered the big bang of superhero comics.

THE AGATHA DETECTIVE AGENCY

"Johnny's in a Turkish bath . . . and I need a man to follow him!"

Created by:
Kin Platt

Debuted in:
Startling Comics #7
(Standard Comics,
May 1941)

Partners to:
Captain Future

More like:
Sherlock *Old Folks*
Holmes, am I right?

©1941 by Standard
Comics

GENERALLY SPEAKING, HEROES CHOOSE their sidekicks and pretty much every element of the partnership. The sidekick's costume, their code name, whether or not they get to fight crime during a particular case or on a school night—that's all the purview of the senior partner.

Heroes also decide whether they even *want* a sidekick. Less-experienced or less-able partners can be a hindrance more than a help, after all. But sometimes the hero doesn't have a choice. *Sometimes the sidekicks decide.*

This is how electricity-packed paladin Captain Future finds himself associated with the Agatha Detective Agency. Founded by Grace Adams—the captain's girlfriend in his civilian identity, Dr. Andrew Bryant—and funded by the group's only other member, Grace's wealthy Aunt Agatha, the agency consistently finds itself embroiled in the captain's adventures and even inspires several exploits in the course of their investigations.

Captain Future meets the agency's operatives even before they form their two-woman business. Enjoying an ocean cruise, Dr. Bryant stumbles across a kidnapping ring run by a gang of jewel thieves. Their target: Grace's Aunt Agatha, whom one crook describes as "an old maid . . . with all the jewels and money in the world!"

They consider her an easy target, but Agatha is far from a fainting dowager, actively pursuing cases and taking on goons twice her size armed with only an umbrella. When her niece is tricked into the clutches of the kidnappers—as Agatha had been, ironically—Agatha fusses angrily: "Might have known that idiot Grace'd fall for it! Now I've got to save us both!"

In fact Captain Future does the saving, despite the lack of respect he receives from his girlfriend. Dr. Bryant apparently emerged from the Clark Kent school of secret identities, faking timidity and mild manners in order to obfuscate his dual life. Unfortunately, Bryant ultimately pales in comparison to his alter ego—which Grace does not let him forget.

"Gosh, Grace . . . ," Bryant comments, "Captain Future certainly threw his strength around this time!"

"Oh, Andy," replies Grace, "if only he'd throw a bit of it your way!"

The Agatha Detective Agency struggles to find clients, but they account for themselves terrifically over roughly a year's worth of appearances. With Captain Future's assistance, they break up a truck-hijacking ring, stop a secret society of masked killers, and disrupt the illegal activities of every type of crook →

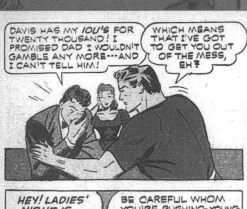

DAVIS HAS MY *IOU'S* FOR TWENTY THOUSAND! I PROMISED DAD I WOULDN'T GAMBLE ANY MORE---AND I CAN'T TELL HIM!

WHICH MEANS THAT I'VE GOT TO GET YOU OUT OF THE MESS, EH?

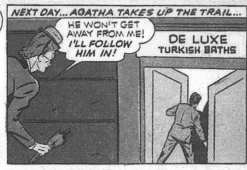

NEXT DAY... AGATHA TAKES UP THE TRAIL...

HE WON'T GET AWAY FROM ME! *I'LL FOLLOW HIM IN!*

DE LUXE TURKISH BATHS

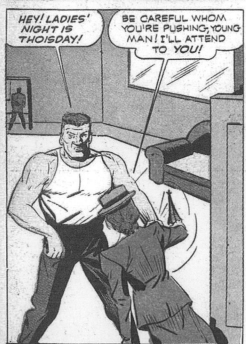

HEY! LADIES' NIGHT IS THOISDAY!

BE CAREFUL WHOM YOU'RE PUSHING, YOUNG MAN! I'LL ATTEND TO *YOU!*

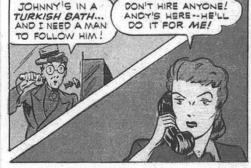

JOHNNY'S IN A *TURKISH BATH...* AND I NEED A MAN TO FOLLOW HIM!

DON'T HIRE ANYONE! ANDY'S HERE--HE'LL DO IT FOR *ME!*

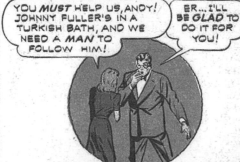

YOU *MUST* HELP US, ANDY! JOHNNY FULLER'S IN A TURKISH BATH, AND WE NEED A *MAN* TO FOLLOW HIM!

ER... I'LL BE *GLAD* TO DO IT FOR YOU!

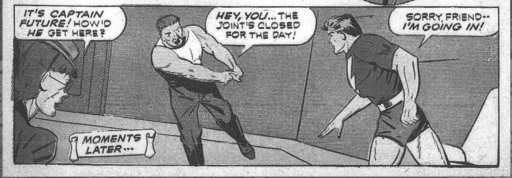

IT'S CAPTAIN FUTURE! HOW'D HE GET HERE?

HEY, YOU... THE JOINT'S CLOSED FOR THE DAY!

SORRY, FRIEND-- I'M GOING IN!

MOMENTS LATER...

from bookies to Bundists.

In the end, the work proves too overwhelming for Agatha. Storming out of the office, she announces, "I don't want to hear another word! This . . . this detective business has got me down!" As she leaves, umbrella in hand, she hollers over her shoulder, "I'm going to consult a psychiatrist . . . before I go crazy myself!" Grace runs the agency for a few more issues before the endeavor shutters for good.

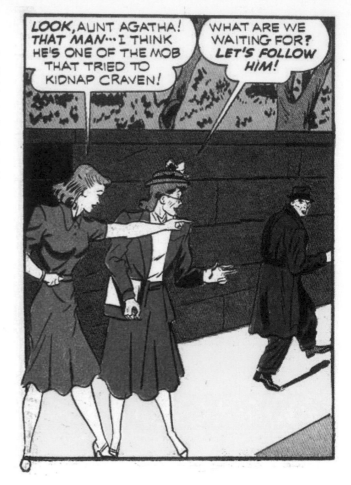

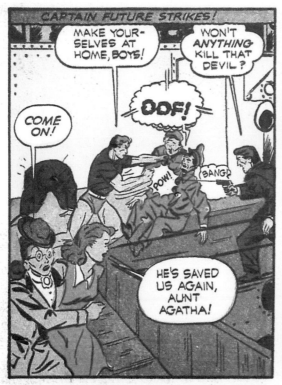

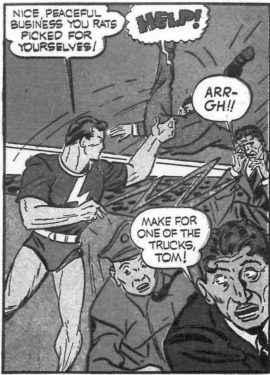

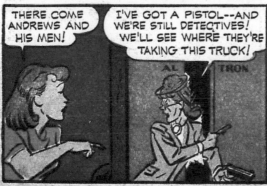

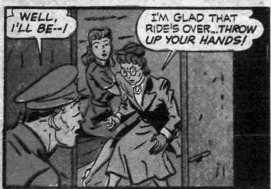

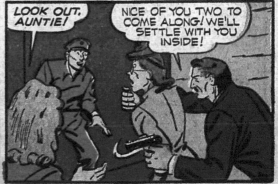

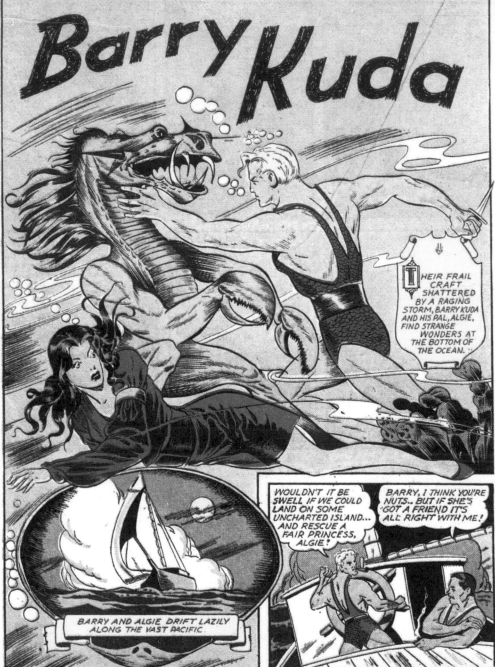

ALGIE

"Hey Barry—I didn't drown . . .
I mean, I can breathe!"

NDERWATER ADVENTURER ALGIE'S LIFE as a reluctant sidekick must have been particularly hard to bear. Besides being trapped in an apparently inescapable sub-oceanic kingdom and frequently having to battle terrible undersea monsters to protect innocent lives, he was also burdened with that unfortunate name.

Algie was partnered with Barry Kuda. While pleasure sailing outside San Francisco, good pals Barry and Algie are suddenly caught in a vicious typhoon. The churning waters form a whirlpool that sucks them to the bottom of the sea. In the real world, that would be the unsettling end to this story. However, by amazing coincidence, they manage to land in the *one spot* beneath the entire Pacific Ocean where surface-dwellers can breathe. Most water-breathing superheroes are native to the element, or they employ some sort of scientific advancement that allows them to survive beneath the waves. But not Barry (or Algie). Pure chance and good fortune kept these two from drowning.

"The coral around here gives off an oxide that takes the place of air," Barry explains. That seems to raise more questions than it answers, but the phenomenon is sufficient to keep the duo underwater long enough to carve out a heroic legacy.

Their stormy sinking has deposited them right into a fracas between a group of aquatic usurpers and the unseated Queen Merma, of the Kingdom of Merma. Control of her eponymous empire has been wrested from the queen's hands by her evil prime minister, which is the problem Barry and Algie unquestioningly proceed to solve.

They return Merma to the throne and stay on as her champions—primarily at Barry's insistence. Other subaquatic enemy nations stage frequent assaults on Merma, requiring Barry and Algie to battle entire armies beneath the waves. But the attractive queen's affection seems to be Barry's real reason for staying—to Algie's eternal frustration.

"Remember that waitress in Frisco!" he bellows at Barry, eager to cut short a romantic clinch between the watery sovereign and her hero. "Go in there and tell Merma we're leaving for America!" Algie reminds him on another occasion.

But Algie's insistence on cutting their visit short rarely pays dividends. For one thing, Barry is smitten. For another, Merma is constantly under attack. And, lastly, who's going to listen to a guy named after slimy water plants? After a half dozen issues or so, the duo's story concluded, with no hint of the men returning to dry land. They might still be down there, Algie having harassed a →

Created by:
Unknown

Debuted in:
Yankee Comics #2
(Harry "A" Chesler,
November 1941)

Sidekick to:
Barry Kuda

Vulnerable to:
Liquid chlorine; a
firm and vigorous
brushing

© 1941 by Harry
"A" Chesler Features
Syndicate

disinterested Barry Kuda about going home, repeatedly, for the past eighty years . . .

EDITOR'S NOTE

Aquaman is likely the best-known undersea superhero, and he also enjoys the company of a younger sidekick. Although Barry Kuda and Aquaman both debuted in 1941, however, Algie predates Aqualad by almost twenty years. So if there are points for being the first underwater superhero sidekick, at least Algie has that going for him.

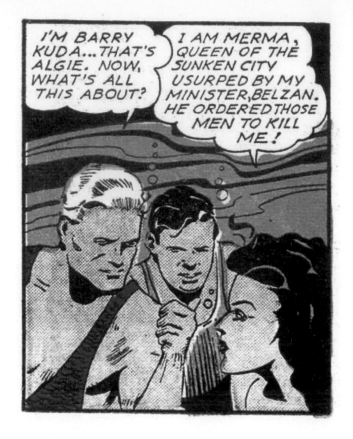

I'M BARRY KUDA...THAT'S ALGIE. NOW, WHAT'S ALL THIS ABOUT?

I AM MERMA, QUEEN OF THE SUNKEN CITY USURPED BY MY MINISTER, BELZAN. HE ORDERED THOSE MEN TO KILL ME!

BRRRR... LOOK AT THAT! MY HANDS ARE FREE... BUT I DON'T THINK THEY'LL BE MUCH GOOD!

WITH A MIGHTY TUG ON THE CHAIN, BARRY SLIPS OUT OF HIS BONDS...

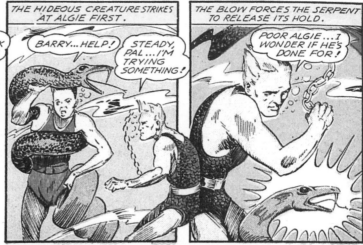

THE HIDEOUS CREATURE STRIKES AT ALGIE FIRST.

BARRY... HELP!

STEADY, PAL... I'M TRYING SOMETHING!

THE BLOW FORCES THE SERPENT TO RELEASE ITS HOLD.

POOR ALGIE... I WONDER IF HE'S DONE FOR!

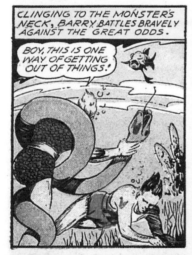

CLINGING TO THE MONSTER'S NECK, BARRY BATTLES BRAVELY AGAINST THE GREAT ODDS.

BOY, THIS IS ONE WAY OF GETTING OUT OF THINGS!

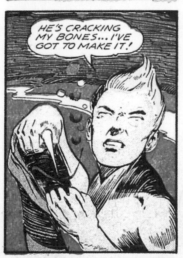

HE'S CRACKING MY BONES... I'VE GOT TO MAKE IT!

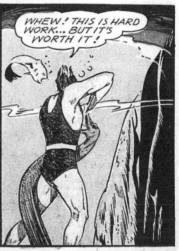

WHEW! THIS IS HARD WORK... BUT IT'S WORTH IT!

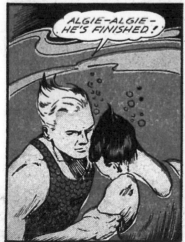

ALGIE-ALGIE - HE'S FINISHED!

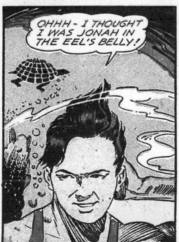

OHHH - I THOUGHT I WAS JONAH IN THE EEL'S BELLY!

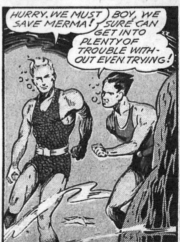

HURRY. WE MUST SAVE MERMA!

BOY, WE SURE CAN GET INTO PLENTY OF TROUBLE WITHOUT EVEN TRYING!

THE APPRENTICE

"Don't call me a scullery maid! I'm a sorcerer's apprentice, I am!"

Created by:
Henry C. Kiefer

Debuted in:
Red Band Comics
#1 (Rural Home,
November 1944)

Partnered with:
The Sorcerer

Current job status:
Fired

© 1944 by Rural Home
Publishing

THE PHRASE *THE APPRENTICE* may carry reality-show connotations for modern audiences, but it's a familiar term that dates back hundreds of years. It's also the handle—and occupation—of a semi-comical kid hero whose adventures took place in the story-rich environment of the Italian Renaissance.

"Fifteenth century Venice," reads the caption preceding one of his adventures. "Romantic . . . colorful . . . and as deadly as a striking cobra . . . A time when arguments were settled either by the sword, or, and this was more usual . . . with poison." This is the world in which a young man (who bears the very un-Venetian handle of Little Joe Djerk) operates. A little lazy, slow-witted, and prone to catastrophe, Joe ends up serving a mighty wizard—known only as the Sorcerer—in an internship position. His responsibilities primarily involve sweeping.

Nonetheless, Joe also dabbles in occasional magic. He takes liberties with his master's spell books, purloins the occasional magical artifact, and commands a collection of "friendly" demons—his "familiars," to whom he frequently passes off his chores. He also gets himself into trouble more often than not. Besides evil witches and wizards, Joe confronts prominent (and easily insulted) noblemen, famed duelists, and even the infamous poisoner Lucretia Borgia.

And for the most part, Joe escalates conflicts rather than solve them: his short temper embroils him in a duel with a master swordsman, he loses control of a magic broom, he serves as a punching bag for an aggressive court jester, and so on. It's not a dignified life, the life of an apprentice.

At the end of his short and sporadic career, Joe graduates to his own feature. (The whole Djerk clan must have had a real thrill seeing the family name in the masthead, for once.) But Joe's biggest moment took place when the assorted heroes of Red Band Comics gathered to loan their powers to the rookie crime fighter Captain Milksop. "I've been sent here by Red Band Heroes, Inc., to help you," Joe explains, adding instructions that sound more like a prank. "By rubbing this book on top of your head 'round and 'round, and by saying the magic phrase *Red Band Comics* . . . you will become a greater hero than us all!"

It sounds like questionable magic at best, but who better to know than the Sorcerer's Apprentice?

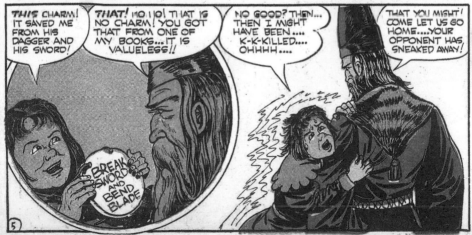

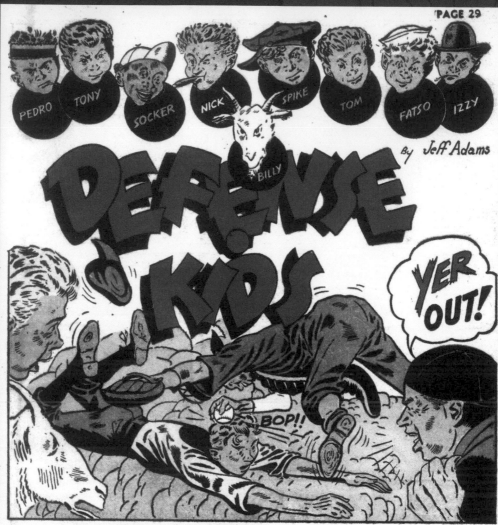

BILLY THE BUMPER
"-!"

ANIMAL SIDEKICKS ARE TYPICALLY drawn from the ranks of the faithful hound or the agile monkey; their intelligence and pedigree make these types of critters especially suited for aiding an adventuring human hero. But other animals can also pitch in, and no better example exists than "Bomber" Billy the Bumper, the exceptionally aggressive and short-tempered goat mascot of the Gas House Gang.

Not that the Gas House Gang—aka the Defense Kids—needed backup. This expansive team of working-class youngsters boasted a variety of backgrounds and had the numbers to prove it. Always ready for a scrap, sharp-tongued and fiercely patriotic, the Defense Kids were Izzy, Tom, Spike, Fatso, Socker, Tony, Nick, and Pedro—a veritable platoon of plucky pals!

On their own, the Defense Kids were a force to be reckoned with. Possessed of nothing but toughness and persistence, they made short work of fifth columnists and Nazi saboteurs across their modest borough. Even the local cops were fans. When a prominent police captain hears that the Gas House Gang had been ejected from a heated stickball game, he exclaims, "What? The Gas House Gang beaten! How did that ever happen???"

The real secret weapon was Billy the Bumper. Following a contentious call by the umpire, Billy is wound up. "Here it comes, folks," announces one caption. "Billy's beginning to feel that **URGE!**" That is, the urge felt by any innocent billy goat pushed to the edge: to head-butt first and ask questions never.

In fact, Billy's primary contribution as sidekick to a team of eight mirthful misfits is surrendering to "the urge." When a group of Nazi sympathizers is discovered using a local brewery as a hideout, the rumbled insurrectionists attempt to drown the boys in a handy beer vat. "But," portends the subsequent caption, "there is one member of the gang the Nazis didn't get. Ole Bomber Billy, who is beginning to feel the **URGE!!**" The gang-busting goat is portrayed immediately thereafter dazzled and dizzy, having knocked some sense into a dozen or more ratzis. "Billy nearly knocked himself out!" observes an amazed Tom. The Defense Kids were exceptionally tough—they rumbled with other youth gangs, they argued with adults in positions of authority, and more than a few of them were depicted as smoking—but Billy made them invincible.

Created by:
Vernon Henkel

Debuted in:
Rangers Comics #3
(Fiction House,
February 1942)

Mascot of:
The Defense Kids

General mood:
Gruff

© 1942 by Fiction House

BINGO

"We got any skeletons in our closet that we could sell?"

Created by:
Fred Morgan

Debuted in:
Prize Comics #35
(Prize Comics,
October 1943)

Partnered with:
The Flying Fist

Not to be confused with:
Plinko, Yahtzee,
Uno, Lotto

© 1943 by Prize Comics

LADIES AND GENTLEMEN, PLEASE put your hands together for America's favorite costumed crime fighters! They'll make you laugh, they'll make you cry, they'll punch a few Nazis in the eye.

Meet professional entertainer Freddy Tapps and his younger brother Junior, a self-described "Complete Vaudeville Show"—and they ain't lying. Their performance is packed with singing, dancing, magic, acrobatics, juggling, and light comedy. But when the curtain falls, the duo brings these same skills to bear on the underworld in their secret identities as the Flying Fist and his kid partner, Bingo.

Unlike most costumed crime fighters, neither Freddy nor Junior hides behind his alias. In fact, "The Flying Fist and Bingo" appear to be the duo's stage names in addition to their noms de guerre. They even wear the same costumes in both roles. It's a wonder that the criminal underworld never wiped them out in their dressing room. Then again, their enemies might have realized that it would be easier to simply let the impoverished paladins starve to death. The Complete Vaudeville Show they may have been, but Freddy and Junior spent most of their time unemployed and hustling for engagements.

Luckily for the readers, the world of entertainment provided no end of mysteries and murder for the performing pair to investigate: jewel-thieving magicians, the occasional Nazi or racketeer, even a locked-room double homicide involving a theater manager and a seal trainer.

The Flying Fist is the uncontested senior partner. Freddy takes the lead in all of the job hunting, clue gathering, and crime fighting. This opens a world of possibilities for the quick-witted and sharp-tongued Bingo, who generally gets all the good lines while his brother is occupied with the heavy lifting.

"I've been walking on cardboard so long," Bingo complains, indicating the shabby condition of his only pair of shoes. "I don't like leather, anyway!" On another occasion, Freddy mumbles discontentedly about a glum audience, "You know, I don't have to do this for a living," and Junior replies, "Yeah, I know! You could starve to death!"

The Flying Fist and Bingo eventually trade in their stage-friendly superhero getups and cardboard shoes for footwear of the gum-soled variety as full-time detectives. But Bingo doesn't sacrifice his sarcastic streak. When his brother instructs a client to "make out a check payable to Frederick J. Tapps" for a particularly dangerous case, Bingo saltily adds, "In care of the morgue, maybe." (Rimshot!)

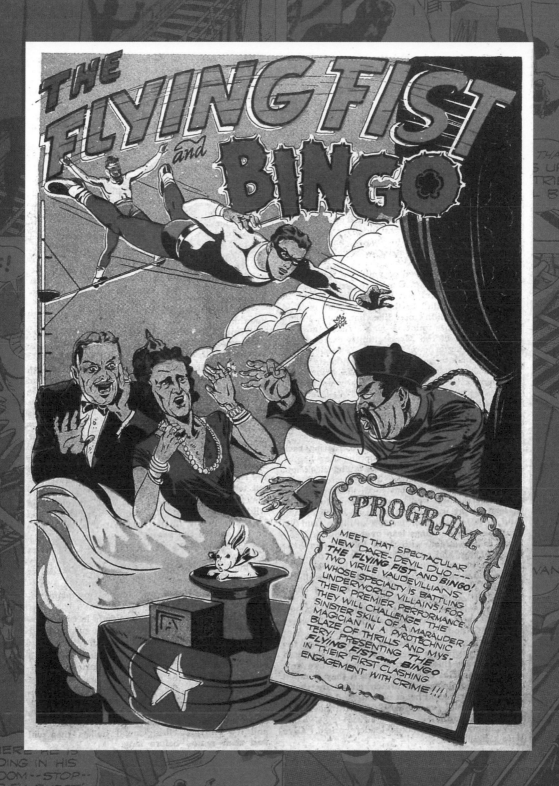

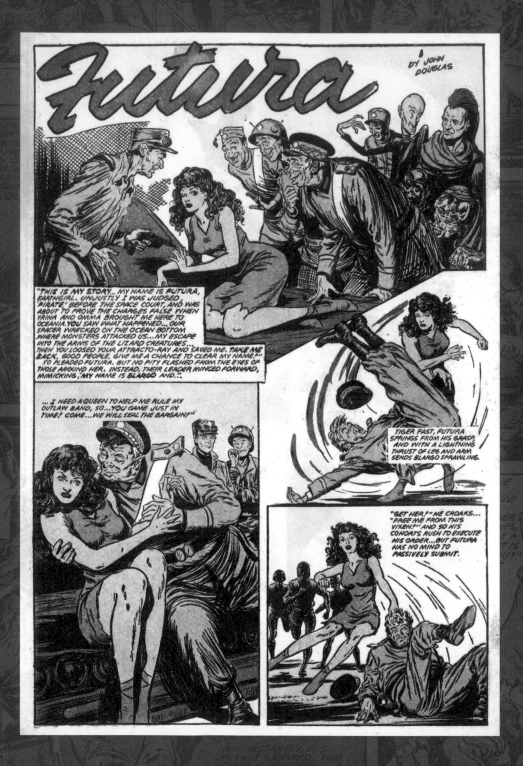

BLARGO THE LAWLESS

"If I must die, then let me die with her. For of living creatures, Futura is the most beautiful and brave of all!"

AS FAR AS FIRST impressions go, Blargo the Lawless could not possibly have started off on a worse foot. Because if there's one thing you shouldn't do as sidekick, it's force yourself upon your eventual partner.

Heavyset, middle-aged, and sporting a face like the underside of a pan full of scrambled eggs, Blargo was not winning any beauty contests. What he did have going for him was a ferocious fighting style, practically inhuman strength, and a loyal crew of undersea scavengers called the Fishermen. Based on the small, water-covered planet of Oceania, they earned their fortune by illegally selling looted subaquatic contraband.

Into this scenario dropped the lovely Futura, a former Earth-bound secretary named Marcia Reynolds turned into an intergalactic heroine of the far-flung future. Having been abducted by the Brain-Lords of Cymradia, an alien race, the otherwise ordinary woman is declared a "prize of prizes" throughout the universe for her laudable hidden qualities. This immediately makes her a target for a small army of galaxy-conquering menaces, weird monster-people, and intergalactic space pirates. Which brings us back to Blargo.

When Futura overpowers her captors on the way to Oceania, their ship crashes into the sea. Dodging terrible monsters and savage lizard-men, she is rescued by Blargo's welcoming crew. Unfortunately, Blargo himself proves a little too welcoming, looming over her as she's taken to the Fishermen's home base. "My name is Blargo," he announces, adding hungrily as he leans in for a kiss, "and I need a queen to help me rule my outlaw band!"

Futura answers his offer by flipping him helplessly to the floor, liberally beating the daylights out of his sizable crew of hardened pirates, and escaping in one of Blargo's ships.

But this seems only to encourage Blargo's ardor, impressed as he is by Futura's indomitable spirit. Pursuing her in a second vehicle, the scavenger captain encounters a terrible sea creature that wrecks his ship. Futura's strength and courage saves him from certain death, and she carries him on her back to safety. From that moment, the bond between the two is sealed, and Blargo's inappropriate affection turns to worshipful adoration.

For the remainder of the series, Blargo provides a strong right hand (and left hand, and both feet, and he probably bites, too) against Futura's multitude of weird cosmic enemies. Resembling a science-fiction version of *The Perils of Pauline*, Futura's adventures pit the pair against other pirates, birdmen, assort- →

Created by:
John Douglas

Debuted in:
Planet Comics #59
(Fiction House,
March 1949)

Partnered with:
Futura

**Is there a
Mrs. Blargo?**
We hope not.

© 1948 by Fiction House

ed monsters, their own artificial du-
plicates, and severed telepathic heads
resting on ornate vases. Space sounds
amazing.

Blargo is of a particularly pe-
culiar school of sidekickery. As an
unwelcome addition to Futura's
adventures—and, in fact, an early
enemy—he nonetheless is changed
for the better by his association with
the heroine whom he openly adores.
Despite their unconscionable be-
ginnings, the pair develop a platonic
affection, which seems a suitable re-
ward for Blargo's transition from sex-
ist scoundrel to valuable sidekick. The
pair ends their time together in a hap-
py embrace, having defeated one last
wave of alien no-goodniks.

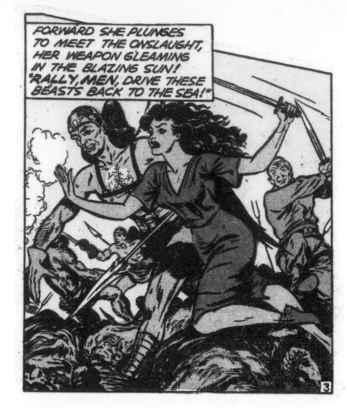

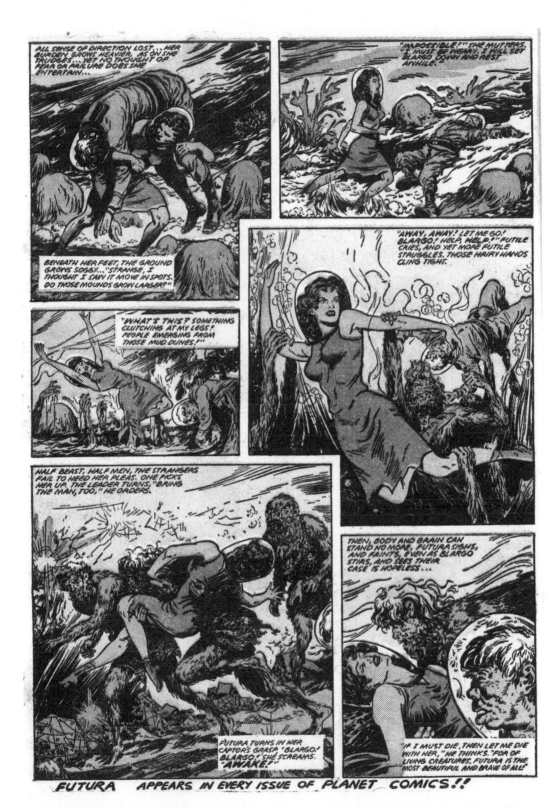

FUTURA APPEARS IN EVERY ISSUE OF PLANET COMICS!!

THE BOY RANGERS (AND LOCO)

"You dirty killer! If I had you, I'd have ripped your arm loose and beat your head off with it!"

Created by:
Unknown

Debuted in:
Clue Comics
#1 (Hillman
Periodicals, January
1943)

Partnered with:
Jackie Law

**Biggest
achievements:**
Operating a giant
robot, controlling a
homicidal maniac

© 1943 by Hillman
Periodicals

J ACKIE LAW, LEADER OF the Boy Rangers, had every reason to seek vengeance upon the crime world. His pals, on the other hand, seem to have joined his crusade strictly out of feelings of loyalty and friendship. Well, most of them. The cadre's youngest member enjoys the pure pleasure of beating crooks with a baseball bat.

On the way home from a sandlot football game with his four closest buddies, Jackie witnesses a horrific tragedy unfold: Jackie's father, foreman of a construction site, is pushed into a jumbo-sized concrete mixer by crooks as a warning to other business owners who refuse to participate in their criminal-protection racket.

Not surprisingly, this engenders in Jackie an abiding hatred for evildoers. "I'll get them," he pledges, tears streaming down his cheeks, "I'll get them all! From now on, all criminals are my enemies!" Jackie's friends waste no time in cosigning his newly adopted mission as the Boy Rangers.

The youngsters assign themselves ranks and convert their football uniforms into crime-fighting togs emblazoned with the letter R. Naturally, Jackie is given the rank of general. Husky Buck is appointed major, talkative Froggy is made captain, buck-toothed Corny is the team's sergeant, and diminutive but frisky Gorilla is assigned the rank of private. This suits Gorilla, who possesses a violent streak a mile wide. "That means I'll have to do all of the fightin'!" he exclaims joyfully. "O'boy, o'boy!"

He's also the ranger most likely to leave a mark. In the team's few appearances, Gorilla is depicted tearing at his opponent's ears with his teeth, jumping forcefully on their faces, and pushing them in front of speeding mine carts.

A few issues into their adventures, another sidekick joins Jackie Law's roster: a giant experimental robot named Loco. Standing several stories tall, the titanic automaton requires a quintet of operators—one in each limb and another to run the head. The Boy Rangers use Loco to turn the tables on the Nazi agents who attempted to steal the 'bot and then keep him for one more adventure before returning to exclusively flesh-and-blood crime fighting. No explanation is given for the colossus's disappearance. Given that this was during wartime, Loco was probably more valuable to the war effort as scrap metal. Not to mention too dangerous to leave in the hands of a kid named Gorilla.

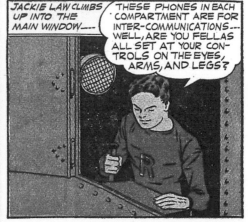

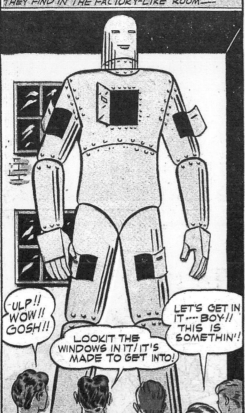

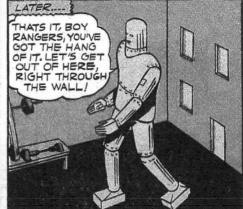

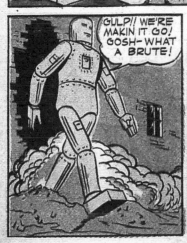

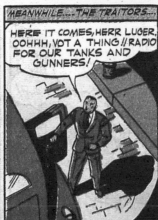

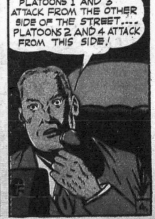

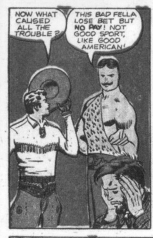

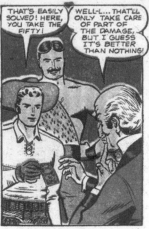
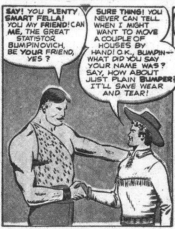
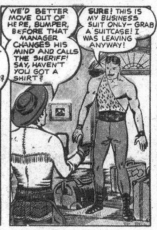
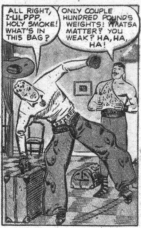
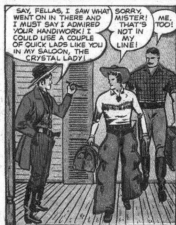
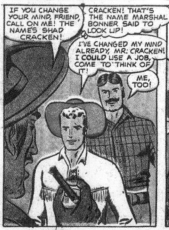
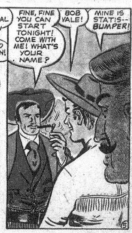

BUMPER

"I butt heads with a bull once and knock him to sleeping!"

WHO IS THE GREAT Statistor Bumpinovitch? Besides a mountain of mustachioed muscle, he's the sidekick to Bob Vale—aka cowboy hero Black Diamond—and the owner of the toughest skull this side of the Rio Grande.

Black Diamond was secretly a gunfighter whose father had been gunned down by a wicked desperado. Wearing a mask to hide his identity, he pursued lawless men across the lawless, ruthless "Eldorado [*sic*] for crime" that the Wild West had become. He had no particular assets outside of a sharpshooter's eye, a superbly trained horse . . . and good taste in sidekicks.

Bumper is introduced inside a grimy saloon in Red Dog Creek. A strongman of the Eugen Sandow variety—in fact, Bumper overtly resembles the legendary bodybuilder—the heavily accented colossus is busily showing off his physique to impressed ladies and intimidated men. Capitalizing on Bumper's boasts of having out-butted both a goat and a bull, an onlooker challenges the strongman to shatter a solid oak door using nothing but his rock-hard head and a running start.

Naturally, he knocks the door to the ground. "No good hinges," he explains, "or I split wood in middle." With no shortage of pride, he adds, "Plenty strong head, huh?"

When the other fellow refuses to pay up, a donnybrook ensues. Owing to his tremendous strength, Bumper naturally cleans house on anyone dim-witted enough to take him on and makes a wreck of the hotel lobby while he's at it. Since this is the Old West, however, guns quickly become involved. A conveniently passing Bob Vale disarms a man whose gun is trained directly on Bumper, subsequently earning the giant's loyalty. "You plenty smart! You my good friend!"

From that point on, Bumper is Bob's close compatriot—in both of his identities. Whether associating with such a noticeable and imposing figure complicated Bob's effort to maintain his alter ego was left unexplored.

Unfortunately, Bumper rapidly dropped his strongman garb, closely followed by his head-butting proclivities and his Eastern European accent. Midway through the Black Diamond and Bumper's run, Statistor is indistinguishable from any number of other cowboy sidekicks. This is an unfortunate dilution of such a strong character.

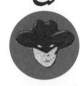

Created by:
William Overgard

Debuted in:
Black Diamond Western #9 (Lev Gleason, March 1949)

Sidekick to:
Black Diamond

He's so strong that he has a:
Handlebarbell mustache

© 1949 by Lev Gleason

BUTCH

"A woman gets toughened to the hard knocks of life . . ."

Created by:
George Brenner

Debuted in:
Crack Comics #21
(Quality Comics,
February 1942)

Mascot to:
The Clock

Favorite dish to serve:
A knuckle sandwich

© 1942 by Quality Comics

THE CLOCK IS ONE of comicdom's oldest characters, debuting in 1936—years before more prominent characters like Batman, Superman, and Captain America. In his sharp suit and simple mask, he was the model for dozens of other vigilantes, and he provided a direct link between the trigger-happy heroes of pulps and the costumed do-gooders of comics. But the Clock ran slower than his contemporaries when it came to having a sidekick.

Badly wounded after a shootout with a gang of crooks, he wanders weakly through the streets of the city. Delirious, but desperate to keep his identity secret, the hero chooses to spend his final minutes in what he believes to be a deserted shack at the end of a neglected alley.

But the shack isn't deserted, it's home to the orphaned street girl Butch. Despite her young age and short stature, Butch is tough as nails. As a strange, injured man comes stumbling through her home, Butch's main concern is the invasion of her privacy. "Hey!" she shouts. "What's the idea o' bustin' in on a lady when she's dressin'!!"

The Clock arrives just in time to pass out from his wounds. As several months tick by, Butch slowly nurses him back to health with a combination of first aid, hot milk, and heartfelt prayer. Believing her ward to be a crook on the run from the law, Butch is nonetheless disinclined to turn him over to the authorities. "Please don't let this man die," she pleads with a higher power, "even if he is a gangster . . . "

As a matter of fact, the Clock turning out to be a gangster would suit Butch just fine. After her ministrations prove successful, the Clock proceeds to leave the shack and resume his war on crime—but Butch has other ideas. "I always wanted to be a moll," she confesses, haranguing the Clock into taking her on as a partner.

Butch promptly proves invaluable. With her job hawking newspapers on a street corner, she's privy to assorted scuttlebutt drifting up from the city's underworld. She's also tough, fearless, and relentless—even the Clock must concede to her constant demands, which usually means letting her tag along on his investigations.

EDITOR'S NOTE

Butch was in fact the Clock's second sidekick. Preceding her was Pat "Pug" Brady, an ex-athlete who bore an uncanny resemblance to Brian O'Brien, the Clock's secret identity.

'BEFORE I CARVE 'EM UP, SLUG-- SOICH 'EM!

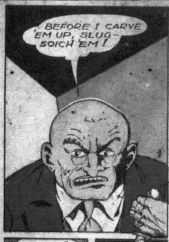

THE CROOK SLIPS HIS HAND INTO THE CLOCK'S POCKET--

EYOWW--

THE GUN FLIES OUT OF HIS HAND--

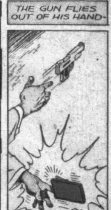

GOT IT!-- BET THAT'S TH' FIRST TIME THAT TRAD CAUGHT THAT KIND OF A RAT--ULP!-- THIS ROD--

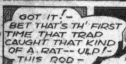

H-H-T'S L-L-LOADED!

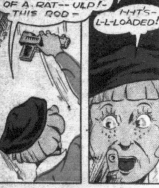

O-K-K-KAY, Y-YOU M-MUGS-- M-MY TRIGGER FINGER'S SH-SHAKY-- S-SO D-DO AS I S-SAY-- UNTIE TH' C-C-CLOCK-- Q-Q-Q-FAST--

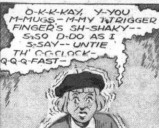

G-GO T-TO WORK ON EM, B-BOSS-- B-BEFORE I' SH-SHAKE T-TO P-P-PIECES--

YOU BET!

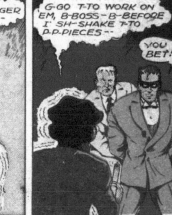

OH HUM--THAT'S THE LAST!

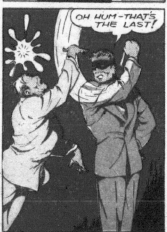

NOW, BUTCH--THERE'S A FEW THINGS I WANT TO KNOW-- THE FIRST IS-- HOW'D THAT TRAD GET IN MY POCKET ??

N-NOT NOW-- B-BOSS--PLEASE, I--I'M SUFFER- ING F-FROM N-NERVOUS NERVES-- A-A LOADED G-GAT... GULP

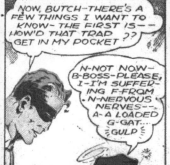

CHIPPER

"Reckoner! Look out!"

&

THE RECKONER WAS AN unremarkable—even ordinary—entry into the annals of masked crime fighting. He boasted no powers, gadgets, or advanced crime-busting tactics. No origin story was ever provided for him. Even his costume, resplendent as it was—top hat, formal tails, and a half-cowl mask—resembled the signature outfits of several dozens of other heroes from the same era. And for that matter, what does his nom de guerre even mean? Does he *reckon* quite a lot? But cab driver Matty Martin did have one thing going for him: his kid sidekick, Rocky.

A red-headed fireball, Rocky possessed all the most desirable traits in a sidekick. He was a crack shot with a slingshot and equally quick with a snappy rejoinder. The turtlenecked terror was also fearless and eager for action. In his first appearance, he fires a pebble into a crook's hand, causing the baddie to drop the gun he'd aimed at the Reckoner's back. Apparently the Reckoner didn't reckon with that!

As if all that weren't enough, Rocky was also one heck of a booster. "Attaboy Reckoner," he hollers as his hero clears a path through a gang of tough guys. "Give it to 'em, kiddo!" Not that he sat on the sidelines. "Let 'em have it, Reckoner!" he enthuses in the next panel. "I'm right behind ya!"

Rocky was a dynamic addition to the Reckoner's unexceptional adventures. In fact, he may be the ideal incarnation of his particular breed of sidekick—the non-powered street orphan who's resourceful, packed with personality, and ready for a fight. So what makes Rocky suitable for inclusion in this book? What makes Rocky regrettable?

Nothing, except that he was immediately replaced by Chipper.

A change in creative teams between the Reckoner's first and second appearances dramatically altered his sidekick. Chipper joined conversations primarily so that the Reckoner could explain plot points to readers. Not much of a fighter, Chipper was knocked down or injured more often than not—a handy excuse to allow crooks to remain at liberty until the third act. Compared to Rocky, Chipper was a pale substitute.

On one occasion, Chipper took down a couple of Reckoner's foes with a deftly wielded kitchen chair, saying, "Every time I let you out of my sight, something happens . . . !" This was an exception, however. And Rocky probably wouldn't have needed the chair.

Created by:
Bob Fujitani

Debuted in:
Cat-Man Comics
#27 (Holyoke, April 1945)

Sidekick to:
The Reckoner

Most notable skill:
Making people wonder what happened to Rocky

© 1945 by The Holyoke Publishing Company

CLAWITES

"Attack . . . Heil Claw!!"

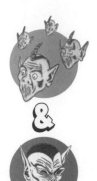

Created by:
Bob Wood

Debuted in:
Daredevil Comics
#16 (Lev Gleason,
April 1943)

Henchmen to:
The Claw

Job description:
Allegiance to the
Claw, death

© 1943 by Lev Gleason

PROVIDING HENCHPERSON SERVICES FOR a big-league supervillain is no beauty contest. A felonious factotum needs only to be able to follow orders, confound the hero, and do a little light killing here and there. Movie-star good looks are not mandatory. This is very good news for the Clawites, the transformed creature-servants of the gruesome colossus known as the Claw.

The fanged, jaundiced Claw was a persistent thorn in the side of the many heroes from the Lev Gleason line of comics, including the original Daredevil, the Ghost, and Silver Streak (who teamed up with Whiz, King of Falcons; see page 130). A sometimes ally of Axis powers in Europe and Asia, he also repeatedly attempted to assume control of every nation on Earth as a solo act. This persistence partly explains why the Claw starred in an ongoing feature, as few villains have.

The Claw was outfitted with a destructive arsenal of unimaginable variety and power, including his vital Clawite servants—former prisoners who had been mutated into creatures that even the Claw considered to be "winged horrors." The green-skinned, scaly brutes possessed forked tails and carried pitchforks, evoking popular images of satanic creatures. Rather than boasting devil's horns, though, most Clawites had a single, narwhal-like protrusion sprouting from their foreheads.

Although the Clawites could speak English, they frequently indulged in an unearthly, horrifying battle cry. "Ee-ee-e-oe-oo" would ring out when the Clawites rushed into the fray, unsettling their targets and making a terrible racket besides.

The Claw was understandably hard on his underlings; he had a reputation as a ruthless menace to maintain, not to mention a raging hatred of all living creatures. Clawites were frequently murdered by their boss for minor infractions. "Remember," he shouts after them as they embark on a mission at his command, "allegiance to the Claw or death!" Sometimes both were involved; Clawites seemed practically made to be killed, falling to the likes of escaped convicts, theater actors, scientists, and college professors.

In the end, the most determined detractor of the Clawites was always the Claw himself. Frequently referring to his devoted aides as "swine," "fools," "pigs," "idiots," and so on, he seemed unconcerned with their survival on a fundamental level. Not the best gig even in times of high unemployment. But hey . . . it's a living.

I TRIED MY BEST TO REMEMBER THE WAY! -ONCE YOU CLEAN UP THAT MONSTER YOU CAN DO ANYTHING YOU WANT WITH ME!... PRISON AGAIN WILL BE HEAVEN!

WE'LL TALK ABOUT THAT LATER!

IS LEADING THEM BACK TO CLAW!

WE MUST PREVENT AT ALL COSTS!

YEAH, THIS IS RIGHT! -WE WENT SOUTH, THEN TURNED WEST, IT WAS IN A MOUNTAIN LIKE...

THIS TIME WE'LL POLISH THAT FIEND FOR GOOD!

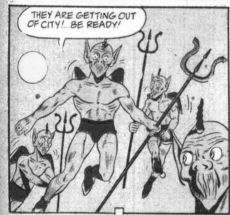

THEY ARE GETTING OUT OF CITY!...BE READY!

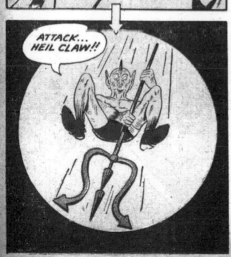

ATTACK... HEIL CLAW!!

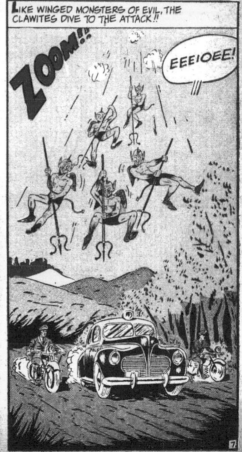

LIKE WINGED MONSTERS OF EVIL, THE CLAWITES DIVE TO THE ATTACK!!

ZOOM!!

EEE!OEE!

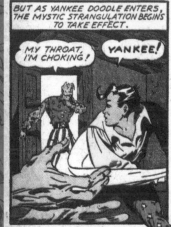

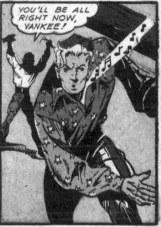

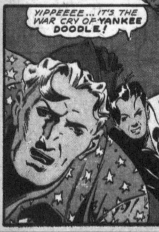

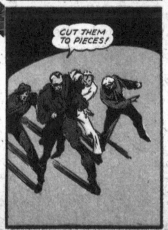

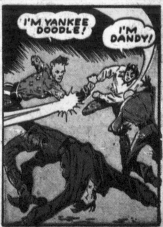

DANDY

"Wish I had a piece of chocolate cake to pass the time away with."

ANDY DOODLE WAS DOGGEDLY determined to become a dressed-up do-gooder. This unchallenging tongue twister describes a sidekick so intent on gaining superpowers, he relies on the five-second rule to make it happen.

Before Dandy gets his chance to shine superheroically, however, we must learn of his senior partner's beginnings thanks to one of the more gruesome origins in comics. An unnamed scientist recruits "a strange group of crippled war veterans" to aid him in developing an "invincibility injection." Lacking any greater glimpse into the process, we must conclude that the serum *and* its test subject are made from the dismembered corpses of the aforementioned study volunteers. Gulp! "Hours of transplanting delicate living organisims [*sic*]" results in a fluid that contains "the strength of an army." The serum is hastily injected into the experiment's ultimate test subject (and apparent Frankenstein's monster): Yankee Doodle Jones.

Left out of the festivities is the scientist's teenage son, Dandy, who longs for a shot of that strength-enhancing corpse juice, musing: "Gosh, if only Dad would inject me with some of that!"

Dandy doesn't have to wait long. Axis saboteurs interrupt the experiment, fatally shooting the serum's inventor before Yankee receives the full contents of the syringe. In a move both patriotic and woefully unhygienic, Dandy grabs the used needle, promptly injecting what remains of its potent cargo directly into his own arm.

With his dying breath, the old scientist passes the management of Yankee and Dandy's Axis-smashing activities to the literal spirit of Uncle Sam. Before you know it, their patriotic patronus is assigning them missions of national importance. He sometimes rewards them with cake.

Dandy does most of the hard work. Lazy in his civilian identity (also sass-mouthed, fidgety, and obsessed with chocolate cake), he's a dynamo in his Dandy duds. While he engages in all of the sleuthing, footwork, and initial fisticuffs, Yankee has a tendency to make his entrance right at the end of a fight.

And even then he relies on Dandy's direction. Despite being powered by corpse juice and the patronage of America's spirit of freedom, Yankee must whistle the song that bears his name—"the war cry of Yankee Doodle"—to refresh his flagging abilities. But he seems to need Dandy's prompting to do it. Obviously, without Dandy the whole Doodle operation would fall apart.

Created by:
George Sultan
and/or Lou Fine

Debuted in:
Yankee Comics #1
(Harry "A" Chesler,
September 1941)

Partnered with:
Yankee Doodle
Jones

Weaknesses:
Chocolate cake, sass

© 1941 Harry "A"
Chesler Features
Syndicate

DICKY
"Right with you, Warrior!"

Created by:
Otto Binder and an
unknown artist

Debuted in:
Banner Comics #3
(Ace Magazines,
September 1941)

Partnered with:
The Lone Warrior

Attitude:
A little dicky

© 1941 by Ace Magazines

HY DOES A SUPERHERO called the Lone Warrior even *have* a partner?

And yet . . . the Lone Ranger wouldn't have been the same without Tonto. The Japanese samurai manga epic *Lone Wolf and Cub* exhibited a similar disdain for eponymous accuracy. So one could argue that there's precedent for the partnered loner archetype.

To be fair, Stan Carter tried to make it as a solo act, repeatedly discouraging his brother Dicky from any dreams of superheroic sidekicking. Stan pointedly recalls their mutual origin to make his case: "Dad was the world's greatest scientist," he states. "Before he died, he inoculated us with the Power Elixir and told me to go out and fight evil! I'm carrying out his wishes," he insists, adding emphatically, "as the *Lone* Warrior!"

Be that as it may, Dicky Carter—whose costumed alter ego is also called Dicky, a serious oversight in terms of personal security—remains glued to his older brother's side. Decked out in a nearly identical getup, Dicky boasts the same powers as the Warrior. The impressively strong duo can bend metal bars and lay out gangs of crooks with a single blow. Once or twice per page they're shown running frantically, limbs fully akimbo, implying super-speed. And they're frequently depicted in the midst of powerful leaps. Unfortunately, more than once, a super-leap ends in unconsciousness when the Warrior and Dicky conk their heads on a hard surface.

The Lone Warrior and Dicky get around in the Wonder Ship, presumably another invention of their father's. This small crimson craft can function as plane, boat, or submarine, and it produces tank treads from nowhere and jousts with enemy artillery. If the Lone Warrior keeps Dicky around for no other reason, it's because someone has to keep the Wonder Ship idling while he's out knocking around the Nazis.

Despite his brother's resistance, Dicky handles the responsibilities of sidekicking with aplomb. Besides being a valuable fighting partner, he masters the classic talents of agreeing with everything the hero says and frequently telling the hero how great he is. He doesn't show much ambition, but Dicky seems motivated less by the desire to battle injustice and more by wanting to spend time with his brother. However Dicky's antics contradict the Lone Warrior's code name, you can't fault him for his fraternal fealty.

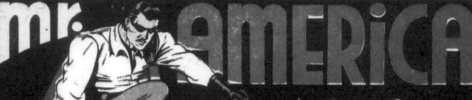

FATMAN

"If that flying carpet ever has puppies, I want one!"

A LAMPSHADE, A FLORAL-PATTERNED CURTAIN, and a suit of red long underwear—that's all it takes to dress like a superhero! Well, that's all it takes to dress like the *sidekick* to a superhero, at the very least.

That bizarre conglomeration is the outfit donned by Fatman, the portly pal of whip-wielding superhero Mr. America. The full-figured fellow under the lampshade was Bob Daley, confidant and close associate of oil magnate, superhero, and eventual espionage agent Tex Thompson.

Thompson had been the star of a series of adventure strips running in *Action Comics* (the home of Superman and one of the best-selling comics of the era), and after his apparent death, Thompson dyes his hair and adopts the secret identity of Mr. America.

And not long after that, his good pal Bob follows suit. Bristling at having been left behind "for his own good" from one of Mr. America's adventures, Bob comes to a fateful decision. "Treating me like a child!" he spits. "I'd like to show Mr. America I'm valuable, too! I'd show these crooks!"

Exactly what Daley intended to show the crooks is up for debate, because Bob has either quirky ideas about masked vigilantism or, alternatively, a good sense of humor. "Something that will inspire fear!" he crows as he places a lampshade on his head, adding, "This curtain will do!" Armed with an ink-filled squirt gun and a broom (which gives rise to his spontaneous catchphrase "I'll sweep up crime!"), Fatman swoops into action.

While his best pal Bob is busy dressing himself in upholstery remnants, Thompson is enjoying some success with a weird experiment. Dousing his cape with strange chemicals, Mr. America manages to invent a *flying carpet*. So both heroes are now wearing home furnishings as capes. It must be nice to have something in common with your partner.

Bob's alter ego is revealed fairly early on to Mr. America, which only further cements their partnership. The pair fight saboteurs and Axis agents, with Bob displaying surprising acumen as a crime fighter. The duo even acquires a femme fatale nemesis called the Queen Bee (who was as much the archenemy of Fatman as she was of Mr. America).

Improbably, Fatman is that rare sidekick who was given the opportunity to graduate to solo hero status. He's cut loose when Thompson adopts his *third* identity, this time an American espionage agent operating overseas as the Americommando. (The pair had been often billed as the Americommandos, but apparently Thomson found it too catchy a title to share.)

&

Created by:
Ken Fitch and Bernard Baily

Debuted in:
Action Comics vol. 1 #1 (DC Comics, June 1938)

Partnered with:
Tex Thompson/ Mr. America/The Americommando

Sometimes mistaken for:
An obese lamp

© 1938 by DC Comics

Fatman receives new marching orders from no less a voice of authority than President of the United States Franklin Delano Roosevelt. "Will you carry on your job of crime fighting—alone?" the president puts to the portly paladin. Although his solo career never materialized outside of a few satirical references, Fatman leaves that meeting with the best intentions. "Go on without Mr. America," he stammers. "I-I never thought I could . . . but if America needs him, I'll do my part—gulp—alone!!"

EDITOR'S NOTE

Fatman's appearance—not to mention his surprisingly successful rough-and-tumble fighting style—may have borrowed liberally from an earlier Golden Age superhero. The Red Tornado was, in her civilian identity, Abigail Mathilda "Ma" Hunkel, the formidable matriarch of a raucous tenement family. When danger called, Ma dispensed with her apron and donned the same sort of long underwear uniform worn by Fatman. However, where Fatman preferred a lampshade for a helmet and curtains for a cape, the Red Tornado preferred a cooking pot and a bath towel, respectively.

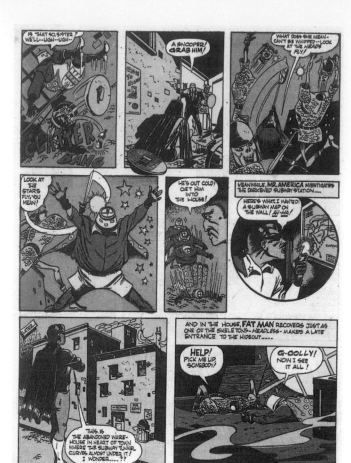

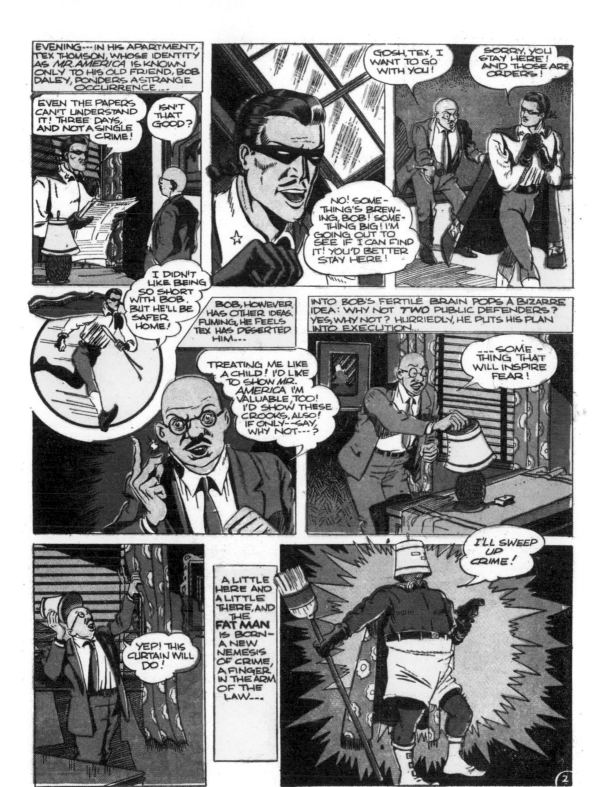

FRECKLES, SUSAN, AND FOXEY

"Oh-ho! There's work to do!"

Created by:
Unknown

Debuted in:
C-M-O Comics
#1 (Centaur
Publications, 1942)

Partnered with:
Super Ann

**Member most
likely to be thrown
off a bridge:**
Susan, hands down

© 1942 by Centaur
Publications

THREE YOUNG WOMEN FROM Lodi, Arizona, make good and find themselves in Hollywood—foiling a couple of kidnappings along the way. That's a pretty good plot for a series and doesn't even mention the abused dog the trio rescues.

Super Ann was the somewhat exaggerated moniker for Ann Allan, a thoroughly unpowered young woman with dreams of making it in Hollywood. Fortune seems to smile on her and her two closest friends—swinging bobby-soxer Freckles Doyle and learned scold Susan Green—when they're hired as extras for a film being shot in their hometown. On-set jealousy leads one of the film's leading ladies to arrange for the abduction of the other, which puts Ann and her pals on the case.

Ann's associates run to extremes when it comes to their personalities. Fresh and forward Freckles speaks fluent hepcat and is easily starstruck by the transplanted Hollywood glamour. By contrast, Susan is a cynic, wielding her large vocabulary and disdain for trivial concerns as a bludgeon. Between the two of them, the banter flows like soda from a fountain. Freckles expresses her admiration of a beautiful starlet, blurting, "She's sure in the groove," and Susan snaps back, "Really Freckles . . . please speak English!"

Susan is unrelenting in her theft of joy. As Ann and Freckles become increasingly excited about their film debut, Susan languidly admonishes them: "Very amusing but it's all make-believe, you know!" Later, on her way to meet celebrity actress Alma Trent, Susan confrontationally asserts, "I'll ask her about the relative merits of Moliere and Shakespeare!" Susan, to put it bluntly, seems like a bit of a trial.

Their canine companion Foxey (a fox terrier, naturally) joins the trio when Ann rescues him from a beating by his former owner, embittered movie star Zala Nadon. Foxey returns the favor by rescuing Ann from an explosion that was set by Zala, who promptly reforms out of guilt. You would think that someone named Super Ann could have rescued herself faster than any small dog could, but perhaps delegation of responsibility is her superpower.

Ann and her friends costarred in *C-M-O Comics*, a unique magazine sponsored by the Chicago Mail Order Company that doubled as a catalog of goods. Inset panels praised the functional and attractive fashions sported by Susan, Freckles, Ann, and other characters, plus wares used in the story, offering descriptions and instructions on how to purchase them. For example: "Freckles's wool cardigan sweater is finely detailed, with purled shoulders and →

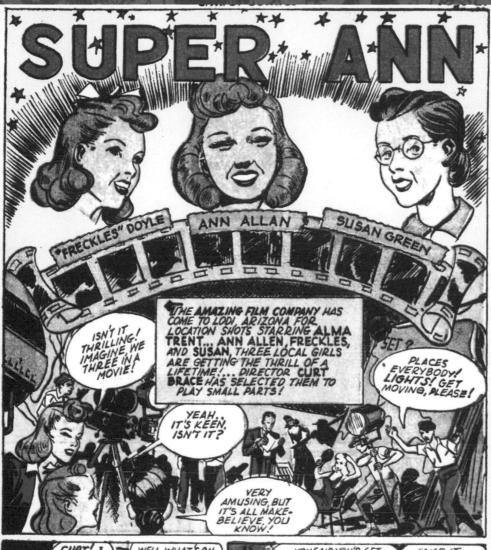

a ribbon-bound front," explains one listing. Ann has "a two-tone jacket" and Susan is depicted wearing "just the type of shirt the girls prefer," whatever that means.

EDITOR'S NOTE

Super Ann and her friends weren't the only comic book heroes to shill for Chicago Mail Order's catalog. Other characters whose adventures were interrupted to promote assorted department-store wares included Argentinian cowpoke the Gaucho, kid troubleshooters Jack and Judy Alden, unseen avenger the Invisible Terror, patriotic juvenile Star-Spangles Branner, and disturbingly elastic Plymo the Rubber Man.

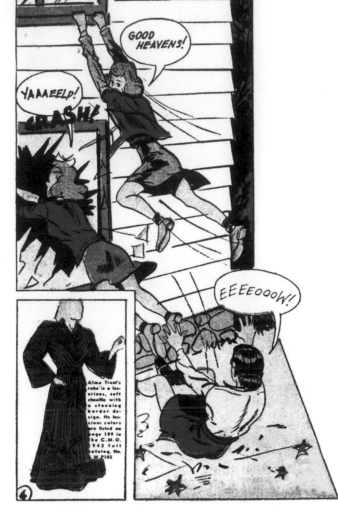

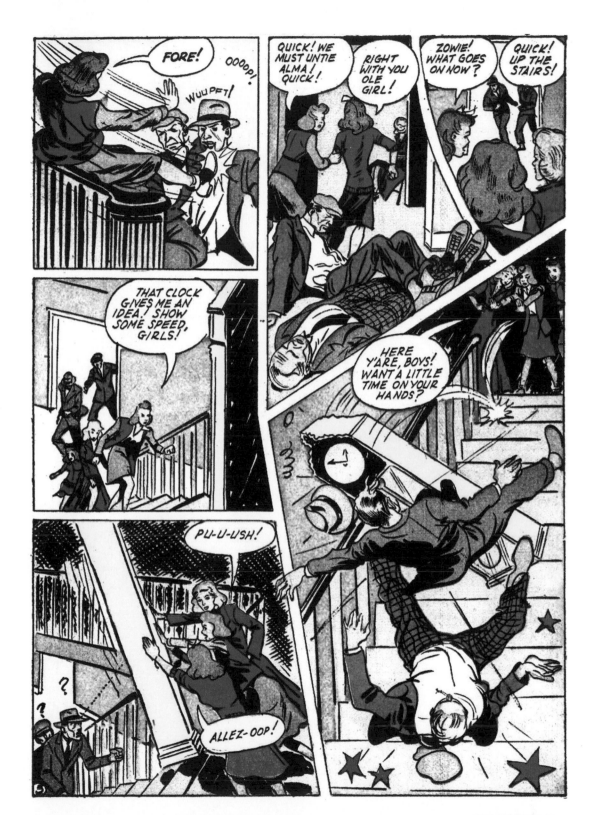

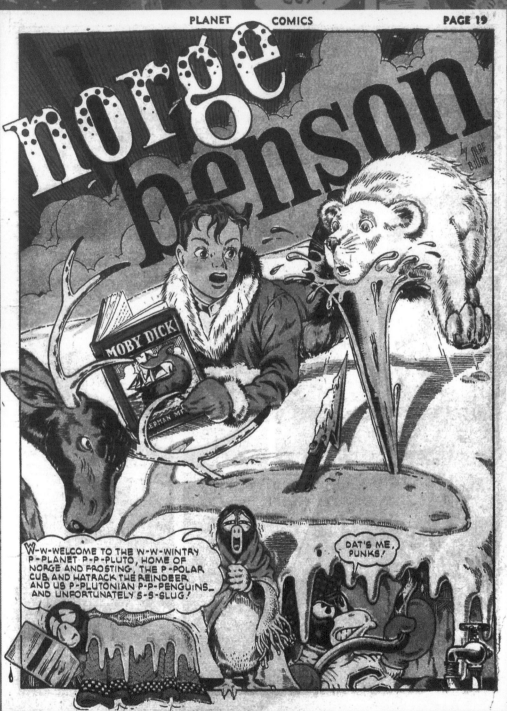

FROSTING

"Oops! I've lost my bearings!

HE ONLY LUCK THAT ever befell interplanetary explorer Norge Benson came in the form of ursine friendship. Dubbed the "Wrong-Way Corrigan of the space-ways," Benson makes an expedition to Pluto that ends in (relative) disaster. Dashing over the glacier-mottled landscape of the frozen world, Norge neglectfully plows his "stout little craft" into the mouth of a previously dormant "dry ice volcano." Agitated by the collision, the volcano erupts, sending the vessel plunging into the sub-arctic temperatures of Pluto's freezing oceans.

At least Norge has a good excuse. While he should have been paying attention to the ship's trajectory, Benson was busy cuddling his polar bear cub pal, Frosting! Cuddling a baby polar bear takes precedence over navigation, according to any space pilot manual I can think of.

Soon Norge and Frosting are rescued by the native inhabitants of Pluto, an advanced species of "Plutocratic" penguins possessed of a working English vocabulary. Frosting also speaks English—mentally, anyway. The little polar bear's thought balloons (and, on very rare occasions, speech bubbles) are riddled with characteristically bearish dialogue. Bounding over the frozen wastes on a reindeer's back, Frosting muses, "I'd rather be eatin' reindeer steaks than ridin' on 'em!" That's gratitude for you.

Norge and Frosting's time on Pluto is marked by frequent catastrophes and kerfuffles. Chief among their problems was Slug, a roughneck Plutonian who led an outlaw band of "hooligan penguins." At one point they capture Frosting and keep him in an ice cage at their hideout. One threatens to serve Frosting as "bear steaks" and adds, "And foidermore, wise guy, it looks like I'm gonna have a new fur coat, get me?" Luckily, Frosting could count on the friendly penguins and his dedicated pal Norge to haul him out of danger.

Frosting's contributions to the pair's adventures involved being captured, getting into trouble, and frequently being knocked or blown across the landscape—standard sidekick fare. Both the bear and his master spent quite a bit of time getting thrown around. They also mounted expeditions to nearby planets—including as a peace delegation to the warlike worlds of the solar system—although most of their career was spent in the snowy climes of Pluto.

Norge picked up some additional pals during his adventures, including a Plutonian reindeer named Hatrack and Princess Jolie of the planet Pax. But Frosting remained his bosom buddy through the end of the series's run.

Created by:
Al Walker

Debuted in:
Planet Comics #12
(Fiction House,
May 1941)

Partnered with:
Norge Benson

Primary contributions:
Being cuddly, making unbearable puns

© 1941 by Fiction House

GENI

"There's a lesson for you—think well before wishing."

Created by:
Harold DeLay

Debuted in:
Silver Streak Comics #1 (Lev Gleason, December 1939)

Partnered with:
Red Reeves, Boy Magician

Hair color:
Light brown

© 1939 by Lev Gleason

FINDING A GENIE IN A BOTTLE is a fairly common fantasy, so much so that it's a standard of myth and folk tales. Comics, too, are abundant with characters who have stumbled across or somehow earned a magic ring, a magic wand, or an enchanted flask containing a helpful supernatural spirit intent on making wishes come true. Among them is Red Reeves, one of the youngest genie wranglers in comics history.

Red—aka the Boy Magician, although magic is something into which he literally stumbles—is nothing more than an ordinary kid. In fact, it's ordinary kid activities that lead him to the company of his supernatural sidekick. In the middle of a heated game of marbles, a beat cop hauls Red in for playing in the street, and when he's brought home his punishment is mild. Red's mother forces him to stay indoors but allows him to play upstairs in the attic—amid a treasure of trove of forgotten wonders, including one of the legendary djinn!

Finding what appears to be "a peach of a marble" inside an old box, Red shines it on his sleeve. The resulting cloud of smoke reveals Geni, an all-powerful spirit in a turban and red robe who immediately proclaims his allegiance to Red. "I am the slave of that tiny globe which you call a marble," he explains, omitting the details of how he came to be trapped in such a thing. "Rub it and it will summon me at once to do your bidding." Red need not rely on the marble, though. Geni provides him with a "wand of power"—a magic wand with which the youngster can perform magic without the genie's assistance.

The magical stylings of Red and his servant vary wildly. After Geni whisks Red to the boy's grandparents' farm—"It's 100 miles away," explains Red, though the journey takes only moments—both attempt to build a new barn for the property. The sturdy structure created by the wave of Red's wand replaces the elaborate—and impractical—Mughal-style palace that Geni had enthusiastically conjured.

In fact, when it comes to using magic Geni proves to be somewhat bloodthirsty and trigger-happy. When a burglar breaks into Red's home, the hapless crook slips on the magic marble, awakening the genie. Appearing with a giant scimitar, Geni declares, "I am the slave of that marble that you stepped on—and rudely summoned me from my peaceful slumbers! Now you must die!" Red must be grateful that Geni was in a better mood when he discovered the marble.

Red, by contrast, listens intently to the intruder's hard-luck story and then uses his wand to reverse the reluctant thief's fortunes. After setting him up with →

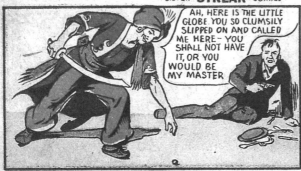

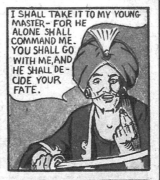

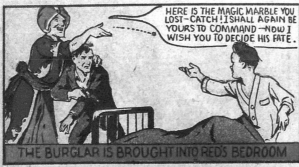

THE BURGLAR IS BROUGHT INTO RED'S BEDROOM

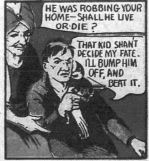

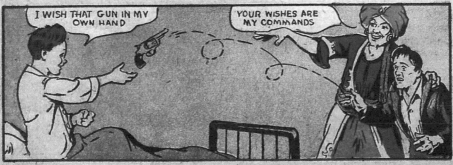

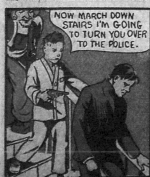

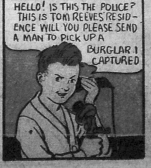

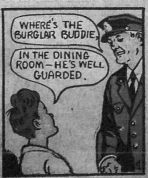

a nice house in the country, Red encourages his father to find rewarding work for the would-be burglar. The result is a life that is utterly redeemed and reclaimed. Given that the intruder would have been cut into ribbons if Geni had had his way, it's for the best that Red is calling the shots and not completely dependent on his genie's magic.

EDITOR'S NOTE

Red wasn't the only young'un to command mystical forces beyond his ken. School-age stage magician Jimmy Apollo also possessed his own genie, the mighty Magicmaster (see page 165), and DC's Johnny Thunder was famously able to command his magical pink thunderbolt with the use of his magic word, "Cei-U" (pronounced "say you!").

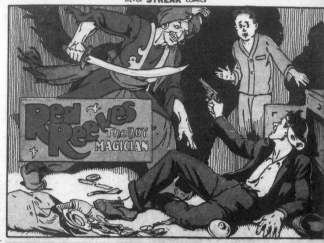

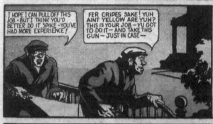

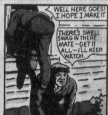

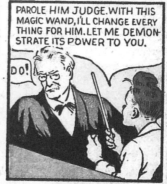

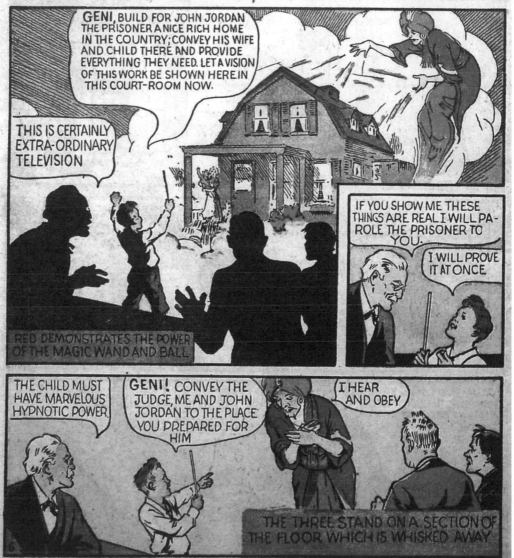

HOBO HARPER

JOHN HARPER, YOUNG MILLIONAIRE, SUDDENLY REPENTED OVER HIS LAZY MISSPENT YOUTH AND THE WAY IN WHICH HE SQUANDERED HALF HIS FORTUNE. SO HE GAVE THE BALANCE OF HIS MONEY TO A WORTHWHILE CHARITY NOW, AS "HOBO" HARPER, JOHN LEADS A BAND OF OTHER "GENTLEMEN OF THE ROAD", SEEKING ADVENTURE AND RIGHTING ANY WRONGS THEY MAY RUN ACROSS

OH, GIVE ME THE WIDE OPEN HIGHWAY

HOBO HARPER AND HIS BAND MAKE CAMP JUST OUTSIDE A SMALL MIDWESTERN TOWN

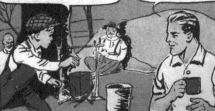

HOBO HARPER! SOMETHING CRAZY IS GOING ON DOWN IN THE WOODS!

WHY, IT'S YOUNG BILLY BARTON! WHAT IS IT BILLY?

I SAW 'EM, I TELL YOU. A BUNCH OF MEN IN THE WOODS PAINTING A HORSE!

THAT'S A FUNNY THING TO BE DOING THIS TIME OF NIGHT! WE'LL HAVE TO LOOK INTO THAT.

THE GENTLEMEN OF THE ROAD

"Did you hear him call us tramps, Hobo?"

THE EVERYMAN NATURE OF the hobo character, and the built-in backstory of strife and hardship, have made this an appealing—if only sporadically appearing—hero of comics, television, and assorted other media. Among these great fictional hobos are John Harper and his allies, the Gentlemen of the Road.

Embarrassed by his profligate ways, Harper had divested himself of his great fortune (to the benefit of a "worthy charity") and dedicated himself to the life of an itinerant troubleshooter. A caption explains: "John Harper, ex-millionaire, is now known as 'Hobo Harper,' leader of a Robin Hood band of 'Gentlemen of the Road' who travel far and wide, seeking adventure, befriending the poor and oppressed."

Chief among the hobos who aid Harper are his beefy pal Baldy, who had played a giant in a carnival sideshow, and the retired vaudevillian Crisco.

When their adventures fall to fisticuffs, Baldy and Crisco's talents emerge. The hulking Baldy has to be restrained more than encouraged in fights because of his tremendous strength. Crisco's flamboyant characteristics include surprising agility, a grandiloquent manner of speech, and his big bay window. "I may be fat but, boy, am I tricky!" he exclaims as he flattens a musclebound goon. "Excuse me while I part my hair on your shirt!" he adds, head-butting another in the solar plexus.

As for the Robin Hood comparison, the Gentlemen of the Road boast some Merry Men–esque qualities. Although they don't redistribute wealth from the rich to the poor, they frequently intercede in affairs where affluent individuals take advantage of hardworking common folk.

This isn't to say that they're universally celebrated for their bravery. In one adventure, Hobo puts his life on the line to rescue an unconscious woman who had been placed in the path of an oncoming train. While Baldy and Crisco attempt to flag the train to a stop, an irritated conductor sneers, "Just a bunch of 'bos probably drunk on sterno!" as he guns it, unaware of the potential victim ahead. (Hobo rescues her in the nick of time.)

Despite this lack of respect, the Gentlemen of the Road continued to aid any individual who needed protection. Accolades and admiration are nice, but if Hobo Harrison teaches us anything, it's that for a true hero, an altruistic spirit and the open road are the best rewards.

Created by:
Sam Gilman

Debuted in:
Amazing Man Comics
#25 (Centaur
Publications,
December 1941)

Partnered with:
Hobo Harper

**Favorite kind
of pie:**
Any type currently
cooling on a
windowsill

© 1941 by Centaur
Publications

H
"—"

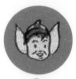

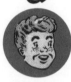

Created by:
George Roussos

Debuted in:
Advertisement in
Action Comics vol. 1
#6 (Thom McAn,
May 1946)

Sidekick to:
Thom McAn

**Could you repeat
that?**
"__"

© 1946 by Thom McAn

DVERTISERS IN COMIC BOOKS have never been shy about adopting the language of the medium. Almost from the beginning, companies have hawked their wares using single-page comic-style adventures.

Many companies created four-color champions to extol the virtues of their products: Tootsie Rolls had Captain Tootsie, Grape-Nuts had Volto from Mars. Pepsi the Pepsi-Cola Cop was a frequent feature in many magazines. The impish Peter Wheat adventured on behalf of a bakery of the same name, and U. S. Royal bike tires sponsored the adventures of their eponymous two-fisted he-man.

And then there was the heroic youngster named Thom McAn who served as the head of the very exclusive Thom McAn Club and advocated for the advantages of Thom McAn shoes, on behalf of the shoe-store chain Thom McAn. Many readers may be sensing a theme. As predictable as all those repetitions might become, Thom was full of surprises. When danger called—and it called often—Thom would don his Bazooka-Shoes. This superpowered footwear of indeterminate origin allowed the young man to fly impossibly fast, emit destructive jets of pure flame, carve out ravines, and emit "super-magnetic power" that could haul heavy machinery with ease. And then there's the superior arch support . . .

Emitting his battle cry "BAZOO-O-OOKA!" Thom tackled secret earthquake machines, rampaging elephants, broken dams, runaway bulldozers, firebugs, mad scientists, Axis opponents, and more. But he couldn't do any of this without H.

In addition to the kids from the Thom McAn Club (anyone can join, providing that they wear Thom McAn shoes), Thom is assisted by a silent, diminutive elf known only by his single-letter appellation. "Why does 'H' never speak?" asks the tagline at the end of every adventure. "Because he's like the 'H' in 'Thom McAn'—*always silent*! (The 'H' is silent, but the value **shouts out loud!**)" This has all the hallmarks of a Zen koan. (In fact, H speaks frequently, but his word balloons are charmingly empty.)

The gremlin's primary responsibility: caring for Thom's Bazooka-Shoes. When danger calls, he hands over the rocket-powered penny loafers to the young hero. When Thom returns victorious from his trials, H gives Thom his "Everyday Thom McAns" and stows the Bazooka-Shoes somewhere unseen. Perhaps H kept silent to avoid spilling the location of the amazing shoes, lest they fall into the wrong . . . feet.

HOW THOM McAN PREVENTED A CAVE DISASTER

WITH HIS MAGIC "BAZOOKA-SHOES"

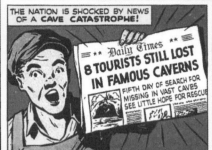

THE NATION IS SHOCKED BY NEWS OF A **CAVE CATASTROPHE!**

Daily Times

8 TOURISTS STILL LOST IN FAMOUS CAVERNS

FIFTH DAY OF SEARCH FOR MISSING IN VAST CAVES SEE LITTLE HOPE FOR RESCUE

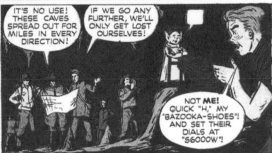

IT'S NO USE! THESE CAVES SPREAD OUT FOR MILES IN EVERY DIRECTION!

IF WE GO ANY FURTHER, WE'LL ONLY GET LOST OURSELVES!

NOT **ME!** QUICK "H," MY "BAZOOKA-SHOES"! AND SET THEIR DIALS AT "S6000W"!

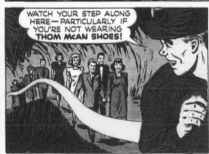

SET AT "S6000W," THOM'S MAGIC FLYING SHOES LEAVE A TRAIL OF **SOLID LIGHT!**

I'LL COVER EVERY SQUARE INCH UNTIL I FIND THEM! AND **THEN...**

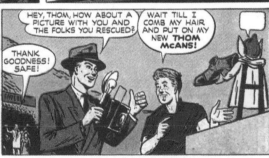

YIPPEE! FOUND AT LAST!

BUT CAN YOU LEAD US OUT AGAIN?

IT'S EASY, FOLKS! JUST FOLLOW THESE ROPES OF **SOLID LIGHT!**

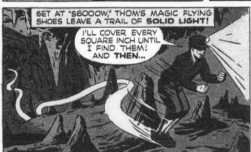

WATCH YOUR STEP ALONG HERE—PARTICULARLY IF YOU'RE NOT WEARING **THOM McAN SHOES!**

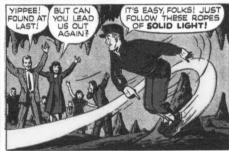

THANK GOODNESS! SAFE!

HEY, THOM, HOW ABOUT A PICTURE WITH YOU AND THE FOLKS YOU RESCUED?

WAIT TILL I COMB MY HAIR AND PUT ON MY NEW **THOM McANS!**

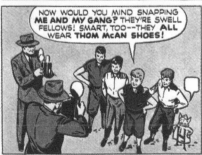

NOW WOULD YOU MIND SNAPPING **ME AND MY GANG?** THEY'RE SWELL FELLOWS! SMART, TOO--THEY **ALL** WEAR **THOM McAN SHOES!**

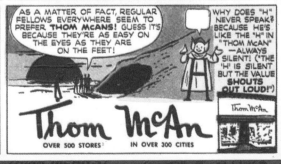

AS A MATTER OF FACT, REGULAR FELLOWS EVERYWHERE SEEM TO PREFER **THOM McANS!** GUESS IT'S BECAUSE THEY'RE AS EASY ON THE EYES AS THEY ARE ON THE FEET!

WHY DOES "H" NEVER SPEAK? BECAUSE HE'S LIKE THE "H" IN "THOM McAN"—ALWAYS SILENT! ("THE 'H' IS SILENT BUT THE VALUE SHOUTS OUT LOUD!")

Thom McAn

OVER 500 STORES IN OVER 300 CITIES

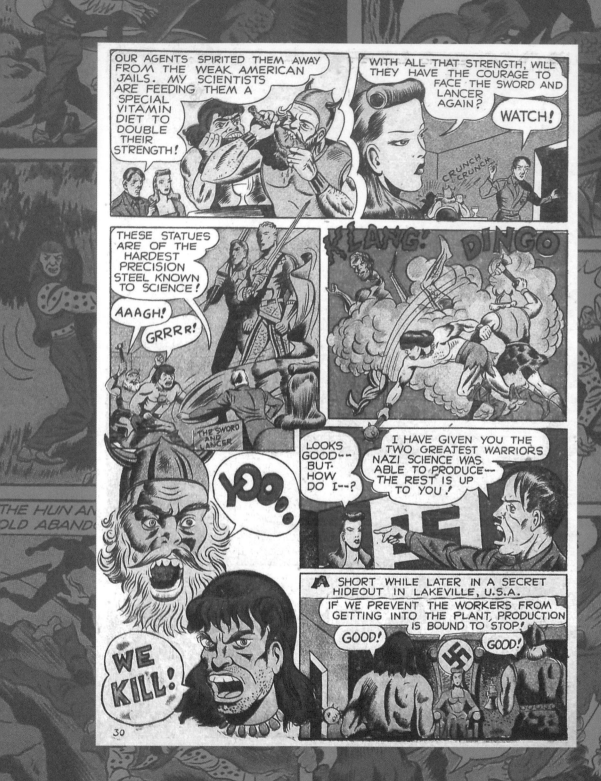

THE HUN AND THE GOTH

"Puny thing! I crush!"
"Me fight too!"

ARTHURIAN-THEMED SUPERHERO THE SWORD made a point to stick close to his inspiration. In his heroic alter ego, teenager Arthur Lake wielded the legendary sword Excalibur and palled around with both a youthful squire and a twentieth-century version of Merlin (see Moe Lynne, page 76). So it seems only natural that the Sword would also meet a modern-day Morgan le Fay: Axis spy Faye Morgana. Furthermore, if the Sword gets multiple sidekicks, then Morgana should too.

Though Faye Morgana—also known as the Daughter of Death—wielded significant magical abilities, she preferred to strike with a deadly whip. She also commanded a network of Nazi spies in the United States, and when her mission was compromised owing to heroic intervention, Morgana received backup from Germany, escorted by the Fuhrer himself!

Morgana is gifted with a pair of tough Nazi agents: the Hun and the Goth. Described by Hitler as "true Aryan warriors," they certainly look the part—or, at least, they would have a few hundred years ago. Befitting his name, Goth is a husky bearded man, bearing a mighty axe and wearing a horned helmet. Hun is one of those shirtless barbarian types, complete with mace and shield.

Even if they didn't cut a pair of imposing figures, the Hun and the Goth's ruthless barbarism would be sure to make their reputation. Morgana is horrified at the sight of the two hulking brutes being let loose on a group of innocent hostages. "Enough!" she cries, staring at atrocities that could only take place off-panel. "Even I can't bear to see any more!"

The Hun and the Goth's inaugural outing ends in defeat, but Hitler frees them from their American prison. As the two brutes chow down brutishly on a meal of roast fowl and wine, Hitler explains, "My scientists are feeding them a special vitamin diet to double their strength!" This gives them the moxie to confront the Sword and his allies, almost overwhelming them. A mob of riled townspeople turns the tide, however, and hands Morgana and her subordinates another defeat.

The addition of yet another henchman—the diminutive but accurately named Genius—does little to reverse their fortunes. After one last defeat at the hands of the Sword, the Hun and the Goth vanish back into the history that spawned them.

Created by:
Earl Da Voren

Debuted in:
Super-Mystery Comics vol. 3 #3 (Ace Magazines, January 1943)

Henchmen to:
Faye Morgana

Isn't the Goth too depressed to fight?
That's the wrong kind of goth.

© 1943 by Ace Magazines

KID TYRANT

"Get in there—squash-head! An' keep da yap buttoned!"

&

Created by:
Al Fagaly

Debuted in:
Target Comics
vol. 3 #1 (Novelty,
March 1942)

Sidekick to:
The Chameleon

**Not to be
confused with:**
Boy Dictator,
Young Hitler,
Mussolini Jr.

© 1942 by Novelty Press

I N ADDITION TO HIS ROLE as crusading newspaper editor, Peter Stockbridge was also known to the public as the heroic Chameleon. Employing the power of his family's newspaper, as well as his tremendous skill at disguise and his own two fists, the Chameleon served his city—and country—almost every waking moment of his day.

Accompanying him on some of his adventures, whether the Chameleon liked it or not, was his young ward Ragsy Murphy. Enthusiastic, tough, and clever, Ragsy was an orphan newsboy who one day finds the Chameleon wandering the streets in an amnesiac daze. After the kid helps Stockbridge regain his memory and his wealth, the newspaperman gratefully adopts Ragsy.

When a platoon-sized gang of juvenile delinquents terrorizes the city, Ragsy decides to investigate on his own. He joins the crew and ponders how best to disrupt their plans. Inspiration comes, as it often does, from the printed page. "If I could only figure a way to mess up dis job without them recognizing me," he ponders aloud. "If only I had a uniform like me favorite comic character, here—the Tyrant!"

Inspired, Ragsy takes needle and thread to an old ski suit, transforming it into the dramatic black-and-green costume of Kid Tyrant. He rushes into battle depending on only his wits, courage, and strength—and a water pistol that shoots blinding acid. Oh, and his "small super car," a red roadster capable of tremendous speed. "I'll have to move carefully in this bus," he muses, "avoid cops—'cause there's no license on it!" With a whistle clutched between his teeth ("Dis whistle will be me trademark!" he declares), Kid Tyrant upsets the gang's brazen assault on a high-society cocktail party.

Overnight, Kid Tyrant becomes something of a folk hero. As he bears down on the headquarters of his nemesis, the Hood, he summons an army of eager admirers with a whistle blow. Using his intelligence and charisma, the Kid wrangles the motley crew of spontaneously assembled civilian soldiers into a well-oiled unit, and they shut down the Hood's operation for good.

Kid Tyrant hangs up his ski suit promptly thereafter. This robs Stockbridge of a little amusement. "I see you're reading Tyrant Comics, Ragsy—how would you like to be the Kid Tyrant . . . " he inquires, pointedly adding, " . . . or *are* you the Kid Tyrant, by any chance?"

"Don't be nutty, Pete!!" Ragsy replies, sunk into an overstuffed easy chair, "dis stuff is just funny!"

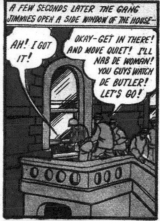
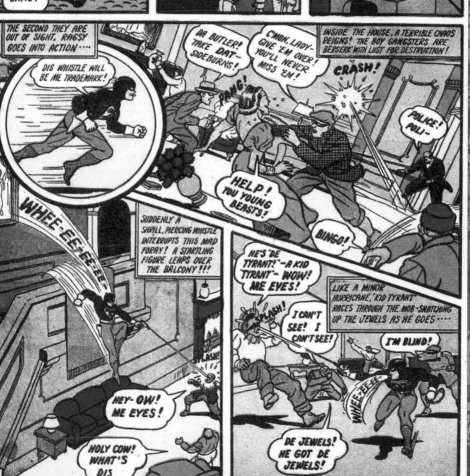

THE LIEUTENANT MARVELS

"I guess we're kinda Second Lieutenant Marvels."

HE MOTTO AROUND THE offices of Fawcett Comics must have been "Stick with what works." This would explain why their exceptionally popular superhero Captain Marvel was, early in his career, gifted with a small coterie of adjuncts and associates boasting the same costume and powers (with some exceptions; see "The Many Sidekicks of: Captain Marvel," page 68). First among the captain's many partners against crime, however—before his other, more enduring allies had even been conceived—were the Lieutenant Marvels.

To recap: When boy radio reporter Billy Batson speaks the name of an ancient wizard—SHAZAM!—he is transformed by magic lightning into the world's mightiest mortal, Captain Marvel.

But one day, three other boys *also* named Billy Batson arrive at radio station WHIZ to meet their name-alike role model. Thanks to some sort of supernatural loophole, they discover that they too can become red-suited superheroes by uttering the increasingly ubiquitous magic word. Decked out in uniforms identical to that of their superior officer, they each receive a third of the original Captain's powers—they're sharing a full portion among them, after all.

The boys adopt slightly derogatory nicknames so as to be told apart. The short, stocky Billy from Brooklyn is unkindly assigned the title of Fat Marvel; the laconic, Ozark-born Billy is dubbed Hill Marvel; and the lanky Texas representative is addressed as Tall Marvel. The nicknames seem to have been an inside joke from the Fawcett offices: the lieutenants were loosely based on three members of the publisher's art department, Paul Peck, Ed Hamilton, and Frank Taggart (Tall, Hill, and Fat, respectively).

The lieutenants have made only sporadic appearances in assorted Marvel Family comics, largely serving as an emergency cavalry for the series headliners. But when Captain Marvel, Mary Marvel, and Captain Marvel Jr. find themselves outnumbered (or overwhelmed by their responsibilities), they can count on the Lieutenant Marvels to lend valuable assistance. They're also handy stand-ins for Cap, should an important personal appearance be interrupted by a sudden invasion from the Monster Society of Evil.

Although not the most prominent members of the colorfully costumed crew, the lieutenants represent the peculiar and enduring charm of the Marvel Family. Through innumerable reboots of the franchise, these ancillary officers keep finding a way back into the family they first helped create.

Created by:
C. C. Beck and unknown writer(s)

Debuted in:
Whiz Comics vol. 1 #5 (Fawcett Comics, September 1941)

Partnered with:
Captain Marvel (and the Marvel Family)

Type of sidekicks:
Triply redundant

© 1941 by DC Comics

THE MANY SIDEKICKS OF
CAPTAIN MARVEL

CAPTAIN MARVEL MAY BOAST more partners, sidekicks, and lookalikes than any other costumed crime fighter in comic book history. By providing liberal access to the magic word that grants him his mighty powers, he has surrounded himself with enough lightning-emblazoned B-listers to fill a football stadium.

Most prominent of these supporting super-heroes are Billy Batson's friend Freddy Freeman—a disabled newsboy who moonlights as the mighty Captain Marvel Jr.—and his once-long-lost sister Mary, whose alter ego

Mary Marvel seems to hint overmuch at her secret identity. These three heroes formed the core of the Marvel Family and were the stars of several Shazam-themed titles produced by Fawcett Comics throughout the forties and fifties.

But not everyone in the Marvel Family was magically gifted. A soft-hearted grifter bearing the unlikely handle of Dudley H. Dudley frequently dressed up in a homemade costume and joined the superheroes as their Uncle Marvel. (In the classic comedy tradition of lazy men using lumbago as an excuse for not working,

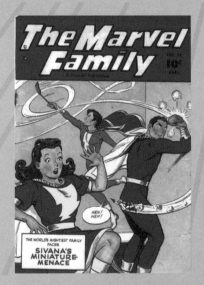

THE WORLD'S MIGHTIEST FAMILY FACES **SIVANA'S MINIATURE MENACE**

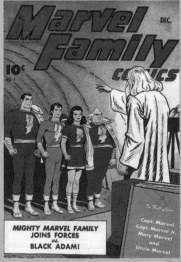

MIGHTY MARVEL FAMILY **JOINS FORCES** vs. **BLACK ADAM!**

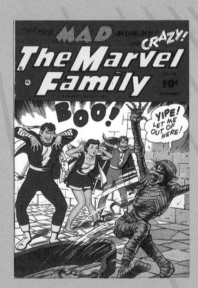

he'd claim that a case of the "ol' Shazambago" kept him from flying). Dudley's niece and Mary's best friend, Freckles, was also without powers but nonetheless would rush into battle as Freckles Marvel.

Other sidekicks included the well-dressed, well-mannered talking tiger Tawky Tawny, a popular fixture of the Marvel books. Also frequently of assistance were Billy's boss at the radio station, pals like Whitey and Sunny, and Magnificus and Beautia Sivana, the children of his bitterest foe who had rejected their father's wicked ways. Not every sidekick was worth remembering; an unfortunate Stepin Fetchit–type character named Steamboat was escorted away from the Marvel cast of characters relatively early on.

Headlining his own book was Cap's most unlikely alternate number—Hoppy the Marvel Bunny! A pink rabbit from a world of anthropomorphic animals, Hoppy was granted powers equal to Cap's upon uttering the familiar magic word. How he learned it, however, is a question for the ages. Cap and Hoppy have met only infrequently, and the topic never seemed to come up.

In fact, the Marvel Family ultimately grew so large that they acquired a fight song, frequently sung when the whole clan went into battle together:

> Marvels here, Marvels there
> Marvels, Marvels everywhere
> We chase evil to its lair and beat it
> Marvels short, Marvels tall
> Marvels, Marvels one and all
> When we hear our duty call we meet it

Keep the lyrics handy for the next time you and your friends go to karaoke.

All artwork © DC Comics

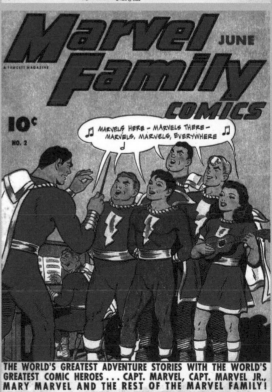

MESSENGERS OF KOLAH

"Gee, don't you think we guys ever get tired of getting you out of trouble?"

Created by:
Charles Sultan

Debuted in:
Punch Comics #1
(Harry "A" Chesler,
December 1941)

Assistants to:
Mr. E

Known relatives:
Lawn gnomes,
Keebler Elves

© 1941 by Harry
"A" Chesler Features
Syndicate

HE HERO MR. E was the star of a fairly long-running comic feature—complete with cover appearances—across a pair of Harry "A" Chesler's often outrageous comics. And yet, for the entirety of his run, he did it without superpowers, gadgets, or magical abilities of his own. How? Well, Mr. E had one outstanding skill: he knew how to delegate.

Prior to his crime-fighting career, Mr. E was evidently an amateur archaeologist of some sort—or at least a very lucky tourist. He finds a strange statue of the god Kolah in the ruins of a previously undiscovered prehistoric civilization and stashes it in a hidden basement chamber of his urban brownstone. When wrongdoing occurs, Kolah grants Mr. E prophetic and revelatory visions that lead him to the culprits, so that justice may be served.

But Mr. E doesn't right wrongs alone. Most of the hard work is undertaken by the Messengers of Kolah. The tiny, elflike critters—complete with pointed caps, pointy ears, and long beards—are dispatched by Kolah to assist Mr. E in his adventures. They have the power of transformation, although it is largely restricted to the ability to become a crow or a bat. On occasion they dress for their role, though, sometimes resembling pint-sized policemen, sailors, firefighters, and so on when performing specific tasks.

For the most part, the messengers are unnamed and silent. But after a few issues, some begin to make their personalities known, such as the sharp-tongued Spike, who pipes up whenever a quick quip is called for. Other identified members included Tim, Butch, and Zipper. (What sort of prehistoric culture produced supernatural beings with names like these is not touched upon in the series.)

In the grand scheme, the messengers carry more water for Kolah's crusade against injustice than Mr. E does: they distract and disable Mr. E's opponents, bring the police to assist the often-beleaguered hero, disarm gunmen, and do thankless footwork. When gangsters discover the location of Kolah's statue and attempt to wreck the idol, it's the messengers (whom one crook calls "Mr. E's tiny jerks!") who expertly defend the homestead. Honestly, they might be the real heroes in this equation, although their name doesn't appear on the comic's masthead. Consider this just another case of management taking the credit while the little guys do all the work.

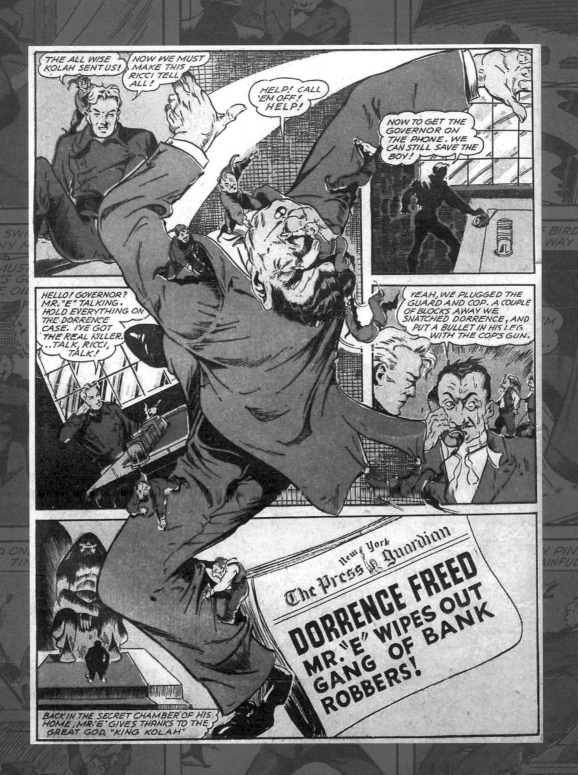

MIDGE

"Ohhh-h! Now I'm only six inches high!"

PINT-SIZED POWERHOUSE DOLL MAN had a long and storied career as a diminutive do-gooder in the pages of both *Feature Comics* and his eponymous title. From the beginning, he was aided in his one-doll-man war on crime by his fiancée, Martha Roberts.

Martha began her career as Doll Man's assistant and confidante in a strictly civilian capacity, possessing no superpowers. After her first decade in print, though, she gained shrinking abilities identical to her partner's. Decking herself out in a color-reversed version of Doll Man's costume, she joined him on his adventures as, predictably enough, Doll Girl.

But long before Martha picked up the Doll Girl habit, she enjoyed a brief excursion into the miniature world as the chipper, six-inch-tall heroine Midge. And it's all owing to a wish . . .

The incident begins as Doll Man, in his full-size secret identity of Darrel Dane, sits "in a meditative mood" and ponders questions of crime fighting. "I've had curious adventures as the Doll Man . . . ," he muses, "won furious fights against mighty adversaries—but it's been lonesome! Sometimes I wish I had a partner." Meanwhile, in another part of town, Martha Roberts stares at a roaring fireplace and finds her thoughts turning to her half-pint hero. "The Doll Man! So much heroism in so tiny a body!" she thinks. "I wish I could help him in his battle for the right things!"

In a *Freaky Friday*–type scenario, the mutual mental meanderings of Darrel and Martha produce a surprising result. "By a strange combination of will powers," explains an explosive caption, "Martha has shrunk to the size of the Doll Man!" The mental connection seems to remain in effect as each member of the reduced duo is equally—if remotely—intrigued by a newspaper article about a series of mysterious deaths. Doll Man rushes to solve the crime, and Martha independently chooses the same course of action. "Since I'm the Doll Man's size now, I'll do as he does . . . investigate possible crimes!"

Unfortunately for Martha, what she actually does is narrowly avoid being eaten by a spider, a frog, and a rat, in that order. Doll Man's timely intervention saves her, and finally the diminutive pair are united. It's almost a first-time meeting because Doll Man—for no particular reason—does not recognize Martha at her six-inch height. (To be fair, Martha, regardless of her size, never recognized Darrel in his Doll Man togs—even though they were engaged to be married.) She introduces herself as Midge and proceeds to help him solve the mysterious murders.

Created by:
Will Eisner (Martha Roberts); unknown (Midge)

Debuted in:
Feature Comics #77 (Quality Comics, April 1944)

Sidekick to:
Doll Man

Shoe size:
.01a, or a European .001

© 1944 by Quality Comics

→

Midge proves to be an exceptional addition to the crime-fighting duo. Forceful and insistent, she's able to command full-size humans through sheer moxie, and being "a size smaller" than her male counterpart, she easily slips into cracks though which Doll Man cannot pass.

Much as she gained her powers, Martha loses them when she and Darrel idly consider returning to full size. Although she never again adopted her Midge identity—despite desperately wanting to, according to her internal dialogue—the experience certainly paved the way for Martha's later career as Doll Girl.

EDITOR'S NOTE

Martha—as either Midge or Doll Girl—wasn't Doll Man's only sidekick. He also frequently rode around on the back of the quite ordinary-sized Elmo the Wonder Dog!

BUT TWO OTHERS APPROACH THE SCENE OF THREE DEATHS ---

AS THAT GIRL SAID TO THE BOY - BE CAREFUL!

BUT I'M NOT JOE BRAMBER! I'M THE DOLL MAN! I WANT A CLOSE LOOK!

LOOK, DOLL MAN! - THAT BIRD'S THIRSTY! I'LL JUMP ON THE PEDAL AND GIVE IT A DRINK!

CAREFUL, MIDGE!

THE DOLL MAN SPEAKS HIS WARNING TOO LATE! AS MIDGE PUTS HER WEIGHT ON THE PEDAL, WATER SPURTS ON THE BIRD!

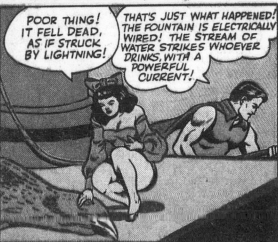

POOR THING! IT FELL DEAD, AS IF STRUCK BY LIGHTNING!

THAT'S JUST WHAT HAPPENED! THE FOUNTAIN IS ELECTRICALLY WIRED! THE STREAM OF WATER STRIKES WHOEVER DRINKS, WITH A POWERFUL CURRENT!

—AND THE WIRES LEAD TO THAT LITTLE SHACK, HIDDEN IN THE GARDEN!

HERE'S THE REASON FOR THOSE DEATHS! THE POLICE SAID HEART DISEASE —BUT IT WAS REALLY ELECTRIC SHOCK!

MOE LYNNE

"Hrumph! I'll write to the president and demand my rights, egad!"

Created by:
L. B. Cole

Debuted in:
Super-Mystery Comics vol. 3 #6 (Ace Magazines, October 1943)

Sidekick to:
The Sword and Lancer

What's he have up his sleeve?
Your wallet, probably

© 1943 by Ace Magazines

EENAGER ARTHUR LAKE STUMBLES across a hidden cavern, which turns out to be the burial tomb of the legendary King Arthur! He finds the enchanted sword Excalibur buried with its owner—despite what legend has to say on the matter—and tugs it from its stony sheath. Arthur is immediately transformed into the Sword: a powerful adult figure clad in golden armor and possessed of tremendous, superhuman strength.

As origins go, this is a pretty good one. At the very least, it's more glamorous than that of the Sword's trusted advisor, Merlin—known in his civilian identity as Moe Lynne. We first meet Moe as he's being thrown out of a moving boxcar. "Beat it, 'bo!" hollers the man who heaves Moe's bulk from the train. "The railroads are supposed to be paid for transporting passengers!"

Yes, the twentieth-century incarnation of the acclaimed wizard Merlin is a hobo. Although to be fair, Moe has enjoyed a storied life. A former entertainer, the acclaimed juggler and sleight-of-hand artist is quick to show off his manifold skills—once performed in front of the crowned heads of Europe, as the old saying goes.

In fact, those very skills set him on the path to sidekickery. Entertaining a group of youngsters—including Arthur Lake—Moe absentmindedly adds a fallen cigarette case to a collection of objects that he's juggling. Unbeknownst to Moe, the case was dropped by the Sword's deadly nemesis, Faye Morgana (who boasts her own pair of sidekicks, the Hun and the Goth; see page 63). Containing secret information regarding America's wartime defense plans, the cigarette case is of great interest to Morgana—and also to Moe, for a different reason. "This should bring a fin in any hock shop!" he notes.

Arthur Lake and his pal Lance are searching for the case, which Moe accidentally lets slip from his pocket, but the pair end up encountering Morgana and her goons instead. As the wicked whip-wielding Morgana absconds with Moe and the case, Arthur and Lance rush to the secret room where they've stashed Excalibur.

Drawing Excalibur not only transforms Arthur into the Sword, but also turns Lance into his primary sidekick, the Lancer. But this time a third transformation takes place: across town, as he attempts to delay Morgana's vengeful hand by showing off some simple magic tricks, Moe is suddenly transformed into the wizard Merlin!

Complete with peaked cap and flowing beard, Merlin sends Morgana running with a handful of spells. "Alla Ca-Zalla! Jumbo-Mumbo! Gadzooks!" he →

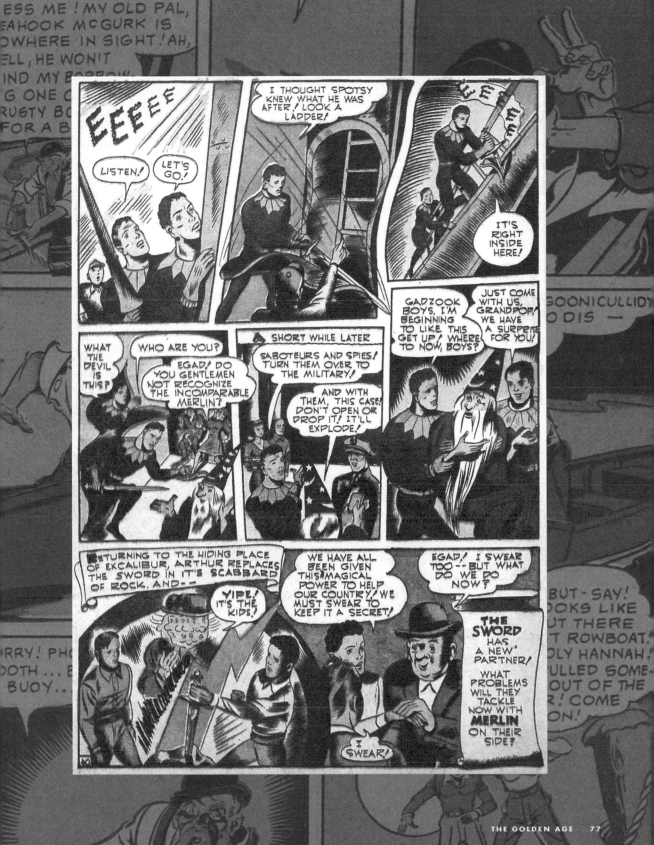

cries as he turns Morgana's whip into a deadly snake. "My power amazes even me!"

Moe stays on with the Sword and Lancer, though he possesses no control over his transformations. Acquiring a job in Arthur's father's munitions plant, the twentieth-century Merlin waits to be called upon in times of need, turning from plump prestidigitator to wizened wizard whenever Excalibur is drawn.

EDITOR'S NOTE

Moe was overtly based on movie comedian W. C. Fields, to the extent that he favored Fields-isms like "My little chickadee" and "Egad!"

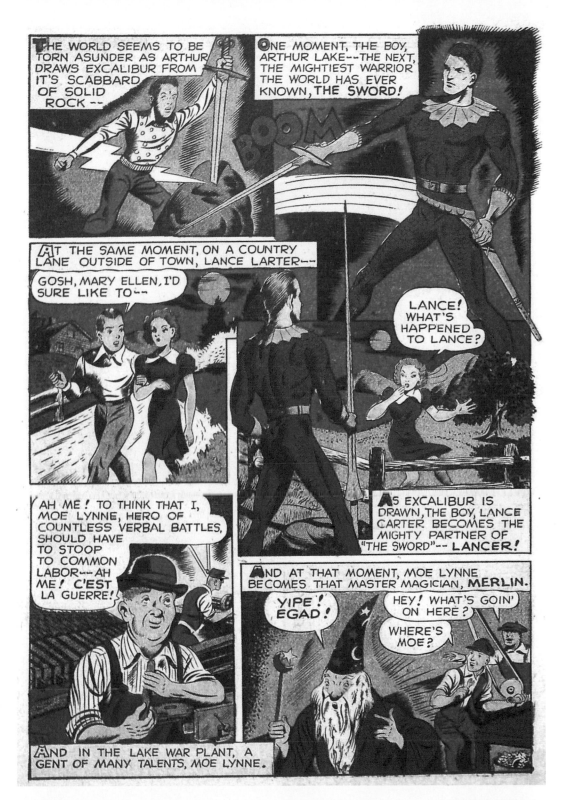

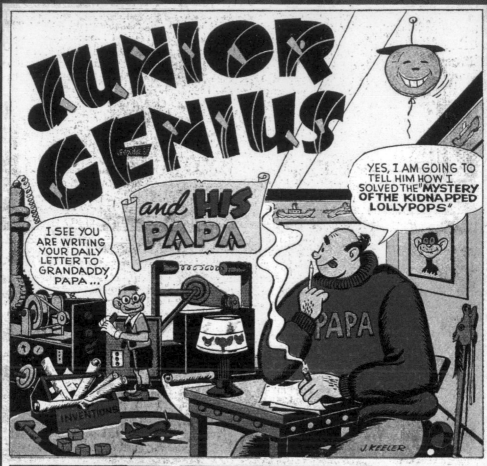

PAPA

"Kin I have my lolly-pop now?"

PAPA WAS HULKING, BALD, and (woefully) stupid. But he loved his son Junior (more or less) and was (almost) always game to help develop his boy's scientific curiosity. Yet despite being the paterfamilias of the two-person clan, he was unquestionably the sidekick of this duo. Which is probably inevitable when you're the proud and often-puzzled parent of the prodigy Junior Genius.

Papa and Junior reside in a sprawling house on the outskirts of a sleepy town. Nonetheless, they manage to frequently to find danger, crime, and excitement. When a tantalizing mystery rears its head—anything from criminal acts of sabotage to a mere scientific challenge—Junior is on hand to invent just the thing needed to investigate.

For his part, Papa is loaded with brute strength and an easygoing nature. This ends up being a tremendous boon to Junior, whose inventions are invariably heavy and sizable enough to warrant being lugged around by a pack animal. Lacking one of those, Papa does all the heavy lifting, to his extreme displeasure. "Aw, Junior!" he complains, carrying the better part of a full-sized railroad track on his back. "When are you going to stop strapping these gadgets to my back?" Idly tightening straps and bolts, Junior replies, "You know we can't afford a mule, Papa!"

Papa is very much like a large child, and his friends seem cast from the same mold. He hangs out with a gang of long-bearded codgers whose only interest seems to be model railroads. He also possesses a pal named Broombrain who, despite an equally absent intelligence, at least manages to discover a down-on-his-luck genie hanging out in a bottle by the sidewalk.

Papa has a couple of interests. For one thing, he's happy to hunt down crooks—in fact, he does so with or without Junior's help—and fortunate for him, he's either too tough or too stupid to acknowledge pain. He's capable of cleaning house on a half dozen bad guys at once without succumbing to a barrage of fists, bottles, and brickbats of all varieties. Unfortunately, his brute strength does nothing to mitigate the bruises, bumps, and black eyes he receives.

Papa's other passion is lollypops. Depicted with one of the sweet treats in pretty much every adventure, Papa becomes an inconsolable when he hears that the latest delivery has been delayed. "No lollypops?!! Somehow I had a feeling there would be no lollypops," he mutters, adding a plaintive "I'm a failure! Sob-sob."

Created by:
Jack Keeler

Debuted in:
Stuntman #1
(Harvey Comics,
April-May 1946)

Sidekick of:
Junior Genius

Occupation:
All-day sucker

© 1946 by Harvey
Comics

→

Despite Junior's genius status, the duo's expeditions end in success only about half the time. Experiments like creating a flying carpet from a dusty old rug or turning a jug-eared cousin into an airplane backfire spectacularly. Nonetheless, Junior is never shy about claiming victory in every setback, which is a skill he may have inherited from Papa. Whether they always win or not, at least Papa and Junior *feel* like winners every time. (Except when the lollypops aren't delivered.)

EDITOR'S NOTE

Fathers who 'kick for their offspring typically get the short end of the stick. For instance, gargantuan perma-infant Baby Huey often made life difficult—to the point of injury—for his well-intentioned "Papa Duck." Even an uncle/nephew relationship was typically stacked against the older relative, such as in the case of Donald Duck. Frequently tormented by the antics of his nephews, Donald likewise tormented his own Uncle Scrooge in turn!

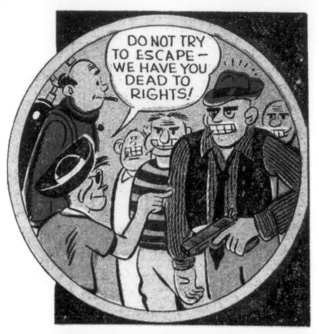

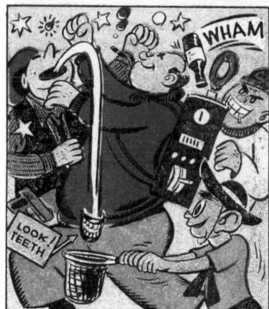

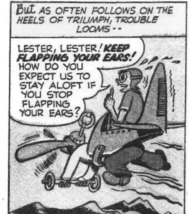

PEEP

"I bet you killed a thousand Nazis in France, Jeep!"

Created by:
Charles Voight

Debuted in:
Jeep Comics #1 (R. B. Leffingwell and Co., Winter 1944)

Partnered with:
Jeep

Rides in a:
Jeep (a different one)

© 1944 by R. B. Leffingwell and Co.

MAGINE BEING NOT ONLY a kid sidekick to an adult hero, but also playing second fiddle to a flying Jeep! Such was the status of Peep, the frisky boy companion of an army vet whose only known name was the same as the vehicle he'd expropriated from the U.S. military: Jeep. Confusing, but the soldier's reason for going the mononymic route is pretty evident, inasmuch as the utility vehicle was the star of the show.

"I'm glad the army gave me my old jeep in place of my discharge pay!" admits Jeep to his young partner Peep, as he fiddles with an improvement of his own invention. Having affixed a "rocket gadget" to the doughty four-wheeler, Jeep and Peep are in possession of the world's only flying jeep. "That rocket is so terrific it will run on a few drops of fuel," exclaims Jeep (the human one, that is) proudly, as Peep dribbles a scant two drops of lighter fluid into the rocket's fuel tank while they zoom over the rooftops.

Consistently depicted on the book's covers, Jeep and his flying jeep were obviously the star attractions. This unfortunately left Peep to his own devices, which worked to his detriment more than once. Although their first adventure saw the pugilistic pair and their flying flivver taking on the decidedly unusual threat of *living pickpocket trees*, further excursions seemed to center exclusively on Peep's personal troubles and emotional shortcomings.

For instance, his second adventure spotlights Peep as a guest of honor at the local Junior Chamber of Commerce's premier social event. Unfortunately, he makes an utter ass of himself, owing to his poor manners and awkward self-consciousness. Later, he develops an unrequited crush on an adult teacher and steals his partner's flying car in order to follow her to a recently inherited property in Florida. To be fair, Peep suspects that she might be in danger and is therefore rushing to save her. To be blunt, though, the poor, troubled kid probably would have dashed down to the panhandle for any excuse.

A third adventure makes great hay of Peep's broadening belly, as the junior hero develops a yen for hamburgers. While Jeep dedicates his energy to solving a mystery wherein the chief loan officers of several banks are reduced to half their original height, Peep has been attending reducing classes at a local gym. That the gym in question turns out to be the hideout of the size-stealing scientist responsible for the crimes is only a lucky coincidence. If Peep suspected that man-shrinking crooks were leading his Jazzercise classes, he certainly kept it to himself. →

Peep makes for a valuable object lesson regarding the hazards of sidekickery. Not only does the sidekick have to contend with the threat of death, dismemberment, and general victimization at the hands of the hero's enemies, the relationship also deals severe damage to the sidekick's ego. No wonder Peep was portrayed as a nervous wreck; even flying around in a rocket-powered jeep was probably more stress than an ordinary kid could be expected to handle.

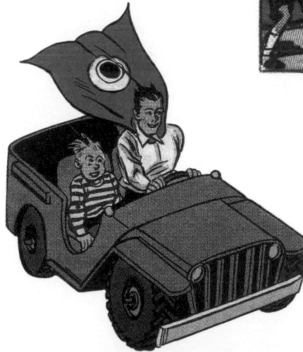

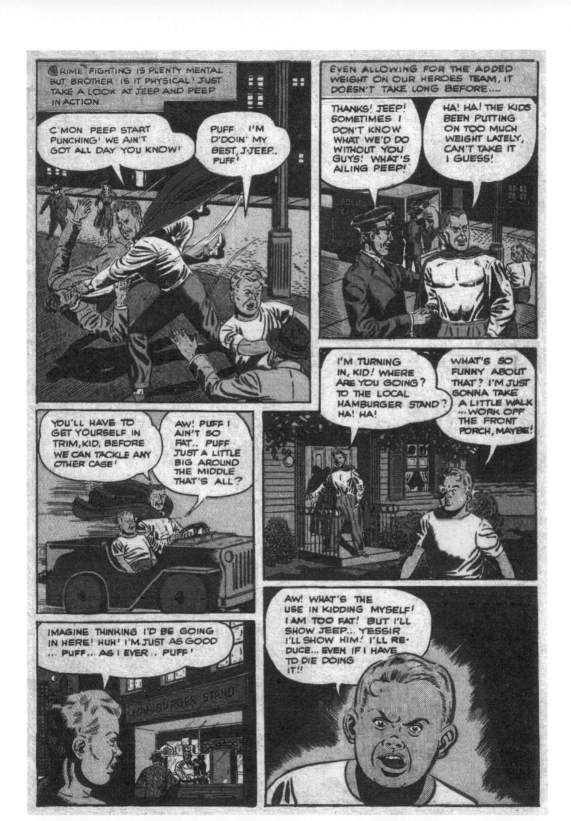

MY NAME IS BIZZY! *PHINEAS P. BIZZY!*

BIZZY, EH? HOW DO YOU FIT INTO THIS CASE?

I RUN A PICKLE FACTORY... BUT LIFE IS SO *DULL* IN MY PICKLE SHOP...SO I GENERALLY GO OUT AND HUNT UP SOME EXCITEMENT!

PICKLES! UGHH! AND I THOUGHT YOU MIGHT HAVE A LEAD ON WHO BUMPED OFF CONRAD LESTER!

...AND HELP ME RECOVER HIS RECORD BOOK— THE ONLY THING THAT COULD PROVE MY INNOCENCE!

THE RED DOOR! THAT MAN SAID HE WOULD MEET CHARLIE AT THE RED DOOR! C'MON!

HUH?

SNAP!

THERE IT IS. IT'S A NIGHT CLUB!

SO THIS IS WHERE THAT GUY CAME FROM WHO BUSTED INTO MY OFFICE THIS AFTERNOON!

THE FLOOR SHOW IS ON! LET'S SIT AT THIS TABLE AND PLAY WE'RE CUSTOMERS...

PHINEAS P. BIZZY

"Have a pickle!"

A SIDEKICK OR OTHER LESSER CHARACTER whose skill set supersedes that of the protagonist is a common occurrence, not only in comics but in other media; examples include Jeeves and Wooster, Zapp Brannigan and Kif, Wallace and Gromit, and many more. And occasionally subordinate partners possess skills that complement those of the hero. Nonetheless, being outshone by your second banana is a shameful fate. And that's what befell two-fisted private eye Mr. In-Between—owing to his pickle-packing pal Phineas P. Bizzy.

Mr. In-Between was so dubbed because he claimed to have positioned himself "between the law and the underworld!" He punched the clock as a private detective and, in his sole adventure, sought to prove the innocence of a widow falsely accused of her wealthy husband's shocking murder. Boilerplate stuff. It wasn't Mr. In-Between's fault that someone else was better informed, better armed, and already on the case.

That someone else was Bizzy, a comically plump figure sporting a toothbrush mustache and a purple derby. "I run a pickle factory," he explains to Mr. In-Between and accused murderer Velva Lester after pledging his assistance. "But life is so *dull* in my pickle shop . . . so I go out and hunt up some excitement!"

Indeed, "some excitement" he hunts up—in spades. Over the course of a mere three pages of story, Bizzy provides most of the action and almost all of the mystery-solving. While eavesdropping on a crook at an outdoor café, he learns of Lester's innocence. He helps our heroes evade the pursuing police, deploying a smoke bomb to confuse them and dispersing individual officers with a well-wielded blackjack. "Have a pickle!" he offers repeatedly throughout the story. "Always carry some with me, you know!"

Mr. In-Between bowed out after one appearance, taking his supporting cast with him. Nonetheless, it's obvious that an ongoing series would only have elevated pickle-happy amateur troubleshooter Phineas P. Bizzy to prominence as a crime fighter in his own right. The absence of further Mr. In-Between adventures seems to have robbed comicdom of a truly brainy—and briny—detective do-gooder.

Created by:
Vernon Henkel

Debuted in:
A-1 #6 (Magazine Enterprises, October 1946)

Assistant to:
Mr. In-Between

How he undertakes his responsibilities:
With relish

© 1946 by Magazine Enterprise

PHINEAS TUTTS

"Phineas—Tutts—Never—Fails!"

&

Created by:
Raymond Colt and
Joe Doolin

Debuted in:
Rangers Comics #3
(Fiction House,
February 1942)

Sidekick to:
The Rangers of
Freedom

**Maximum number
of characters
named "Phineas"
allowed in this
book:**
Two

© 1942 by Fiction House

THE RANGERS OF FREEDOM was a team of four American youths who had been recruited to serve as a colorful defense against Axis aggression on the home front. Outfitted in bulletproof uniforms (which counterintuitively consisted of short-sleeved shirts and short pants, halving the effectiveness of the injury-resistant wardrobe), the Rangers were physical and mental marvels, selected to serve the nation on behalf of the FBI.

The team comprised Percy Cabot (the "Little Corporal" and brainpower of the troupe), "muscleman" Biff Barkley, and laconic Tex Russell, always ready for a fight. They were joined by former Miss America Gloria Travis, who operated under the handle of Ranger Girl.

Despite their numbers and above-average skills, though, the Rangers had their hands full with the hyper-cranial crimes of Super-Brain. Sporting a head shaped like a titanic turnip, this twisted genius lent his brilliance to the Nazi powers in World War II, frequently targeting American army bases in an attempt to hinder the Allied cause. One of his schemes was so overloaded with menace and threat that the Rangers welcomed the help of diminutive detective Phineas Tutts, proud graduate of the Ace Investigating Correspondence School.

Standing a few heads shorter than his teenage chums, Tutts made up in sartorial splendor what he lacked in verticality. In a lavender suit, gold-colored tie, and brown derby, the gung-ho gumshoe introduces himself to the Rangers in an unforgettable manner. When they're captured by Super-Brain and facing execution, the Rangers are as shocked as anyone to see a man with two buckshot-loaded pistols emerge from under a nearby bear rug. "Ah ha!" cries Tutt authoritatively. "And once again the great crime specialist cracks a case! DON'T MOVE!"

As a diploma-wielding detective, Tutt has assigned himself the task of protecting homeland forces from Axis interference. Not only does he rescue the Rangers from Super-Brain's literal chopping block, but he also alerts them to upcoming dangers. "I trailed these scoundrels to their hideout and overheard their plans," he announces, thumbs tucked under his vest. "A plot is on foot to destroy the U.S. Army in the coming war-games!"

The highly competent Tutt is nonetheless given to speechifying and grandiloquent sentiment, plus the occasional comedic befuddlement. For instance, he pursues what he believes to be a poisoning plot being undertaken at the local army base but is rudely made aware that the supposed cook is merely terrible →

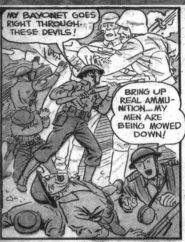

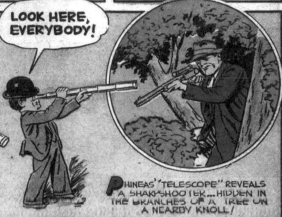

at his job. This makes Tutt a comedic figure, but his bona fides as a crime fighter can't be denied. Whatever they're teaching at the Ace Investigating Correspondence School is clearly top-notch material.

Tutts is an interesting entry into the sidekick scene because, according to the text, he boasted a successful—albeit unpublished—career before encountering the Rangers. And, in fact, after his first appearance, it's implied that he moves on to further unseen solo adventures. Perhaps he's better off going it alone; seeing him trade in that lovely suit for a short-sleeve bulletproof costume would have been a shame.

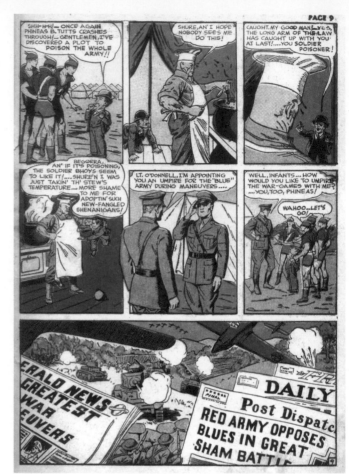

HIYA, RUSTY! WOT'S COOKIN'?

GOOD OLD ROOK... ON THE JOB, AS USUAL! WE'RE DRIVING TO VAN DINE'S HOUSE AT ONCE!

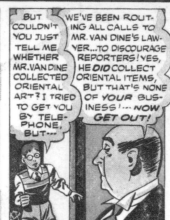

BUT COULDN'T YOU JUST TELL ME WHETHER MR. VAN DINE COLLECTED ORIENTAL ART? I TRIED TO GET YOU BY TELEPHONE, BUT---

WE'VE BEEN ROUTING ALL CALLS TO MR. VAN DINE'S LAWYER...TO DISCOURAGE REPORTERS! YES, HE DID COLLECT ORIENTAL ITEMS, BUT THAT'S NONE OF YOUR BUSINESS!--- NOW GET OUT!

RETURNING, RUSTY RUNS INTO A HORNET'S NEST!

LISTEN, YOU! I JUST GOT A CALL FROM THE VAN DINE'S ABOUT YOU!--- EITHER STICK TO YOUR JOB AS COPY-BOY -- OR YOU'RE FIRED! GET IT?

Y-YESSIR!

CITY EDITOR

EXIT RUSTY! ENTER CRASH KID!

THEY COULDN'T SHAKE YOU OFF THE CASE THAT EASY, EH, PAL? NOW THAT YOU'VE FIGURED THERE WAS SOME CHINEE ART CONNECTION BETWEEN ALL THEM AFFAIRS..

IT'S TIME FOR THE CRASH KID TO CRACK DOWN! THAT'S LUM FONG'S PLACE... SO LET'S GO!

WELL, SHE OPENED EASY ENOUGH!

SHH-HHH! LESS TALKING ---AND FOLLOW ME!

WHAT I WANT IS ANY KIND OF DOCUMENTS THAT MIGHT GIVE US A LEAD TO WHAT THIS IS ALL ABOUT!

THIS LOOKS LIKE SOMETHING -- A RECORD-BOOK! TURN ON A LIGHT, RUSTY .. THE WINDOWS ARE BLACK-ED IN!

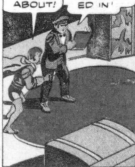

HMM...ALL HIS BUSINESS TRANSACTIONS, EH?

YEAH! AN' HERE'S SUMP'IN FUNNY... THE LATEST ENTRIES HAVE BEEN RIPPED OUT!

G-GOOD LAND O' G-GOSHEN!!

POK!

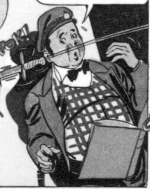

NEXT MOMENT, LIKE A RAGING TORNADO..

CRASH!

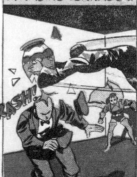

POOK

"G-good land o' G-goshen!!!"

A REDHEADED DYNAMO IN THIGH-HIGH BOOTS and the undeniable star of *Cannonball Comics*, where he was a consistently featured on the covers, the Crash Kid was tough, intelligent, and energetically dedicated to a one-boy war on crime. Is there anything this kid can't do? Well, for one thing, *drive*. This is one of the many reasons that the Crash Kid hangs around with middle-aged cab driver—and top-notch crime-fighting assistant—Pook.

The adventures of the Crash Kid and his trusty adult sidekick were high-octane affairs. Fast-paced, dynamic, and racking up a significant body count, the tales left little time for origins and backstories. But the Kid's commitment to fighting crime is irrefutable. A copyboy at big-city newspaper *The Daily Herald*, the ambitious young man uses every opportunity to take a shot at criminality. Whether via the written word or at the business end of a fist, he knows how to set crooks straight. To that end, and despite his evident youth, he passes himself off as a reporter whenever he can get away with it.

Pook, on the other hand, is a mystery, as neither his story nor his full name is ever revealed. Appearing at Crash Kid's side at a moment's notice—whether the youngster is decked out in his superheroic disguise or killing time as his civilian self, Rusty Adams—Pook is the hero's omnipresent support crew. Besides providing transportation, the apparently fearless and arguably reckless Pook is happy to provide an extra pair of fists when called upon. For that matter, he seems to be fairly well-versed in destruction and violence.

Although Pook is handy to have around for transportation and intelligence gathering, he's hell on wheels. On one occasion, with the Crash Kid perched on his front bumper, Pook engages with a gangster's car, smashing and scraping it as they race along a mountain pass. When he unintentionally pushes the other vehicle down a steep cliff face, Pook expresses no embarrassment or regret. He simply advances the case by calmly rifling through the dead man's pockets in search of clues.

Pook runs errands, crashes his cab through a few walls, joins the Kid in assorted donnybrooks, and even saves his partner from a watery death trap. He's also helpful for conveying the Crash Kid *away* from crimes scenes in order to avoid nosy policemen. The Kid might be, as one radio announcer calls him, "a juvenile bundle of dynamite," but he can accomplish only so much without a driver's license.

Created by:
Bob Oksner

Debuted in:
Cannonball Comics
#1 (Rural Home,
February 1945)

Mascot of:
The Crash Kid

**Auto insurance
premiums:**
Through the roof

© 1945 by Rural Home
Publications

THE RAVEN

"Don't be frightened, miss. I am the Raven!"

Created by:
Frank Borth

Debuted in:
Feature Comics #60
(Quality Comics,
September 1942)

Partnered with:
Spider Widow

**When he'll be
back in print:**
Nevermore

© 1942 by Quality
Comics

THE SEEMINGLY SUPERNATURAL Spider Widow and her beaked cohort the Raven comprise one of the most unusual couples in Golden Age comics. For one thing, superheroines rarely boasted an adult male superhero as a sidekick. Female heroes tended to pal around with young sidekicks of either sex, adult female partners, or the occasional pet (not to mention a host of jungle animals). But not only was the Raven the official and undeniable sidekick—Spider Widow received top billing in the masthead—he was also her love interest!

To put things in contemporary terms, the fairly long-running series featuring Spider Widow and the Raven was some combination of romantic comedy and action adventure. This pair was essentially the Ross and Rachel of superhero comics. The Spider Widow was the "beautiful, wealthy and athletic" socialite Dianne Grayton. When trouble called, Dianne would don a lifelike rubber witch's mask and black peaked cap, becoming "the most horrible dispenser of justice of all time." She was Spider Widow, "Grandmother of Terror!"

What made Dianne's alter ego such a fright wasn't her costume-shop aesthetic. Through some unexplained process or happenstance, the crime-fighting bachelorette possessed the ability to mentally command black widow spiders to do her bidding. When rushing into battle, she made sure to bring with her a sack of aggressive arachnids, with which she would terrify and envenomate crooks as needed.

Spider Widow enjoys a quartet of solo outings before meeting her feathered confederate. In his private study, the Raven—in his unnamed civilian identity—stumbles across a classified ad that had been directed at Spider Widow by a gang of crooks. "So, they want to see the Spider Widow, do they?" he muses from the comfort of his easy chair. "Well so do I!"

Why exactly the Raven wanted to meet Spider Widow is as unexplored as the source of her powers and the Raven's alternate identity. Nonetheless, the mystery man dons his garish purple-and-green costume (we've all seen purple and green ravens before) and dashes to their mutual destination. Together the heroes bust up an Axis spy ring, and they discover an unexpected chemistry, concluding the adventure with an unmasked kiss, although the dark night hides their identities from one another.

For another year, the Raven continues to assist the Spider Widow throughout all variety of menace and disaster. Together they tackle no small number of fifth columnists and racketeers, characters such as the Tiglon Man, and a giant →

spider or two. They even save Christmas on one occasion, helping an old miser adopt the spirit of charity.

Near the end of the Spider Widow's run, a potential romantic rival for the Raven's attention was introduced: Quality's most prominent female superhero, the Phantom Lady. The three characters appeared together in an ongoing adventure that alternated between their respective features—in different titles! This was decades before such crossovers became common practice in comics.

Despite their mutual interest in costumed do-goodery, when the Widow met the Lady an almost-instant competition developed between what one caption called "the two fightingest gals in the history of comic books!" Ostensibly battling for the Raven's affections, the two heroines' mutual resentment manifested itself in overt insult and, on one occasion, a duel with fencing swords.

The Raven negotiated an armistice between the heroines just in time for Spider Widow's series to come to an end. The ultimate fate of the two lovers is unknown, but romantic readers might care to imagine a happy ending for the couple.

EDITOR'S NOTE

Among the few other Golden Age superheroines with male sidekicks was Wonder Woman, whose occasional paramour Steve Trevor served as her trusty sidekick on a number of adventures.

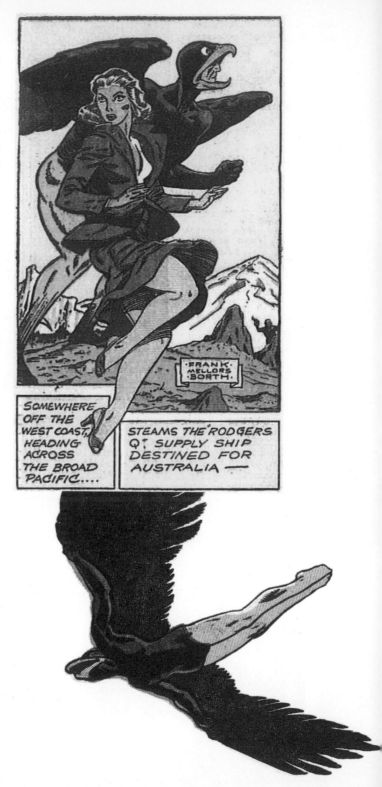

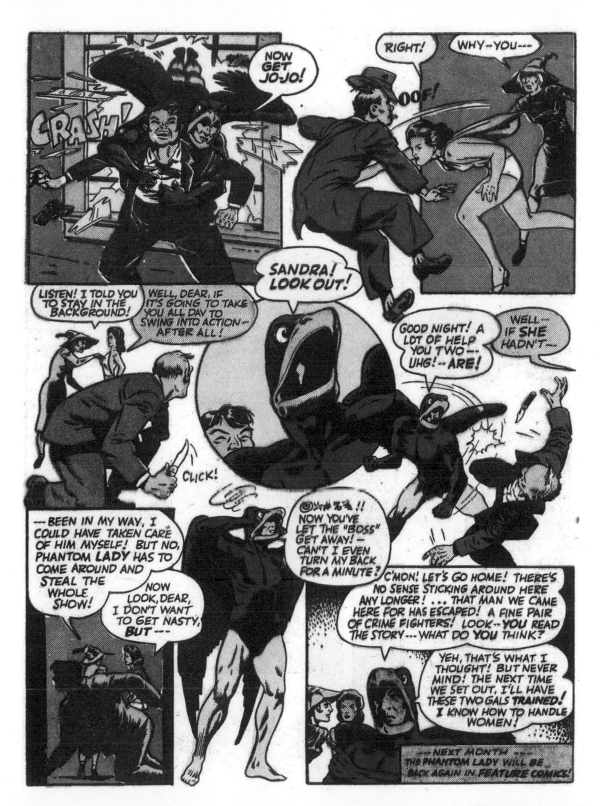

REX THE SEEING EYE DOG
"Bow wow wow."

 NIMAL HEROES HAVE BEEN a staple of comics since the genre's earliest days. Birds of prey, jungle cats, parrots, and monkeys make up a significant proportion of four-footed and feathered do-gooders. But no other animal holds such a prominent place in comics as the faithful hound.

From Superman's superpowered pet Krypto to the Inhumans' oversized, teleporting bulldog Lockjaw to literally dozens of heroic but unpowered pooches with names like Rang-a-Tang, Ace, and Lucky the Pizza Dog, dogs practically own the animal hero franchise.

Among their number is one committed canine who performed double heroic duty. Rex the Seeing Eye Dog is not only the essential assistant to his vision-impaired owner Dan Baxter, but the courageous protector of Baxter's Circus and all the fine folks performing under that big top, as well as its audience. (He also shared his name with other animal sidekicks; see "Editor's Note" on the following page.)

Why do they need protection? Because there's one consistent rule about circuses in comic books: they are, without exception, hotbeds of murder, extortion, and homicidal jealousy. (Presumably this isn't true of real-world circuses, or they'd run out of clowns after a few months.)

Dan Baxter is a "veteran circus owner" whose Baxter's Circus is the home of all sorts of thrills and action, plus the usual thievery and deception. Making up his loyal coterie of performers is his daughter Laura, a star of the trapeze; the sideshow's resident little person, Tom Dooley; the strongman Bruno (unfortunately deceased after one adventure); and a raft of clowns, animals, and other attractions.

When Dan senses nearby trouble, he sends Rex into action with a few terse commands. "Sounds like a runaway cart," Dan observes when a cart containing a vicious lion is set loose among the crowd. "And I hear children screaming! Help them, boy!" With that, Rex darts into action, leaping atop the runaway cart and pulling its brakes with his teeth.

This capacity for ingenious extrapolation defines the German shepherd's heroism. With minimal input from Baxter, Rex also tackles a mad leopard, hunts down dangerous killers, and single-handedly (well, single-*paw*-edly) captures deadly crooks on two different occasions.

Frankly, Rex may be wasting his talents as a guide dog, considering that he exhibits tremendous potential to be trained as a performer in Baxter's →

Created by:
Pagsilang Rey Isip

Debuted in:
Choice Comics #2
(Great Comics
Publications,
February 1942)

Partnered with:
Dan Baxter

Who's a good boy?
Him's a good boy,
yes him's is

© 1942 by Great Comics Publications

circus. But chances are good that the entire operation would collapse if Rex were to divide his attention between the big top and the safety of the circus. More than merely protecting and guiding his master, this very good dog protects and guides his entire circus family.

EDITOR'S NOTE

This pooch shared his name with a DC Comics canine character. Rex the Wonder Dog was a four-legged adventurer whose eponymous title ran for an impressive forty-six issues throughout the 1950s. Although not a circus performer, Rex's adventures took him around the world, to the ocean depths, and into deep space, pitting him against animals and crooks many times his size. He even teamed him up with another animal sidekick—the crime-solving Detective Chimp!

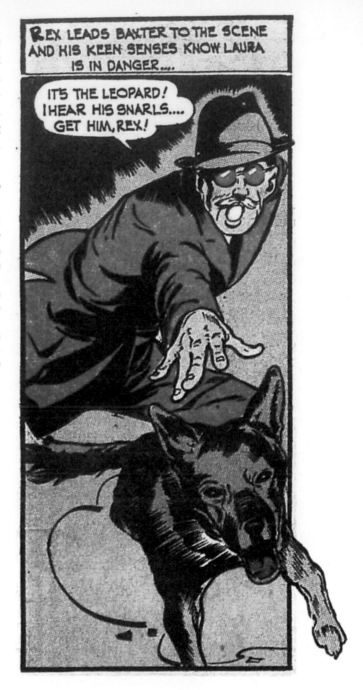

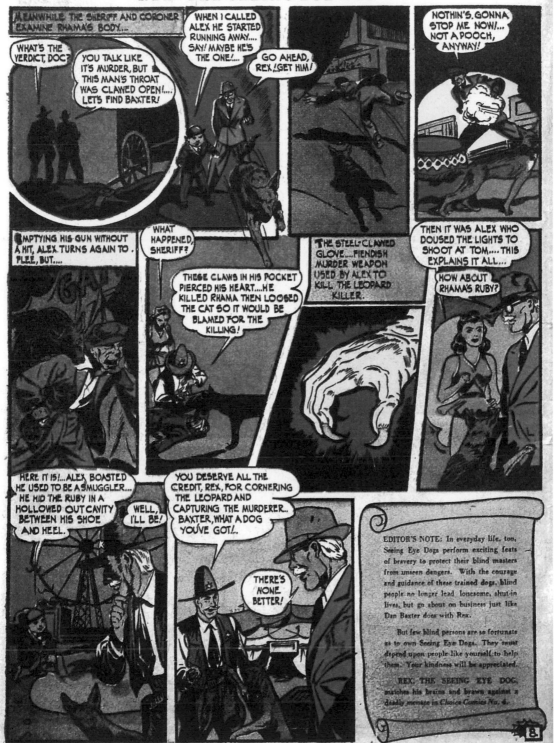

MEANWHILE THE SHERIFF AND CORONER EXAMINE RHAMA'S BODY...

WHAT'S THE VERDICT, DOC?

YOU TALK LIKE IT'S MURDER, BUT THIS MAN'S THROAT WAS CLAWED OPEN!... LET'S FIND BAXTER!

WHEN I CALLED ALEX HE STARTED RUNNING AWAY.... SAY! MAYBE HE'S THE ONE!....

GO AHEAD, REX! GET HIM!

NOTHIN'S GONNA STOP ME NOW!... NOT A POOCH, ANYWAY!

EMPTYING HIS GUN WITHOUT A HIT, ALEX TURNS AGAIN TO FLEE, BUT....

WHAT HAPPENED, SHERIFF?

THESE CLAWS IN HIS POCKET PIERCED HIS HEART....HE KILLED RHAMA THEN LOOSED THE CAT SO IT WOULD BE BLAMED FOR THE KILLING!

THE STEEL-CLAWED GLOVE....FIENDISH MURDER WEAPON USED BY ALEX TO KILL THE LEOPARD KILLER.

THEN IT WAS ALEX WHO DOUSED THE LIGHTS TO SHOOT AT TOM....THIS EXPLAINS IT ALL...

HOW ABOUT RHAMA'S RUBY?

HERE IT IS!...ALEX BOASTED HE USED TO BE A SMUGGLER...HE HID THE RUBY IN A HOLLOWED OUT CAVITY BETWEEN HIS SHOE AND HEEL.

WELL, I'LL BE!

YOU DESERVE ALL THE CREDIT, REX, FOR CORNERING THE LEOPARD AND CAPTURING THE MURDERER.. BAXTER, WHAT A DOG YOU'VE GOT!..

THERE'S NONE BETTER!

EDITOR'S NOTE: In everyday life, too, Seeing Eye Dogs perform exciting feats of bravery to protect their blind masters from unseen dangers. With the courage and guidance of these trained dogs, blind people no longer lead lonesome, shut-in lives, but go about on business just like Dan Baxter does with Rex.

But few blind persons are so fortunate as to own Seeing Eye Dogs. They must depend upon people like yourself to help them. Your kindness will be appreciated.

REX THE SEEING EYE DOG, matches his brains and brawn against a deadly menace in *Choice Comics No. 4*.

RITTY

"Somehow I have a feeling something is going to happen!"

Created by:
John F. Kolb

Debuted in:
Amazing Man Comics #5 (Centaur Publications, October 1939)

Partnered with:
Minimidget

Favorite book:
Little Women

© 1939 by Centaur Publications

I**T'S A TALE AS OLD AS TIME**—a woman does the same work as her male counterpart, goes through all of the same hassles, and is equally responsible for their successes . . . but never gets anything resembling the same amount of credit. Now imagine that both the man and woman in question have been shrunk to six inches high by a mad scientist and were briefly hypnotized into being thimble-sized assassins.

With all of this in mind, why does Minimidget get not only the headlines but a superhero name—dubious as it may be—when his lady partner gets by with just Ritty?

In an off-panel prelude to their saga, Ritty and her male counterpart are abducted by the mad Doctor Barnell. The scientist employs a shrinking serum of his own invention on the duo and Barnell hypnotizes the now pint-sized man—dubbed in subsequent adventures either Supermidget or, as the masthead more commonly suggests, Minimidget—into assassinating Barnell's wealthy but miserly brother with a poisoned (tiny) sword. A slave to the hypnotic command, Minimidget carries out the crime and promptly seems to be killed in an exceptionally undignified manner—caught in a mouse trap! It's a gruesome fate, but a poetic one as well.

But in the following issue a paramedic is shown reviving Minimidget, and that's where the adventures begin. Absolved of the murders, the diminutive duo becomes a source of curiosity among an admiring public. Outfitted with an array of one-twelfth-scale conveyances—including a car, plane, and rocket ship—Minimidget and Ritty embark on a series of wild adventures. Despite their small stature, the pair retain their human strength and an exceptional toughness, which is welcome since they're of a perfect size to be stepped upon.

Over the course of several years, the half-pint heroes rescue thousands from floods and plagues, are worshipped as gods by jungle tribes, travel to the year 3000, find themselves in a fairy tale realm, associate with gnomes, and even make off with a giant robot from the future. Dubbed Big Boy, the ten-foot-tall steel titan briefly serves as Ritty and Minimidget's primary vehicle, as well as a stand-in for them during physical altercations with normal-sized opponents.

Despite fighting alongside Minimidget—and even sporting her own superhero costume—Ritty was denied credit in more ways than matters of billing. Minimidget is cited as the first shrinking superhero in comics (although it's more accurate to describe him as a "shrunken superhero," given that he was unable to regain his former human size), having beaten Quality Comics' Doll →

Man (see page 73) to the punch by a month. Of course, Ritty also predated Doll Man, appearing alongside Minimidget in his first appearance, but was never accorded the same credit.

Making matters worse was that Minimidget wasn't particularly competent. On more than one occasion, his inattention or clumsiness led to some minor catastrophe that Ritty, as his companion, was obliged to help set right. To be perfectly equitable, the series should have been known as "Ritty and Minimidget."

EDITOR'S NOTE

The original Minimidget story, involving the miniature murders committed with a poisoned blade, are reminiscent of the 1936 MGM picture The Devil-Doll. In that film, a mad scientist also uses shrunken assassins to murder people using poisoned needles.

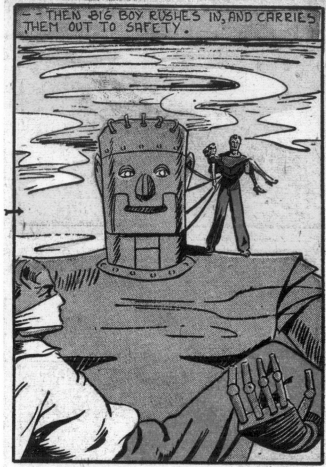

MINIMIDGET

When minimidget and Ritty discovered a house on fire, they didn't realize they were getting into something that was going to tax their super abilities--

--READ ON--

John F Kolb

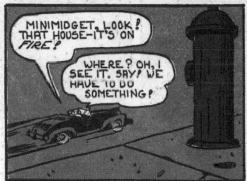

MINIMIDGET, LOOK! THAT HOUSE—IT'S ON FIRE!

WHERE? OH, I SEE IT. SAY! WE HAVE TO DO SOMETHING!

A SMALL RED GLOW SHONE AGAINST THE DARK SKY—THEN A LICK OF FLAME SHOT UP.

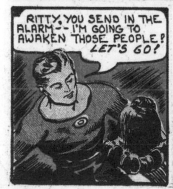

RITTY, YOU SEND IN THE ALARM—— I'M GOING TO AWAKEN THOSE PEOPLE! LET'S GO!

MINIMIDGET, WATCH OUT! DON'T GET HURT!

O.K. I'LL WATCH OUT! SCRAM CAT, I HAVE NO TIME FOR FOOLING!

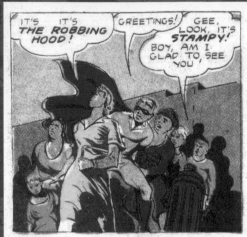

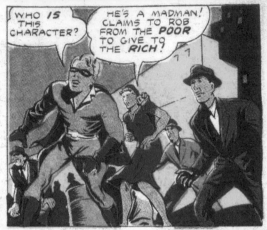

STAMPY

"Here's my stamp of disapproval!"

SADDLED WITH ONE OF THE SILLIEST monikers in the admittedly checkered catalogue of sidekick code names, Stampy might not seem like a character destined to fly high. And yet, he did—literally.

Although their names suggest a relationship to mail, Stampy and his senior partner Airmale boasted no particular connection to the United States Postal Service (except for their frequent use of interminable mail-related puns). In his civilian identity of Professor Kenneth Stephens, Airmale's alter ego was a hyper-confident—if not hyper-*competent*—inventor of a wide array of unpredictable scientific gadgets. So confident was Stephens that some experiment would earn him crime-fighting powers that he wore a superhero costume to his lab.

Considering said costume included a flowing cape and wings mounted to the side of his mask, the professor was fortunate to discover a serum capable granting the power of flight. More specifically, the concoction rendered Stephens lighter than air, a condition made manageable only by wearing a weighted belt riddled with lead and buoyancy-mitigating batteries. And this was the type of adventure of which young Stampy wanted a part.

As were many superheroes at the time, Airmale was managing a successful solo career when his kid sidekick first turned up. His nephew Bobby pays an extended visit, quickly stumbling onto his uncle's secret identity and agitating for the right to join him. "I want to prove that I can be a great help to you!" he insists (following a corrective spanking he'd earned by earlier masquerading in Airmale's costume).

Soon Stampy decks himself out in a junior version of Airmale's getup. He can't fly, but he sure can whine. "Here we are," Stampy grouses, "full-fledged crime-fighters, with uniforms and all, and you won't inject your serum in me so I can fly."

Despite the ethical quandary involved in pumping an untested chemical into a teenager's body, Airmale eventually folds like a cheap suit. Stampy loses no time in earning his keep, becoming such a thorough second banana that he picks up Airmale's tendency to make mail-related puns. And after his upgrade Stampy "cancels" more than a few crooks.

Unfortunately, Airmale and Stampy eventually find themselves under the terminal rubber stamp of cancellation, too. Professor Stephens received his draft notice, cutting short his costumed career—and that of his eager nephew. Stephens isn't about to leave that serum lying around while he's overseas.

Created by:
Fred Morgan

Debuted in:
Prize Comics #37
(Prize Comics,
December 1943)

Partnered with:
Airmale

Current whereabouts:
Address unknown

© 1943 by Prize Comics

STATIC

"Keep your big mouth shut Static."

Created by:
Murray Boltinoff
and Lee Harris

Debuted in:
Detective Comics
#60 (DC Comics,
June 1942)

Partnered with:
Air Wave

**Who wants a
cracker?**
He does

© 1942 by DC Comics

N 1942, THE CREATIVE TEAM behind the superhero feature "Air Wave" appeared to think they'd picked a winner with their hero's new sidekick. "The Batman has Robin," their announcement boasted, "the Green Arrow has Speedy. . . . Every great crime buster has a companion in combat to fight side-by-side with him in the ceaseless crusade on crime."

For Air Wave, that companion was "an all-talking, super-impudent parrot" dubbed Static. He never really threatened to unseat Robin in the annals of sidekick history.

Air Wave was Larry Jordan, an assistant district attorney who had grown increasingly frustrated with rampant crime and racketeering in his city. Like many comic-book district attorneys before him, Larry endeavored to throw out everything he learned in law school, don a bizarre costume, and take out his frustrations under a flashy pseudonym.

As his alias and the two miniature aerials attached to his mask implied, radio technology powered much of Air Wave's arsenal against crime. His ability to electronically throw his voice proved, in its own fashion, as effective as super-strength or laser vision (a not-uncommon scenario among Golden Age heroes, who often counted hyper-effective ventriloquism among their skills). Air Wave could also pick up radio signals, eavesdrop over a matter of miles and—should any of these advantages prove insufficient—immediately deploy retractable "skate-wheels" from the soles of his boots and speed into action.

Despite this eccentric power set, Air Wave became feared by the criminal underworld. So thorough was their universal dread of the high-riding lawman (Air Wave would frequently employ his skates to travel along telephone wires) that a plan was arranged to frame him for murder. And Static the parrot was at its center.

Crooked pet-shop owner Father Kind leads a double life as Bigg City's "sinister master-mind" of crime. Responding to complaints from his lieutenants about Air Wave's uncanny efficacy, Kind hatches a plan involving an abnormally easy-to-train green macaw. Teaching the exceptionally intelligent bird to repeat "Don't kill me, Air Wave," Kind leaves a murdered body behind for the police to find. Naturally, they assume that the babbling bird was repeating the victim's last words, and a manhunt for the aerial-sporting avenger begins.

But Static chooses to *join* Air Wave instead, earning his handle by annoying his newfound master. "Why don't you shut up and get out of here?" demands Air Wave of the omnipresent parrot. "You're worse than static!" The sassy bird →

replies, "Awwrk! I'll bet you say that to all the boys!"

From that point, Static was a constant companion to Air Wave. Not only did the bird help clear the hero's name, he continued to provide valuable services such as blinding or distracting crooks, plucking up important objects midflight, and mimicking his master's voice. All of which met with the hero's somewhat reluctant approval. "You may be more of a liability than an asset," he admits, "but from now on you ride ether with Air Wave!"

And Static's reply? "You're cooking with gas!"

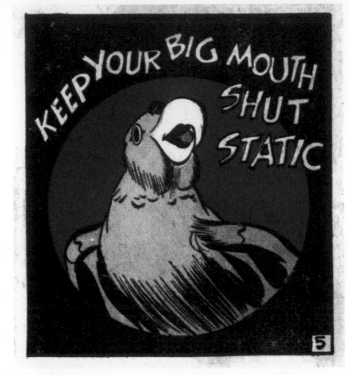

EDITOR'S NOTE

Air Wave wasn't the only superhero with a parrot sidekick. Fellow Golden Age hero Twilight—a U.S. Marine who fought crime wearing a furry union suit—was accompanied by his own wisecracking chatterbox of a bird, Snoopy!

WHILE INSIDE THE BUILDING...

THE COPS ARE HERE!

WHAT'S THE ANGLE ON THAT PARROT, FATHER KIND?

THE POLICE WILL BELIEVE IT WAS SALTZ'S BIRD, REGINALD. THEY'LL THINK ITS REPEATING ITS MASTER'S LAST WORDS... NOW FOR THE MURDER!

OH, DEAR! THIS HURTS ME MORE THAN IT HURTS HIM!

HURRY UP! THE COPS'LL BE HERE ANY MINUTE!

BANG

BANG

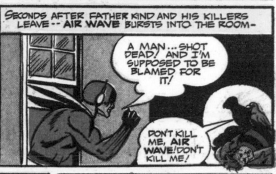

SECONDS AFTER FATHER KIND AND HIS KILLERS LEAVE -- AIR WAVE BURSTS INTO THE ROOM--

A MAN...SHOT DEAD! AND I'M SUPPOSED TO BE BLAMED FOR IT!

DON'T KILL ME, AIR WAVE! DON'T KILL ME!

ALL I CAN LEARN IS THAT HE'S CAPTAIN SALTZ. WHAT A MESS...

YOU SAID IT, CUTIE!

ONLY THE LETHAL WEAPON REMAINS AS A CLUE...

NO FINGERPRINTS ON THE GUN. THE KILLER MUST HAVE WORN GLOVES... OH-OH... WHAT'S THIS? A DELICATE SCENT OF PERFUME. THAT'S ODD!

COMPANY'S COMING! HAR! HAR!

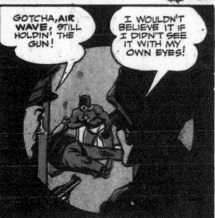

GOTCHA, AIR WAVE, STILL HOLDIN' THE GUN!

I WOULDN'T BELIEVE IT IF I DIDN'T SEE IT WITH MY OWN EYES!

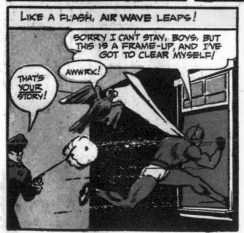

LIKE A FLASH, AIR WAVE LEAPS!

SORRY I CAN'T STAY, BOYS, BUT THIS IS A FRAME-UP, AND I'VE GOT TO CLEAR MYSELF!

THAT'S YOUR STORY!

AWWRK!

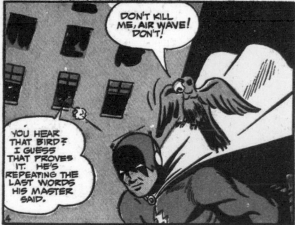

DON'T KILL ME, AIR WAVE! DON'T!

YOU HEAR THAT BIRD? I GUESS THAT PROVES IT. HE'S REPEATING THE LAST WORDS HIS MASTER SAID.

STRIPESY

"Oboy—action is my favorite dish!"

SUPERHEROES AND THEIR SIDEKICKS generally obey an unspoken rule: whichever one of them is old enough to have a driver's license gets to be the senior partner. But adult sidekicks to adolescent superheroes do exist (see Pook, page 95). And among this fairly small fraternity of postpubescent second bananas, the most familiar figure is Stripesy, patriotic pal of the Star-Spangled Kid.

The role reversal even extends into their civilian identities: Stripesy works for the Kid. When not in their colorful costumes, the Star-Spangled Kid is wealthy child prodigy Sylvester Pemberton and Stripesy is his chauffeur/bodyguard Pat Dugan.

Sylvester is brilliant and fiery, but he keeps his fighting spirit hidden to better disguise his Axis-smashing costumed alter ego. In a tradition of wealthy vigilantes that goes back to Zorro and the Scarlet Pimpernel, he plays the role of a haughty, disinterested, and smug scholar and idler, and Pat helps sell the ruse. For example, to keep the Pemberton clan in the dark about their crook-smashing partnership, the young socialite occasionally berates the hired help in public. "Dugan," he demands in once such performance, "next time you bring me home three minutes late, I'll have you discharged!" To this, Pat shakily replies, "It—it won't happen again, kid—er—I mean, sir!!"

Despite being the subordinate member of the duo, Pat brings a lot to the table. For one thing, he trained the Kid in fighting techniques. When Pemberton approvingly reflects that "this idea of ours to battle enemies of our country under dual-identities seems to be working out fine," Pat agrees, with an addendum: "I didn't teach you all my boxing, wrestling and acrobatic stunts for nothing!"

Stripesy also exhibits a peculiar genius with the mechanical. He converts the Pemberton family limousine into an armored, super-fast, flying arsenal dubbed the Star-Rocket Racer. A simple button underneath the dashboard causes segments of the car's body to "whirl and turn automatically," converting an unremarkable luxury vehicle into the "ultra-streamlined rocket car" that the Star-Spangled Kid and Stripesy use on their adventures. Retractable wings even allow the racer to fly! Dugan might have made millions in patents and automotive design, if he didn't have to spend his free time running around dressed like half of the American flag.

This is all the more impressive considering that Stripesy was never portrayed as being the brightest bulb. Possessing a crafty and mischievous sort →

Created by:
Jerry Siegel and
Hal Sherman

Debuted in:
Action Comics #40
(DC Comics,
September 1941)

Partnered with:
The Star-Spangled
Kid

Secret fear:
That horizontal
stripes make him
look fat

© 1941 by DC Comics

of intelligence, he was a clever fighter, but strategy and clue-gathering weren't in his line. The Kid managed the brainwork angles, with Stripesy's intellect confined to memorizing the catalog of complicated fighting techniques they had developed together. All it takes is Kid to shout something like "Signal, Stripesy! X144!" for the burly cohort to take action. "The Kid's a master of strategy," Dugan confesses admiringly as he knocks some gangsters' heads together. (Though it's possible that *all* of the signals meant "knock the gangsters' heads together.")

Despite the able service of his elder partner, the Star-Spangled Kid ultimately moved on to a solo career. Poor Stripesy was left to his own devices—for a while, anyway. At least he still holds a unique place in the comics-related history books as the foremost grown-up to be bossed around by a kid crime buster.

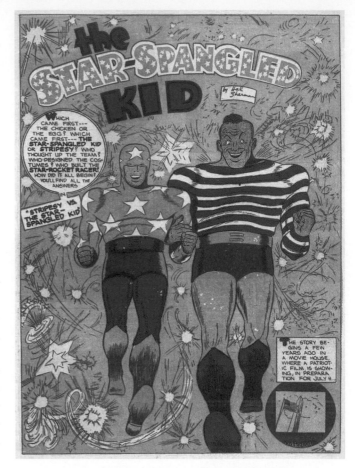

EDITOR'S NOTE

Stripesy enjoyed a second career in modern comics, sidekicking for another teenaged superhero. This time, his stepdaughter Courtney Whitmore—alias Stargirl—called the shots. Stripesy palled around with her in a suit of armor he referred to as S.T.R.I.P.E.

SUPER-ANN

"I'll handle this my own way!"

Created by:
Martin Filchock

Debuted in:
*Amazing Man
Comics* #24
(Centaur
Publications,
October 1941)

Partnered with:
Mighty Man

**Not to be
confused with:**
Normal Ann;
Slightly Better
Than Normal Ann;
Spider-Ann;
Capt-Ann
Ann-merica

© 1941 by Centaur
Publications

AS HIS NAME IMPLIES, the superheroic Mighty Man had no particular need for a sidekick. In practically every appearance his familiar introductory spiel asserted: "He can grow. He can shrink. He can change his features." He could also selectively enlarge, stretch, or shrink parts of his body. (He had a fondness for shrinking to doll size and enlarging his head to normal proportions, deliberately capitalizing on an unsettling chibi-like appearance.) With these abilities and a fairly lengthy run as a solo hero, Mighty Man wasn't in the market for a second banana.

Yet when fate puts him on a path with a mysterious, super-strong young woman, Mighty Man opts to bring her on as his assistant—but on his terms. Super-Ann would be his sidekick, but *he wouldn't let her know about it.*

On a quiet street, a truck deliberately bears down on an innocent puppy that is crossing the road. The only witnesses to this heartless crime are Mighty Man and what the text describes as "a cute helpless looking miss." When Mighty Man pursues the truck, he finds out just how badly the caption understated the young lady's abilities. With one casual blow, "Super-Ann Star" knocks Mighty Man aside and stops the truck cold with her free hand. When the driver attempts to run off, Ann effortlessly flings the heavy vehicle after him like a baseball.

Discreetly following her home, Mighty Man meets the young lady's mother and learns of Ann's patently unconvincing origin. When the petite powerhouse was an infant in the wilds of Alaska, she disappeared into a deadly blizzard. Days later, she returned in the company of a strange old man. "He looked like some creature of the forgotten past," explain Ma Star. Evidently, the strange man had provided the infant Ann shelter in his hidden cave, where he "taught her secrets of another world!"

Whatever the mysteries of the old man may have been is a moot point. "You see," continues Ma Star, "the sun was harmful to him. He probably went back to the cave and died within a few days . . . "

While Mighty Man gets an earful of Super-Ann's backstory, "the World's Strongest Girl" is blithely walking into dangerous situations and clubbing the tar out of bad guys left and right. However, although she is incredibly strong and capable of tremendous leaps and powerful punches and kicks, Ann isn't invulnerable. A conk on the head does her in as well as it would any normal human being.

For this reason, Mighty Man begins keeping an eye on Super-Ann as her →

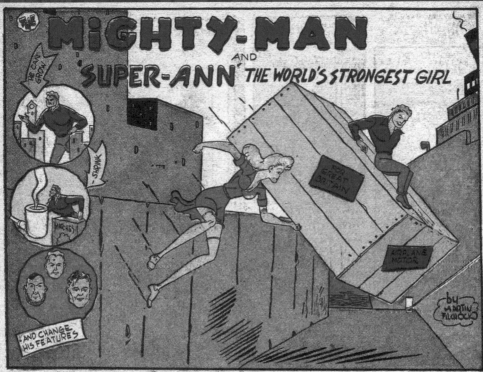

"guardian angel." Over a quartet of appearances, Ann either wanders into Mighty Man's adventures or otherwise draws his attention. While Super-Ann operates in the open—to the point that crooks recognize her at a glance—Mighty Man hangs back and pitches in only when Ann is over-whelmed. This works out so well for the pair that, as of their final appear-ance, Ann was still unaware of her guardian angel's identity. Theirs may be the only case of unacknowledged sidekicking in comics history.

EDITOR'S NOTE

Super-Ann is not to be confused with the Super Ann who palled around with Freckles, Susan, and Foxey (see page 48).

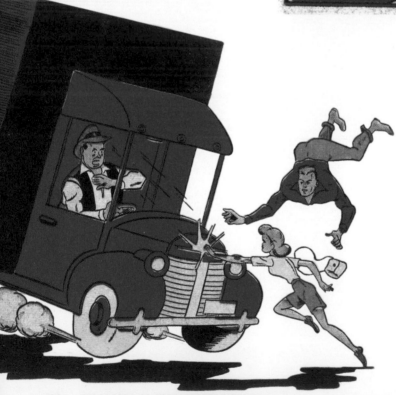

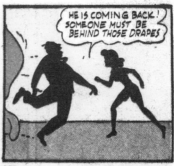

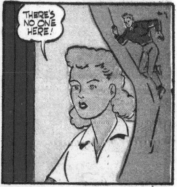

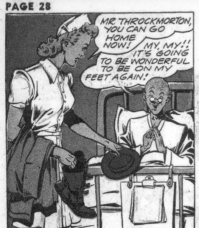

MR. THROCKMORTON, YOU CAN GO HOME NOW!

MY, MY.!! IT'S GOING TO BE WONDERFUL TO BE ON MY FEET AGAIN.!

OH, BOY — MY FEET HAVE FELT ALL TICKLY SINCE I'VE BEEN HERE ... PROBABLY ANXIOUS TO WALK!

HUH? SOMETHING'S HAPPENING TO THROCKMORTON'S SOCK AS HE REACHES DOWN...

POP! SSSSS

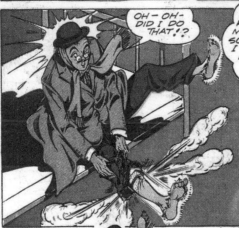

OH — OH — DID I DO THAT.!?

OH MY! THIS REST CERTAINLY DID ME SOME GOOD! I'M SO STRONG NOW THAT I PUSHED MY FEET RIGHT THROUGH MY SHOES.!!

I WONDER IF I'LL BE..ABLE TO WALK...IN A STRAIGHT LINE?

OOOOOH DEAR!

BANG BANG BAM BOOM BOOM

BOOM!

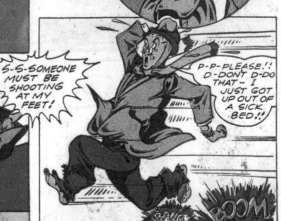

S-S-SOMEONE MUST BE SHOOTING AT MY FEET!

P-P-PLEASE.!! D-DONT D-DO THAT — I JUST GOT UP OUT OF A SICK BED.!!

BANG BOOM

THUNDERFOOT

"My brain isn't exactly negligible! In fact, I'm dynamite at both ends!"

THE MAN WHO WOULD BE Thunderfoot was not bathed in glory from the moment of his debut. "Presenting Hustace Throckmorton," announces a caption, "the only one of his kind in the known world—glory be!" Later, the shade thrown at Throckmorton continues: "Never before has so small a brain and body stirred up so gigantic a mess of trouble day in and day out . . ."

Throckmorton's origin reveals him to be such a timid soul that he allows a group of jeering adolescents to coerce him into leaping from a bridge. "C'mon, Throckmorton!" wheedles one of the boys. "Let's see youse jump down an' fly up again! Betcha can't do it!"

Well, of course he can't. But afraid of being considered "a sissy," Throckmorton chooses to jump. Unsurprisingly, it does not end well.

Rushed to the hospital, the mangled Throckmorton is fortunate—in a manner of speaking—that the Human Bomb, in his civilian identity of Roy Lincoln, is visiting at the same moment. Thanks to an experimental explosive serum, Lincoln is capable of destroying even the mightiest objects with only a touch. Turns out Roy and the fatally injured Throckmorton share a rare blood type ("Type two!" according to the text). After a hasty transfusion, a fraction of the Human Bomb's power is transferred to Throckmorton. Only the destructive ability ends up not in his hands but concentrated below his ankles. Any object coming into contact with his feet—except specially treated "fibro-wax" fabric created by the Human Bomb—is destroyed by a spontaneous blast.

Lincoln apparently feels some sort of responsibility for Throckmorton—and rightly so, what with not having told the doctors that his blood is full of an explosive experimental chemical and all. The pair form a loose-knit crime-fighting team battling ghosts, robots, racketeers, evil magicians, and, in a manner of speaking, Hustace's on-again off-again girlfriend Honey-Bun (a good two feet taller and a hundred pounds heavier than her beau, every inch of her pure muscle).

Despite his partnership with the Human Bomb, Throckmorton never gets the accolades that come with the heroic life. In fact, he's escorted from comics on the receiving end of his own partner's scathing sarcasm. "I was hunting for you to tell you what kind of an idiot I thought you were," the Human Bomb callously explains, adding, "And I still think you are!" No wonder Thunderfoot took it on the heel and toe.

Created by:
Paul Gustavson

Debuted in:
Police Comics #15
(Quality Comics,
January 1943)

Partnered with:
The Human Bomb

Unused aliases:
Missile-toe,
Sole Power,
Birken-shock

© 1943 by Quality
Comics

TINY

"You wanna play rough? Yuh shore picked on the wrong playmate—!"

Created by:
Bruce Elliot and
Ray Willner

Debuted in:
Cat-Man Comics #1
(Helnit Publishing,
May 1941)

Partnered with:
Rag-Man
(sometimes written
as "Ragman")

Specialties:
Throwing punches,
challenging
stereotypes

© 1941 by Helnit
Publishing

TO BE BLUNT ABOUT his inclusion in this volume, the only regrettable thing about two-fisted factotum Tiny is that he never had the chance to blossom as a character. And, for that matter, that the starting point on his journey was no great shakes.

Tiny was chauffeur, valet, and right-hand man to wealthy crusading reporter Jay Garson Jr. When rackets needed busting or killers needed corralling, Garson would trade in his tuxedo and tails for a tattered, patchwork suit and go into the night as Rag-Man. Camouflaged in his threadbare wardrobe, Rag-Man could pass unnoticed among the unfortunate and discarded members of society, seeking crime to punish (and juicy scoops to publish).

What the ironically dubbed Tiny contributed to the operation was transportation, general sidekickery, and two thundering fists that boasted almost superhuman strength. In his first appearance, Tiny busts through a heavy wooden door and throws two grown gangsters around like rag dolls, holding one aloft by the collar in each hand, none of which seems to require effort on his part.

Unfortunately, Tiny was portrayed in much the same fashion that literally hundreds—if not thousands—of other African American characters were in the radio, film, comics, and prose media of the era. Evidently inspired by the antics of early film star Stepin Fetchit, Tiny spoke in the familiar, unflattering patois typically assigned to characters like him. He falls apart at one point, confronted with a hale and hearty Garson who had been previously presumed dead. Wringing his hands, Tiny stammers, "Eyes don't look dat way—! (gulp) It's Mista Garson's ghost!—I knows it—I knows it!" Even his catchphrase—"Yowsuh boss! Yow suh!"—harkened back to the minstrel-show roots of this type of caricature.

But a number of creative teams and individuals worked on Rag-Man's adventures, and among them was no consensus on how to best employ Tiny. In the early strips, he was either a shuffling manservant with a pair of mighty mitts or absent altogether. Later stories, however, sought to elevate Tiny above the low station that had been assigned to him.

Tiny's speech bore the first signs of the change. His *Amos 'n' Andy*–inspired mode of dialogue gave way to what may have been merely a Southern accent (for example, "You fogot ahm in this heah fight!"). Tiny's evolving manner of speech would eventually demonstrate great emotional and intellectual depth. After one busy mission, he muses, "What a sight at the end of an eventful night! The rising sun!"

→

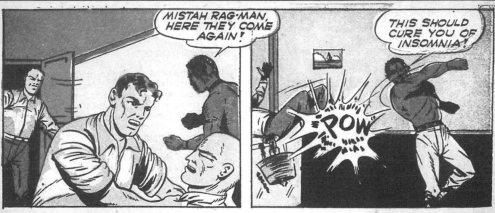

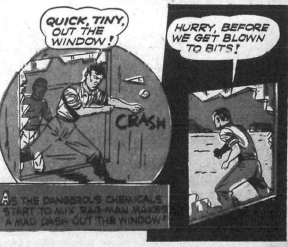

He also began to dress in fancy suits (Rag-Man had, at this point, given up his ratty costumes, although not his superheroic sobriquet), and the pair began acting more like partners. Tiny not only saved the day on some of these adventures, he also took the lead against crooks and criminals of all stripes.

The most prominent indicator of Tiny's elevated station took the form of co-billing. Later stories would boast Tiny's picture under the Rag-Man logo, bearing accolades ranging from the merely factual "The Ragman's faithful helper" to the explosive "Six feet of dynamite!!"

But just as Tiny's star was ascending, the Rag-Man feature fizzled. This is a genuine shame because Tiny seemed likely to continue his rise in prominence. He wouldn't have been the first black character in comics to star in his own feature, but it would nonetheless have been interesting to see Tiny take up adventuring without Rag-Man's company.

EDITOR'S NOTE

Rag-Man was heavily influenced by Will Eisner's *The Spirit*, a revered series that nevertheless had issues with its portrayal of an African American sidekick. Ebony White, originally a middle-aged cab driver and later a pint-sized but streetwise kid sidekick, was vital to the Spirit's crime-fighting career. Unfortunately, he was also an extravagant caricature, sporting a white ring around his lips and a "sho 'nuff" manner of speech. That the otherwise sophisticated series boasted such a regressive character has continued to mar creator Eisner's reputation, as well as defy any satisfactory explanation, however earnestly intended.

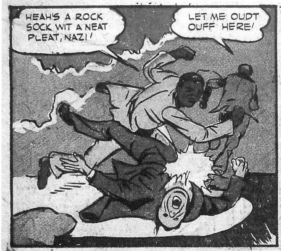

HEAH'S A ROCK SOCK WIT A NEAT PLEAT, NAZI!

LET ME OUDT OUFF HERE!

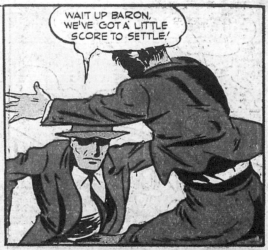

WAIT UP BARON, WE'VE GOT A LITTLE SCORE TO SETTLE!

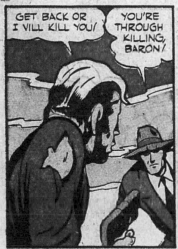

GET BACK OR I VILL KILL YOU!

YOU'RE THROUGH KILLING, BARON!

DROP THAT GUN—YOU'RE SHAKING TOO HARD TO USE IT!

OW!

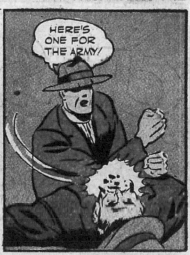

HERE'S ONE FOR THE ARMY!

DE SOLDIER'S WILL SHO' TAKE CARE OB DEM NAZIS, EH, BOSS?

YOU BET, TINY... AND OUR BOYS'LL MOP THE STREETS OF BERLIN WITH THE REST OF HITLER'S STOOGES IN THE NEAR FUTURE...

AND YOU CAN BET YOUR LAST PENNY THAT THE **RAGMAN** WILL MOP UP THE FORCES OF CRIME NO MATTER WHERE THEY PERPETRATE THEIR NEFARIOUS DEEDS, DON'T MISS HIM NEXT MONTH IN

CAT-MAN COMICS

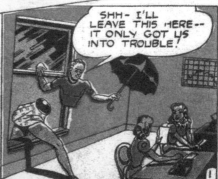

UNGGH

"Tomorrow is new day. Then, maybe steak!"

OST SIDEKICKS AT LEAST get a name—no matter how diminished or juvenile. But Unggh barely rates a grunt. A native of the world of 100,000 BC, Unggh spent most of his youth in pursuit of dinner or avoiding the population of hungry dinosaurs that shouldn't coexist with cavemen but, as in countless fictional tales of the prehistoric world, do.

All of this changes when Unggh is introduced to Worldbeater, a dedicated shirker from the far future. Worldbeater intends to become rich and famous by leveraging his knowledge of modern technology and events. However, he inadvertently directs his Time Car to the prehistoric past, where his anachronistic knowledge is of no use. As a consolation prize, he collects Unggh on his way out of the Middle Paleolithic as he proceeds to his destination, the year 1944.

Unfortunately, Worldbeater's plans yield uneven results. His invisibility paint is only half effective. His mathematical formula for walking through solid matter fails. A machine that eliminates dirty dishes by melting them down and turning them into new dishes does succeed, but Worldbeater loses the wealth it brings him when he's suckered into buying a bridge. Oh, Worldbeater.

But on every one of these occasions, Unggh is there to help. Providing brute strength when necessary, he serves primarily as Worldbeater's conscience. "Unggh think best way to make money is get job!" he announces in the broken English he's somehow acquired, encouraging his partner to take a good look at a newspaper's help wanted section. When Worldbeater gives away a fortune to invest in a get-rich-quick scheme, Unggh pleads, "But Worldbeater . . . we make a thousand dollars a week here!"

Food is never far from Unggh's mind, which may account for his dedicated work ethic. "Caveman have saying," he muses when another easy-money plot has fizzled. "Two birds in bush—no eat. One bird in hand—soon in pot!"

As Worldbeater's schemes wear thin, the partners abandon Earth and embark on a tour of the solar system—still running into trouble at every opportunity. They pick up some traveling companions, like the hairy Martian Jo-Blo and the long-limbed extraterrestrial hepcat Velonica. Neither sticks around long. But they probably made Unggh feel better about his name.

Created by:
Fred Morgan

Debuted in:
Prize Comics #37
(Prize Comics,
December 1943)

Partnered with:
Worldbeater

Full name:
Un G. Gh, Jr.?

© 1943 by Prize Comics

WHIZ, KING OF FALCONS
"Look out below, Streak . . . I'm going into tail-spin!"

Created by:
Jack Cole

Debuted in:
Silver Streak Comics
#6 (Lev Gleason,
September 1940)

Mascot of:
Silver Streak

**How he solves a
problem:**
Wings it

© 1940 by Lev Gleason

SUPER-SPEEDY FLYING HERO Silver Streak was never shy of company. On occasion, he was joined by some of his fellow superheroes. He was also aided by a devoted gal pal, a feisty kid, and, notably, the equally super-fast Whiz, King of Falcons.

While Silver Streak's reputation as the "fastest man on Earth" is still being established, he incurs the wrath of record-seeking gentleman pilot Sir Cedric Baldwin. Infuriated that his own fast-traveling accomplishments are being overlooked—such as a relatively rapid ten-hour flight across the Atlantic—Cedric issues a challenge to the Silver Streak: a race around the world!

Leaving Sir Cedric in the dust, the Streak is distracted by a weeping woman. She explains that her daughter has been abducted by the sinister Sheik Ali Ben Hassen, a cruel figure who wagers vast sums on falconry competitions.

Fate delivers Silver Streak into Hassen's hands. Although the speedy superhero saves the abducted daughter, he's coldcocked upon returning to Hassen's compound by the sheik's thugs. Taking the opportunity of a lifetime, Hassen has a sample of Silver Streak's blood drawn.

"We shall inject my falcon with the blood of this speed demon," announces Hassen. "Then I will have the fastest bird in Arabia!" His prophecy comes true, but not to his benefit. Suddenly possessed of lightning-fast super-speed, the raptor turns on his former master. Now dubbed Whiz by his grateful blood donor, the falcon joins Silver Streak to completely rout Hassen's criminal empire and win the globetrotting marathon.

Of course, it's extremely unlikely that a falcon would receive strange powers from . . . eh, let's not bother finishing that thought. Whiz becomes the Streak's sidekick—rapidly. "It appears I've found my equal in a race," admits the impressed hero, acknowledging the bird's tremendous speed.

Besides attacking crooks (usually on Streak's command, but occasionally on his own thankfully adroit recognizance), Whiz can talk, carries messages for his human partner, disposes of bombs, and even brings the hero his morning newspaper.

Yet for all that, Whiz is eventually overshadowed—and replaced—by Mickey O'Toole, a street tough who also receives a blood transfusion from the Streak and becomes his equally fast kid sidekick Mercury (later redubbed Meteor). Silver Streak came to rely on Whiz less often. The King of Falcons was, ultimately, dethroned.

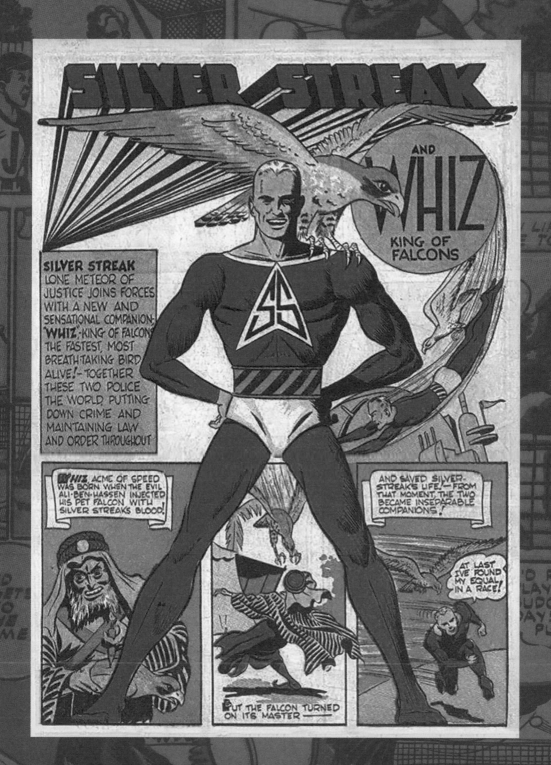

WOOZY WINKS

"I can't let a thousand bucks get away without a scrap!!"

JUST AS ROBIN THE BOY WONDER represents an archetype of the comic book sidekick, so too does Woozy Winks.

Characters like Batman's partner introduced an element of youthful enthusiasm into the often alarmingly grim stories that typified the early era of comics. They also gave younger readers a sympathetic character, someone whose brightly colored boots they could easily imagine themselves filling. Kid sidekicks, in other words, provided a bridge between the adult hero and the youngsters reading their adventures.

On the other end of the spectrum were characters like Woozy Winks—older men, typically portly, often a little crooked, not exactly bright, and blessed with a face that could stop a clock. Woozy comes from a long line of theatrical buffoons, stretching from Shakespeare and commedia dell'arte to radio and vaudeville. These characters elevate the comedic aspects of their partners' adventures, increasing their appeal with antics, slapstick, and snappy patter. And though Woozy wasn't the first of his kind in comics (unlike Robin), he's practically the apotheosis of the comedy sidekick.

But Woozy is also more than just a representative of a particular brand of four-color confederate. His appeal was so powerful during Plastic Man's heyday that he was given subplots of his own and an ongoing feature under his alliterative name.

In his debut, Woozy casually rescues a strange, wizened figure from drowning. "You have save ze life of Zambi! Ze soothsayer!" gushes the doused wizard, turning his powers of magic on his savior. "I hereby bestow upon you the protection of nature!! From this day forth, **no harm you**!!" He adds the all-important magic word, "**Shaddroe!!**"

From that moment, doughy, daffy Woozy is protected from all physical harm. He tests his newfound invulnerability by chucking himself harmlessly off a cliff—a substantive test by any definition.

Inherently unscrupulous, Woozy turns his gift into an opportunity to make a dishonest buck. And, given that he's protected by nature, who could possibly stop him? When stretchable federal agent Plastic Man attempts to arrest Woozy, he's interrupted by an unexpected lightning bolt and a shower of giant hailstones. Winks also enjoys the protection of spontaneous jets of flame, fissures in the earth, and full-grown trees popping out the ground in the blink of an eye. "Where'd that tree come from?" asks a bewildered and frustrated Plastic Man. "An acorn, no doubt!" replies Woozy, idly sauntering away with hands in →

Created by:
Jack Cole

Debuted in:
Police Comics #13
(Quality Comics,
November 1942)

Mascot of:
Plastic Man

Buys the same monogramed towels as:
Wonder Woman,
Walter the Wobot

© 1942 by DC Comics

pockets.

Woozy is eventually turned to the side of law and justice, albeit unwillingly and with frequent recidivism. Plastic Man determines that the best way to mitigate the undefeatable oaf's crime spree is to take him on as a partner. He also plays on Woozy's soft heart, asking him to think of his mother. "What would she say if she knew about your crime career?" Plastic Man pleads to the sorrowful Winks. "Why, it'd break her heart!" he concludes, to which Woozy tearfully replies, "Stop it! Stop it!! I can't take it!"

Zambi the Soothsayer's spell quietly wears off after a few years (he must have phoned in that "Shaddroe!"), and Woozy's criminal tendencies diminish—but never disappear—over the course of his existence. He even becomes enthused about a potential career as a lawman, although he's still inclined to pick the occasional pocket.

EDITOR'S NOTE

Plastic Man has, on occasion, replaced Woozy with other sidekicks. His short-lived Saturday morning cartoon paired him with girlfriend/wife Penny and their Polynesian pal Hula-Hula. A baby Plas joined the cast in the second season, presaging Plastic Man's son Luke (aka Offspring) and vampiric adopted daughter Edwina in the comics. A Silver Age incarnation put Plastic Man in the company of wealthy gal pal Micheline de Lute III and straitlaced pet shop owner Gordy Trueblood.

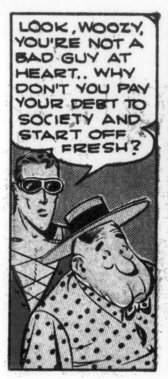

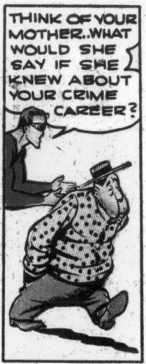

PART 2

THE SILVER AGE

1950-1969

BY THE END OF COMICS' Golden Age, the popularity of the superhero had waned, but sidekicks lived on. The genres that replaced superhero comics continued to employ second bananas, wfrom wily ole prospectors and stoic Indians in western comics to various aliens, robots, and/or space cadets who teamed up with science fiction heroes. Even the controversial horror comics of the day paired lesser fiends with the prominent, pun-happy emcees who introduced their tales of terror. And where would jungle adventure comics be without a loincloth-clad child in constant need of rescuing?

When superhero comics made a comeback in the late 1950s, costumed kid sidekicks reached arguably their apex of ubiquity. DC Comics parlayed the popularity of their top characters' junior partners into the still-successful all-sidekick squad the Teen Titans. This wasn't a new idea. But the Titans became the first franchise to promote sidekicks, celebrating them as adventurers on par with their adult contemporaries. Meanwhile, the trends of the day continued to pad the ranks of the bad guys, providing legions of spy agencies and aggressive aliens to bedevil heroes at the behest of shadowy masterminds.

So while superheroes dwindled in popularity, sidekicks and henchmen continued to thrive across other genres of the medium. And when some of those genres effectively vanished from the comics rack in the 1960s as audiences became superhero-happy once again, the stock of the sidekick only continued to rise.

NOTE: By some accounting, the Silver Age of comics started in the mid-1950s, separated from the Golden Age by a few years of artistic stagnation.

1A

"Remember . . . when-I-leave-you, only-your-incredible-steel-smashing-strength . . . and-your-wits . . . will-stand-between-humans-and-the-evil-robots!"

Created by:
Russ Manning

Debuted in:
Magnus, Robot Fighter vol. 1 #1 (Gold Key Comics, February 1963)

Mentor to:
Magnus, Robot Fighter

Any relationship to the famous condiment?
Yes, it's the *sauce* of his powers LOL

© 1963 by Gold Key Comics

IN THE DISTANT YEAR of 4,000 AD, humanity has transformed the world into a technological utopia. All labor now rests in the metallic mitts of tens of thousands of helpful robots—as do, unfortunately, most art, sports, and invention. The humans of the forty-first century have become passive, unindustrious, and easy targets for any *evil* robot that might pop up to take advantage of them.

Evil robots are a menace worth watching out for, and no denizen of the far future knows this better than the wisest robot of them all: 1A. Built so long ago that his mental and emotional processes have become almost human, 1A takes it upon himself to raise a human protector for the vulnerable citizens of tomorrow. This is Magnus, Robot Fighter, a karate-chopping droid demolisher whom 1A nurtures from infancy in a secret, suboceanic dome.

Magnus explains 1A's grueling—and morally questionable—training regimen: "His solution of man's danger was to take a parentless child . . . me . . . to a bubble-house in the deepest part of the Antarctic Ocean! From the moment I could first understand, 1A trained me for the day I would lead man's revolt against the tyrant robots! He taught me every science known to man . . . even those using tools and machines . . . then he trained me to rely on my brain, rather than the tools! . . . And then, with the most perfect method ever achieved, he trained my body . . . my muscles and nervous system . . . to steel-smashing strength!"

Of course, the irony of 1A's mission to reduce human reliance on robots is that there wouldn't even be a Magnus, Robot Fighter, had it not been for reliance on robots. Not only did 1A train Magnus from birth, but he also must have provided for all of his student's essential human needs. Add to that the deadly robot-specific fighting arts that 1A taught Magnus, and it's difficult to decide if 1A is a peerless parent or a fink consigning his own kind to destruction and obsolescence. 1A is a complicated character.

Being practically human, though, 1A is first and foremost a fatherly figure to Magnus. When the Robot Fighter returns to his childhood home to seek 1A's aid, the elderly figure gently chides his former ward: "Nice-of-you-to-remember-me-once-in-a-while, man-child!" Among his multitude of human skills, 1A appears to have mastered the guilt trip.

OR-IS-IT-THAT-YOU-NEED-MY-HELP?

BOTH, 1A! BUT THE HELP IS *URGENT*! LET US GO TO THE LAB!

MAGNUS TELLS 1A OF SIGMA, THEN...

THE THREE WHINES SEEM IMPORTANT...BUT EXACTLY HOW, I'M NOT SURE! HERE'S ONE... LISTEN...

WHIINE!

I-I-I-E-E-E-O-O-

HMM—THIS-IS-A-VERY-SPECIAL-TAPE-MACHINE, MAGNUS, CAPABLE-OF-SUPER-SLOW-SPEED! LET'S-STRETCH-THAT-WHINE-OUT!

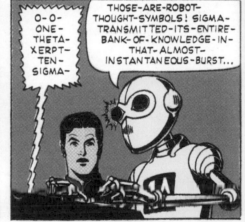

O-O-ONE-THETA-XERPT-TEN-SIGMA-

THOSE-ARE-ROBOT-THOUGHT-SYMBOLS! SIGMA-TRANSMITTED-ITS-ENTIRE-BANK-OF-KNOWLEDGE-IN-THAT-ALMOST-INSTANTANEOUS-BURST...

PROBABLY-TO-ANOTHER-SIGMA-BODY-SOMEWHERE!

AND SOMEHOW, THE MYSTERIOUS MASTER SENT THE NEW SIGMA TO REPLACE THE DESTROYED ONE... INSTANTANEOUSLY!

YES! THAT, I-CANNOT-DUPLICATE! BUT-I-*CAN*-MAKE-YOU-A-TRANSMITTER-OF-ROBOT-THOUGHT-SYMBOLS-SO-POWERFUL-IT-WILL-CANCEL-REGULAR-ROBOT-SIGNALS!

GOOD!

THE SHIELD
vs. "THE MENACE FROM P.E.R.I.L."

ANY LAST WORDS BEFORE YOU DIE, SHIELD?

YEAH! WHO IS... THAT EVIL EYEFUL?

THE OTHER AGENTS AT P.E.R.I.L. CALL ME THE DRAGONFLY! MY SPECIALTY, THE KISS OF DEATH!!!

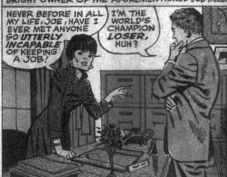

ACTUALLY, OUR TALE BLASTS OFF IN THE OFFICES OF THE ZENITH EMPLOYMENT AGENCY! THE VOICE WHICH IS BERATING JOB-SEEKING JOE HIGGINS BELONGS TO NANCY ZENITH, PRETTY, BRIGHT OWNER OF THE AFOREMENTIONED JOB-MILL.

NEVER BEFORE IN ALL MY LIFE, JOE, HAVE I EVER MET ANYONE SO UTTERLY INCAPABLE OF KEEPING A JOB!

I'M THE WORLD'S CHAMPION LOSER, HUH?

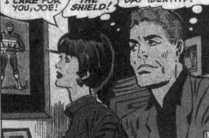

WHY CAN'T YOU HAVE THE WINNING STAMINA OF THE HEROIC SHIELD? DON'T FLINCH LIKE THAT! I'M SAYING THIS ONLY BECAUSE I CARE FOR YOU, JOE!

SHE'D PLOP SMACK ON HER LOVELY PROFILE IF SHE KNEW I'M SECRETLY THE SHIELD!

THROUGH SOME STRANGELY INVERTED, COMPULSIVE PSYCHE-TWISTS, EVEN I CAN'T DIG, I NEG-COMPENSATE FOR BEING SO GREAT AS THE SHIELD, BY BEING MR. GOOF-UP IN MY EVERY-DAY IDENTITY!

AGENTS OF P.E.R.I.L.

"Any last words before you die, Shield?"

IN THE ESPIONAGE-HAPPY ERA of the 1960s, superheroes and supervillains found themselves in the spy game. This largely meant outsized and absurd personalities, clever gadgetry, and—perhaps most important—shadowy organizations dedicated to evil and sporting an appropriately sinister acronym. P.E.R.I.L. was just such an organization.

Like most of these international agencies of crime, P.E.R.I.L. stands for an almost embarrassingly forced moniker: "Personified Evil Ruthlessness, Infamy, and Larceny." This implies that P.E.R.I.L.'s objectives involved lacking empathy, having a bad rep, and occasionally stealing something. You wouldn't think a formal organization would be needed to undertake such an anemic syllabus of crime, but here they are anyway.

P.E.R.I.L. and its veritable army of criminal minions concentrated their efforts on one guy: the Shield, a patriotic crime fighter whom the organization seeks to convert to their side. One member, Dragonfly, floats the idea during a meeting. "You fools," she begins on an unfriendly note, "hasn't it occurred to you that the Shield would make a splendid P.E.R.I.L. agent!"

She also makes this case directly to the Shield. "You send me!" she purrs. "Quit crusading for good! Join P.E.R.I.L. and become an evil cat man!" Why a cat man, exactly? She doesn't elaborate, so readers must use their imagination.

Besides **Dragonfly** and her advertised—but never exhibited—"kiss of death," P.E.R.I.L. employs a roster of other, even more unusual minions.

The green-clad **Alligator**'s outfit inarguably resembles a store-bought Halloween costume. "Mechanically moving fangs on my helmet will rid us of his [sic] opposition," he brags, as his puppetlike helmet slowly mashes its jaws, approaching the Shield's face. The Alligator receives a debilitating shock for his efforts. A later caption describes an even worse humiliation: "The Alligator was jailed the following week, for driving against four red traffic lights while contemplating the Shield's prospects for doom!" Bummer.

The Red Shadow, a "gigantic, powerful, monstrous non-being created out of the atoms in the air," is accompanied by the "jarringly vibrating" **Vibrateer**, and his cohort **the Blender**, whose name is a bit of a misnomer. Rather than wielding whirling blades, the Blender can merely blend into surroundings. To be honest, that's a bit of a letdown.

When discussing their next crooked scheme, one of the ranking members suggests blowing up planet Earth. A wiser voice replies, "Forget it! We're on Earth, too, remember!" It's no wonder these agents were routinely beaten.

Created by:
Jerry Siegel and
Paul Reinman

Debuted in:
Mighty Comics #42
(Archie Comics,
January 1967)

Henchmen to:
P.E.R.I.L.

Hobbies:
Ruthlessness,
infamy, larceny (you
know, the usual)

© 1967 by Archie Comics

THE ANI-MEN

"It's not healthy to spy upon the organization, mister! In fact, it's gonna prove fatal to you!"

Created by:
Bob Powell and
Wally Wood

Debuted in:
Daredevil #10
(Marvel Comics,
October 1965)

Henchmen to:
The Organizer,
Count Nefaria,
Death-Stalker, and
Hammerhead

In the proud tradition of:
The Musicians of
Bremen, the Banana
Splits

© 1965 by Marvel
Comics

CAT-MAN, APE-MAN, FROG-MAN, AND BIRD-MAN aren't just four of the least imaginative names in the history of superhero comics. They're also a repeatedly ill-fated quartet of henchmen for hire: the Ani-Men!

Through a multitude of incarnations, the Ani-Men flubbed assignments and occasionally found themselves unexpectedly murdered. It's a wonder that any self-respecting villain would consider using them for grunt work—which probably accounts for their infrequent appearances.

The original Ani-Men lineup consisted of four members. Townshend Horgan, alias **Cat-Man**, possessed infrared vision and extraordinary agility. Gordon Keefer, aka **Ape-Man**, boasted tremendous strength and formidable fighting skills. Francois "Frog" Le Blanc, a former Navy frogman, was recruited to be the group's literal leaping **Frog-Man**. And, lastly, Henry Hawk, a part-time bookie, was given a set of working wings and assigned the code name **Bird-Man**.

The Ani-Men's costumes and gear (which included oversized communication headsets) are part of what makes them so memorable. Decked out like anthropomorphic versions of their code names, they wear their equipment in chest-hugging, bright yellow vests. This effectively makes them look like they're not wearing pants, as if they were surprisingly realistic Looney Tunes cartoons. (They resolve this with full tunics later on, but it seems like a shame to change such a distinctive trait.)

Losing is primarily what the Ani-Men do—and badly, even by comic-book-villain standards. They were beaten on multiple occasions—individually and as a group—by the sightless superhero Daredevil, and again by Daredevil paired with Spider-Man. Later, they took on Iron Man and not only lost but were killed when a bomb set by a villain named Spymaster exploded prematurely.

A replacement set of Ani-Men makes an appearance soon thereafter, but their luck doesn't seem to run any better. Hired by Death-Stalker to capture Daredevil, the new Ani-Men are rewarded for their success by being murdered by their own boss's electrifying death-touch.

Additional Ani-Men—unrelated to either of the first two incarnations—have popped up in recent years. They seem to have about as much success as the beastly baddies who preceded them.

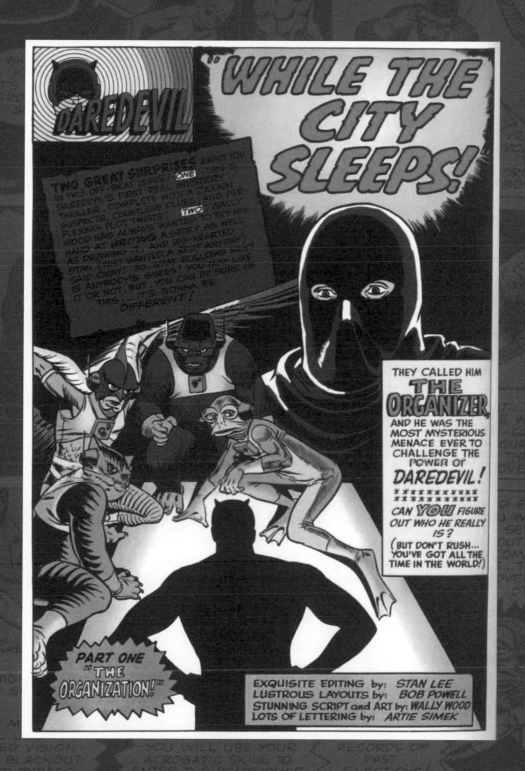

COMET THE SUPER-HORSE

"If I were a man . . . if I were free to tell her of my real feelings, for a girl like that, I'd even give up all my super-powers!"

THE SUPER-PETS OF SUPERMAN and Supergirl have always tested credulity, despite being warmly received by readers. The adventures of Krypto the Super-Dog, Streaky the Super-Cat, Beppo the Super-Monkey, and Comet the Super-Horse were largely comedic and action oriented. As an exception, though, Comet was the only member of the team to venture into romance. And with his owner, Supergirl, no less!

Comet's backstory is unusually complicated for a super-pet. It begins in ancient Greece when the centaur Biron saves the enchantress Circe from an attempted assassination at the hands of the sinister wizard Maldor. As a reward, Circe offers Biron his heart's desire, which is to become fully human for some unexplained reason. Something of an overachiever, Circe concocts two potions—one that will irrevocably change Biron into a man and another that will turn him into a horse.

Naturally the sorceress fumbles the ball, giving Biron the horse serum by mistake. Wracked with guilt, she brews another potion. This one gives all-horse Biron his amazing powers: "The might of Jove, the speed of Mercury, the wisdom of Athena and the telepathic powers of Neptune, King of the Sea!"

Despite his array of amazing abilities, including Neptune's poorly publicized powers of ESP, Biron is ambushed by the vengeful wizard Maldor and banished to an asteroid. The transformed horse is trapped there until, by terrific coincidence, the rocket ship carrying teenaged Supergirl to Earth passes by, disrupting the magical force field that imprisoned Biron.

Believe it or not, *here's where it gets weird.* As Comet the Super-Horse, Biron begins palling around with Supergirl, partnering with her through a series of adventures in the early 1960s. On one of these escapades, Comet discovers that he can become human whenever a comet happens to pass through the solar system. He takes advantage of one of these transformations to don the persona of handsome rodeo champ "Bronco" Bill Starr and *undertakes a romance with the still-teenaged Supergirl.* The transformation is short-lived, and cowboy quietly becomes horse once again. The Super-Horse keeps his secret to himself, leaving Supergirl to brood over her lost love.

For all the nonsensical storylines that have appeared in comics, the list of pet sidekicks who transform into human love interests for their partners before turning back into animals is, thankfully, short. In fact, it might begin and end with Comet, which is a small blessing to be sure.

Created by:
Jerry Siegel and Curt Swan

Debuted in:
Adventure Comics #293 (DC Comics, February 1962)

Sidekick to:
Supergirl

Why the long face?
Unrequited love

© 1962 by DC Comics

CRYLL

"Haha, I only do it for laughs—or to help you, Space Ranger!"

Created by:
Edmond Hamilton,
Gardner Fox, and
Bob Brown

Debuted in:
Showcase #15 (DC
Comics, July 1958)

Sidekick to:
Space Ranger

Apparently made of:
Pencil erasers,
bubblegum

© 1958 by DC Comics

DON'T TELL ANYONE, BUT the handsome yet idle Rick Starr, executive at Allied Solar Enterprises, is secretly Space Ranger—Guardian of the Solar System! Piloting the laser-fast spaceship *Solar King* and decked out in yellow pajamas and a fishbowl helmet, Space Ranger protects the twenty-second century from menaces both extraterrestrial and homegrown.

Thanks to the all-purpose ray pistol he kept holstered at his side, Rick was ready to take on any foe. Armed with his high-temperature Thermoblaze ray, the air-sucking Vacuumizer and paralyzing Numb-Rings—which may also be some sort of snack treat—Space Ranger had the drop on evil aliens, robots, energy beings, and space pirates. But he would be nowhere without the side-kicking of his shape-changing pink partner, Cryll.

Easygoing, good for a laugh, and looking for all the world like one of those squeezable stress dolls, Cryll was Space Ranger's loyal companion from their first published adventure. "It was certainly my lucky day when you found me, stranded far out in the deeps of space beyond Pluto," Cryll recalls in a flashback, and the reader is treated to the sight of Space Ranger carrying in both hands what appears to be a ham frozen in a block of ice. "Whatever happened to his ship came so suddenly that he was frozen solid!" Space Ranger ponders, amazed. "Fortunately, he's still alive!"

Fortunately, indeed. The absurd-looking Cryll frequently rescues Space Ranger from dangers for which the hero's Multi-Ray Pistol is no match. Able to fight crooks as an alien monster or slip aboard their ships disguised as valuable loot, Cryll seems to work harder than his boss.

Cryll also invites readers to learn about the expansive fauna of Earth's neighboring planets. Extraterrestrial life-forms imitated by the shape-changer include the Venusian mouse, the electric eel and iron cat of Neptune, the marsh cat and Earth-Eater of Saturn, the web-lizard of Pluto, and Jupiter's water-blaster. Few comics have educated kids so much about so many nonexistent animals or steered them so wrong about the possibility of life on other worlds in our solar system.

In more recent comics, Cryll attempted to form a superhero team made entirely of sidekicks (including Zook, see page 191). When that effort collapsed, he formed a self-help group for abandoned sidekicks.

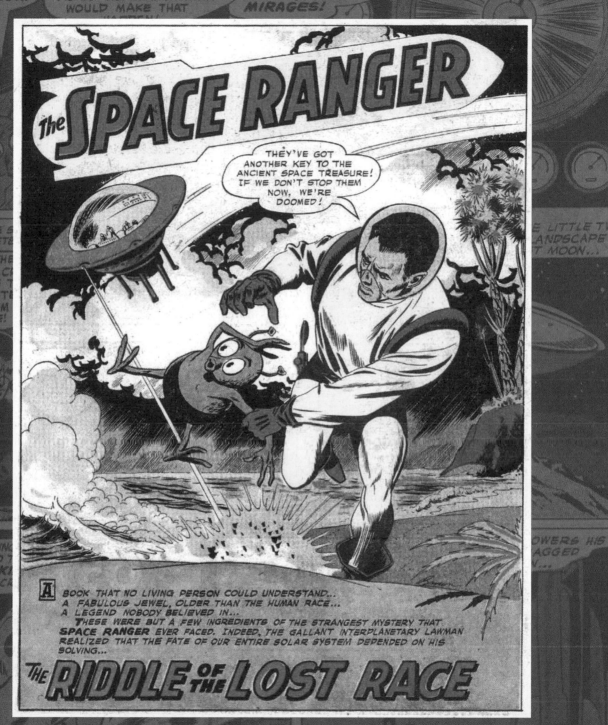

ATTACK! WE OUT-NUMBER HIM!

WE'VE SCORED A NEAR-*MISS*! ENOUGH TO AFFECT HIS *PROPULSION UNIT*!

THEY'RE *GAINING* ON ME! I'LL *NEVER REACH* THE NIKE BASE IN *TIME*! I'M GOING TO HAVE TO FIGHT *EVERY* ONE OF THEM!

WE *HAVE* HIM! NOW... *CLOSE*!

UNGPH! HE HAS MUSCLES OF *IRON*!

IF I CAN KEEP THEM AT *CLOSE QUARTERS*, THEY WON'T BE ABLE TO USE THEIR *GUNS*!

HE MOVES WITH THE *SPEED* OF SHOOTING STARS!

AND HIS FISTS STRIKE LIKE PLUNGING METEORS!

THAT'S IT! HOLD HIM! I CAN FINISH HIM AND... *BEHOLD*! LOOK WHAT HE HAS DONE TO MY *SPEAR*!

I'VE GOT ALL *SORTS* OF SURPRISES FOR YOU, MOON BOY!

I *SHOULD* BE ABLE TO CRUSH HIM WITH *EASE*, BUT MY *STRENGTH* IS OF NO AVAIL!

WE WILL NEVER TAKE HIM *THIS* WAY! EMPLOY YOUR *BLAST* GUNS!

IT NEVER *FAILS*! EVERY TIME I HAVE MY SUIT *SIMONIZED*, SOME JOKER TRIES TO *SPOIL THE FINISH*!

9.

EDAM AND GOUDA

"Dispatch a message back to the Moon..."

THE MYTH OF THE MOON being made of green cheese is, generally speaking, not taken seriously. Even young children recognize the fanciful description as fantasy. However, in the high-tech, science-powered world of Iron Man, it turns out that it's all true, after a fashion.

In luxurious Monte Carlo, Tony Stark's spendthrift cousin Morgan makes a deal with the predictably insidious Count Nefaria. In exchange for forgiveness of a massive gambling debt, Morgan must undermine his wealthier relative's sanity, softening up the iron-suited industrialist for Nefaria's secret scheme.

He does this in part by tormenting Stark with Nefaria's "visio-projector," which causes a fake rocket ship to appear in his line of sight and then vanish so that no one can confirm Stark's UFO sighting.

The plan works fairly well until a cosmic coincidence occurs: a two-alien expedition force under command of an unseen alien overlord lands in the very spot where Stark had originally seen the vanishing rocket ship. Emerging from the saucer-shaped craft, the striking duo is heavily armed and clad in bubble helmets. Or are they wearing glass domes of the type you see placed on cheese boards? It's a worthwhile question: the shaggy green lunar landing party goes whole hog—or is that whole cow?—with cheese references. As more green aliens pour from the spacecraft, we learn that the two creatures leading the assault are named Edam and Gouda.

The writer of this tale, Al Hartley, boasts a lengthy career writing and drawing for teen-oriented humor comics, including Archie Comics. The cheese-themed Moon-aliens would not have seemed particularly out of place there; the teens of Riverdale often encountered science fiction or supernatural menaces, which tended to be played for laughs.

Iron Man defeats the aliens, natch, but the memory of lactose-tolerant lunatics from a green-cheese Moon apparently tickled other Marvel Comics writers. Around two decades after their debut, their home world was changed to a less-problematic location (by then, Earth's Moon was already over-populated with minor alien races). According to *The Official Handbook of the Marvel Universe*, Edam and Gouda and their many friends hail from the planet Froma, recalling the French word for cheese, *fromage*. Later writers expanded the roster of Froma's family tree, adding representatives Colby and Havarti. It's safe to imagine that further visits from Froman citizens will introduce us to Brie, Cheddar, Mozzarella, and good ol' Monterey Jack.

Created by:
Al Hartley and
Don Heck

Debuted in:
Tales of Suspense #68
(Marvel Comics,
July 1966)

Homohmon to:
The Moon?

Favorite color:
Green

**Distinguishing
characteristics:**
Strong odor, melt
smoothly

© 1966 by Marvel
Comics

THE EVIL EYE SOCIETY

"Come closer . . . the Grand Council of the Evil Eye Society has been expecting you!"

Created by:
Ed Herron, Jim Steranko, and Dick Ayers

Debuted in:
Spyman #2 (Harvey Comics, December 1966)

Henchmen to:
Cyclops

Most evil act:
Tricking you into cutting a hole in your comic book

© 1966 by Harvey Comics

FROM THEIR DEBUT, COMICS have embraced an arguably postmodernist sensibility. In recent years, that has grown into a fondness for metafictional storytelling—transcending the linear narrative by, among other tactics, breaking the fourth wall and involving the reader in the story. But groundbreaking contemporary comics writers might be shocked to learn that they have lagged behind the curve. Way back in the swinging '60s, the spy-themed corner of comics introduced an evil organization that extended readers a direct invitation.

"You want to join our organization?" asks Cyclops, the eerie leader of the sinister secret society. "It can be arranged!" He then directs readers to a small, dotted rectangle in the center of the page, in the middle of which is drawn a green-lidded eye. "Cut out this symbol of our all-seeing eye," he continues. "Paste it on your forehead! There—now look in the mirror with all 3 eyes!"

Scissor-happy participants in the program would find themselves with a ruined comic and a new mission in life: "Destroy the forces of Liberty!" bellows Cyclops, his oversized, unblinking eye glaring triumphantly from beneath his cowl.

The liberty is question isn't the abstract concept of personal freedom but, rather, LIBERTY, the espionage organization that is home to cybernetic superhero Spyman. Readers excited about their future as minions in a vast criminal conspiracy were probably sobered by the sight of Spyman with his electro-robot hand, calmly dispatching enemy agents who wore evil-eye stickers on their foreheads. Apparently the only power imbued by the mystical third eye was providing a target for a well-placed left hook.

The Evil Eye Society enjoyed a surprisingly short run, considering that their membership extended off the page and into the real world. Assaulting LIBERTY at their secret base—the Statue of Liberty, appropriately enough—the Evil Eye Society is within seconds of snatching the plans for a "transistorized nuclear weapon," which is "no larger than a child's marble." Cyclops unleashes a deadly "killer-beam" from the center of his tremendous eye. But the beam is *handily* reflected by Spyman, who directs the deadly force back at its master. Cyclops plummets from the top of the Statue of Liberty to his death. No refunds were announced for junior members of the Evil Eye Society.

THE FIVE AGAINST FIVE

"We challenge you to a duel, Crusaders! Accept, or be branded as cowards!"

SUPERHERO TEAMS HAVE A HABIT of attracting teams of supervillains. The villains obey a few traditional ground rules, such as being equitable with their numbers. Which is explicitly what the Five Against Five did—it's even in their name!

The Five were agents of the Brain Emperor, a mega-cerebral baddie from the planet K-Shazor. The emperor unleashes five of his deadliest hench-aliens on the heroic Mighty Crusaders. The patriotic Shield is called upon to face **Thornaldo**, whose biological power is fantastically overcomplicated. "Each of my potion-tipped steely-thorns has a different effect on a victim," he announces, firing deadly spines at a pair of rabbits. One ages dramatically, to the point that "he immediately perished of senility," while the other spontaneously turns into gas.

The unpowered but highly skilled Black Hood, a police officer in his secret identity, tackles a metallic alien resembling a robot named **Bombor**. "A living bomb!" Bombor calls himself. "I was designed to explode both myself and my target upon contact!" It's a nice trick, but can he do it twice?

Fly-Girl faces **Wax-Man**, a figure of semi-liquid paraffin whose "flame-like brilliance atop [his] form" turns the heroine's lower half into quickly melting wax. Fly-Man—arguably the most powerful of the Crusaders—is paired with **Force-Man**. Resembling nothing less than an oil-coated booger in human form, Force-Man boasts, "I can multiply a thousand-fold within myself any power that assaults me!" And the Comet is tasked with facing **Electroso**, whose "electric-touch" is capable of destroying anything.

The heroes make short work of their opponents: Thornaldo is haplessly flung into a quicksand patch, Wax-Man's life-giving flame is extinguished by Fly-Girl's rapidly beating wings, and Electroso is drawn into a makeshift lightning rod. As for Bombor, he's destroyed by the Black Hood's flying robot stallion. "The robot-horse sacrificed himself to save his master," thinks the Hood, idly stating what is possibly the most absurd line in comics history.

Fly-Man also overcomes his foe, with a clever plan. He explains: "I concentrated on imparting to him the greatest force of all . . . the power for doing good!" Force-Man accepts defeat. "Farewell, Fly-Man!" he hollers over his shoulder, "I see the error of my ways! I shall return whence I came!" This was the end of the Five Against Five, and the end of the Brain Emperor came soon after. Maybe they should have brought a sixth.

Created by:
Jerry Siegel

Debuted in:
Mighty Crusaders
#1 (Archie Comics,
1965)

Henchmen to:
The Brain Emperor

No relation to:
The Jackson Five;
the Five Chinese
Brothers; Five Guys
Burgers and Fries

© 1965 by Archie Comics

THE FIVE FACES OF DR. SPECTRO

"Five Dr. Spectros! What havoc we can cause!"

Created by:
Joe Gill and Steve Ditko

Debuted in:
Captain Atom #81 (Charlton Comics, July 1966)

Henchmen to:
Dr. Spectro

Can masquerade as:
A mood ring, a Pride flag, a basket of Easter eggs

© 1966 by Charlton Comics

FEW CRIMINAL MASTERMINDS have been able to do what Dr. Spectro did. Against all odds and defying reason, he became his own henchmen.

Spectro was a repeat opponent of Charlton Comics' Captain Atom. A tragic figure, he had begun his career as a medical doctor who invented colored rays capable of controlling human emotions and curing disease. But mockery from the medical community drove him to display his invention at a circus sideshow, of all places, where it inevitably attracted the attention of crooks. A struggle with a gang of bank robbers intent on using Spectro's inventions for crime results in Spectro stumbling into his own Hate-Ray and become the malevolent Master of Moods.

After an initial defeat, Spectro's disembodied form hovers in the upper atmosphere, using a powerful lightning storm to recombine his dissipated atoms. With a "KRAK!" and a "BAM!" the plan succeeds—partially. Spectro has become five smaller versions of himself, each sporting a different color—violet, yellow, sky blue, avocado green, and deep orange—and distinct powers to match.

The tiny baddies despise and plot against one another, but their individual colored rays are evenly matched, resulting in a détente. In order to recombine their bodies, thereby reincarnating their original self and resuming their torment of law and justice, they resolve to work together. Though they do call each other "fool!" a lot.

But tragedy is built into Dr. Spectro's literally split personality. His violet self seems to have inherited the original doctor's urge to help humanity. During a raid, the violet Spectro is surprised by Kathy, a young girl whose illness confines her to crutches. Touched by her condition, he tries his purple ray on the girl and discovers that its healing properties remain intact. Kathy can once again walk unaided, and this fragment of Spectro's personality pledges to ensure that his recombined form will once again help people—even if his other selves anticipate a return to death and destruction.

Did the violet Spectro's plan work? It's difficult to say. Captain Atom interrupts the reincarnation plan at the moment of fusing; the five pint-sized doppelgangers are reunited as a full-grown but raving mad villain, and Atom is left to wonder what would have happened had he not interfered. "Would the united Dr. Spectro have ever been good again?" he ponders as Spectro is led away in handcuffs. "Will I ever know the truth?"

GAGGY

"Got to keep the boss laughing—that's my job!"

WHEN THE JOKER DEBUTED in 1940, he was portrayed as a grisly, sadistic murderer. If you pick up a Batman comic today, you'll find that he's still a grisly, sadistic murderer. However, for a brief, chaste interim in the 1960s, the Clown Prince of Crime was little more than a flamboyant bank robber and theatrical thief, for whom violence was restricted to cornball booby traps and the occasional slugfest. It was this innocent era that produced the curiously christened Gagsworth A. Gagsworthy—aka the Joker's original sidekick, Gaggy the Dwarf.

So how exactly did this pint-sized prankster assist the Joker's felonious tomfoolery? For one thing, he could shatter glass with his voice. For another, he was always itching for a fight—particularly against Batman's teenaged sidekick Robin the Boy Wonder. But Gaggy's most valuable contribution was simply that he was the Joker's crime inspiration.

"How do you like that!" observes one henchman, after Gaggy's fumbling leads the Joker to plot out a series of thematic burglaries. "That stand-in for a fireplug makes the Joker laugh . . . and when the Joker laughs hard enough—he comes up with a crime scheme!"

More than a mere muse, Gaggy accounts for himself expertly in his few depicted outings with his boss's gang. He shatters a chandelier using only a shout, sending it crashing down on an unsuspecting group of prison guards. He briefly disables the Boy Wonder in the middle of a fight and nearly exposes the Dynamic Duo's secret identities in the process. He's an all-around asset to this criminal enterprise.

In fact, it's the Joker who ends up souring the illicit expedition. Though Gaggy has successfully crept up on the Caped Crusader and covered the crime fighter's eyes, the Joker's unfamiliarity with fisticuffs leads the mirthful mountebank to miss his sightless target and, instead, slug his precious pal right in the eye—effectively ending the fight then and there.

In a more merciful medium, Gaggy might have been allowed to retire. However, more than forty years after his debut, Gaggy returned to comics—obsessive, irrational, and looking to snuff out the life of the Joker's latest partner in crime, Harley Quinn. Even Gaggy became a grisly, sadistic murderer in the end.

Created by:
Gardner Fox and Sheldon Moldoff

Debuted in:
Batman vol. 1 #186 (DC Comics, November 1966)

Henchman to:
The Joker

Successors:
Jokey, Punny, Pranky, Situational Humory

© 1966 by DC Comics

EDITOR'S NOTE

The Joker has employed assorted henchmen, patsies, and aides in his war against decency. Notable among them is Jackanapes, a clown-suited, intelligent, and articulate gorilla whom the Joker raised—and trained—from infancy!

KNIGHTS OF WUNDAGORE

"I need no training! My ancestors lived for battle! Now, the time has come for me to revert to type!"

Created by:
Stan Lee and
Jack Kirby

Debuted in:
The Mighty Thor
vol. 1 #134 (Marvel
Comics, November
1966)

Henchmen to:
The High
Evolutionary

Summary:
Petting zoo meets
the Knights Templar

© 1966 by Marvel
Comics

FEW CHARACTERS IN MAINSTREAM COMICS have a story as complex, contradictory, and just plain baffling as that of the Knights of Wundagore. These characters are a wonderful example of what makes superhero comics such an exciting genre. Few other media could embrace *The Island of Dr. Moreau* plus the legends of King Arthur by way of hard science fiction.

The story begins when geneticist Herbert Wyndham develops an amazing device known as the Genetic Accelerator. But his peers in the scientific community laugh off Wyndham's claims that the device can evolve animals to human levels of sophistication. "I must find a place to work," he decides, cradling the body of his now-manlike pet Dalmatian, brought low by a rifle shot, "where my subjects will be safe from unthinking bumblers!"

Wyndham relocates to a distant bumbler-free mountain range, dons an imposing suit of magenta-and-ivory armor, and rechristens himself the High Evolutionary. Whether the name refers to his self-image as an exalted genius, his mountain-top laboratory, or some altered state of consciousness is hard to say. In any case, from his vantage point on Wundagore Mountain, he creates evolutionarily advanced hybrid creatures, a combination of human and animal.

"Here I created my New-Men," he explains, "modeling them after the knights of old—striving to teach them a code of honor and chivalry!" The first are Porga and Tagar (respectively, an evolved pig and tiger), and soon they're joined by Sir Lyan, Sir Hogg, Sir Ram, Lord Gator, Lady Vermin, and other scientifically advanced fauna.

But one rogue creature exposes himself to the full power of the Genetic Accelerator and emerges as a "super-beast." Boasting a "brain of man—as it will be a million years hence" plus "the power of a wolf—as *he* will be a million years hence," and dubbed the Man-Beast, he proves powerful enough to defeat the Mighty Thor. Next, he creates an army of evil New-Men.

Summon the Knights of Wundagore! On their high-flying Atomic Steeds, the elaborately armored knights meet the evil New-Men on the battlefield. They vanquish their enemies and punish them honorably—by launching them toward a distant galaxy. (Chivalry has weird rules.)

The knights later migrate to a perfect replica of the Earth positioned on the opposite side of the sun and then relocate to a planet orbiting Sirius, even as High Evolutionary returns to Wundagore, creating a new roster of knights.

LITTLE AMBROSE

"Hey! Stop pushing me around!"

FEW COMIC BOOK FRANCHISES have exhibited the chameleon-like ability to adapt to a multitude of genres displayed by Riverdale's boy celebrity, Archie Andrews. The redheaded teen and his close-knit coterie have not only enjoyed life as icons of innocuous teen humor, they've also inhabited the prehistoric past, donned superhero togs, engaged in gadget-crazy espionage adventures, and taken on an array of ghosts, aliens, robots, and other assorted menaces.

Arguably the most successful variation was *Little Archie*, a grade-school adaptation of the cast of Archie Comics. Naturally there was Little Archie, but there was also Little Reggie, Little Jughead, Little Betty, and Little Veronica, and so on. Additionally, there was poor Little Ambrose.

Created specifically for the series, Ambrose was inducted into the gang seemingly as a target for abuse. Subordinate to the rest of the Archie crew, the uncertain, bashful Ambrose Pipps seemed to exist for no other reason than to be the scapegoat.

The humor in *Little Archie* was rougher than that of the mainstream books. Creator Bob Bolling seemed inordinately attracted to segments in which an aggravated Archie would take out his frustrations physically on any friend within arm's reach. Unfortunately, Little Ambrose seemed built to take such abuse, and not just from Archie. Little Mooso, Little Reggie, and even laconic Little Jughead were occasionally shown to vent their bile at Riverdale's most kickable kid.

In the first issue of his own spin-off comic, Ambrose is repeatedly made the victim of his playmates' rough antics: he is twice robbed of his meager "life's savings," forced to enter a terrifying haunted house, and strong-armed into surrendering an impressive soapbox bus of his own invention only to be abandoned when it runs amok. He's also forced to pretend to be a giant camera (explaining that would take more space than is available here), has his good ideas stolen by Little Archie, and is otherwise generally either slugged, bullied, or intimidated throughout his adventures, without ever retaliating.

Ambrose vanished from comics well before the Little Archie adventures ran their course. A brief cameo in a recent storyline portrayed the now-adult Ambrose as an orphaned child of divorce suffering from delusions and still enduring the jeers and mockery of his peers. It seems cruel to revive him just to leave him worse off than when he left. Poor Little Ambrose, indeed.

Created by:
Bob Bolling

Debuted in:
Little Archie #4
(Archie Comics,
Fall 1957)

Sidekick to:
Little Archie

Level of self-esteem:
Comes up short

© 1957 by Archie Comics

LITTLE DOT'S UNCLES AND AUNTS
"You sure saved the day, Dot!"

Created by:
Various Harvey
Comics writers and
artists

Debuted in:
Harvey Hits #4
(Harvey Comics,
December 1957)

Partnered with:
Little Dot

**Location of family
reunion:**
The entire
Northern
Hemisphere

© 1957 by Harvey
Comics

ARVEY COMICS' DOT-OBSESSED HEADLINER, Little Dot, is more than some junior incarnation of Yayoi Kusama. She's also a problem-solver, much to the delight of her platoon of bizarre relatives.

For our purposes, the primary question is whether Dot's aunts and uncles serve as her sidekicks or, conversely, if she's *their* sidekick. Little Dot is the title character, true; her relatives generally receive secondary credit. But Little Dot resolves *their* problems—essentially, she helps them accomplish their goals, which puts her in the sidekick role.

Either way, Dot's elders are legion. They even had their own spin-off title, which ran sporadically for more than a decade. Dot's uncles and aunts tended to have very specific jobs and interests, usually relevant to their names. Her rodeo star Uncle Hoot frequently played a role in Dot's adventures. Uncle Gill, a deep-sea fisherman, requires Dot's assistance with dangerous ocean creatures, and Dot steals the show from stage magician Uncle Tricky.

There's an army of others, like daredevil Uncle Stunty, law-enforcing Aunt Badge, water-happy Aunt Aqua, agricultural Uncle Sod, Aunt Chirpy the bird lover, risk-addicted Uncle Daring, sleuthing Uncle Gumshu, brilliant Uncle Branes, off-kilter Uncle Odmund Ball, shy Uncle Bashful, morose Uncle Gloomy, and chipper Aunt Smiley. A Hollywood adventure involves Aunt Glamma, Uncle Mogul, and Uncle Rock; a visit to the circus introduces Uncle Bigg Top, and the local fireworks factory employs her eternally nervous Uncle Quiver.

Dot helps Uncle Foamy perfect a new detergent, encourages Aunt Joy to invent a new doll, and is employed by Aunt Sugar (not to be confused with Aunt Sweetooth) to develop a new type of bubblegum. There's also Uncle Vinegar, Uncle Cuckoo, Uncle Splatter, Uncles Coffdrop, Icy, Nugget, Seller, and Shower, and Aunt Filma. You might meet Uncle Hocus, Aunt Scribble, Uncle Space, Uncle Felix, Aunt Teeny, Uncle Airy, Uncle Astro, Aunt Gwendolyn, Aunt Hope, Uncle Butch, Uncle Pressly, Aunt Sobb, and Uncle Typo.

Then there's Aunt Flora, Uncle Frosty, Uncle Cueball, Uncle Junk, Uncle Brayv and Uncle Hansom, Uncle Braggmore, Aunt Trayl, Uncle Speedy and Uncle Jet, spy couple Uncle Espion and Aunt Mata, pleasant Uncle Smiley, and atomic scientist Uncle Sowerdo.

If nothing else, the roster explains why her parents never sent Dot to a therapist to address her preoccupation with dots. Clearly this is a family in which appellation equals destiny.

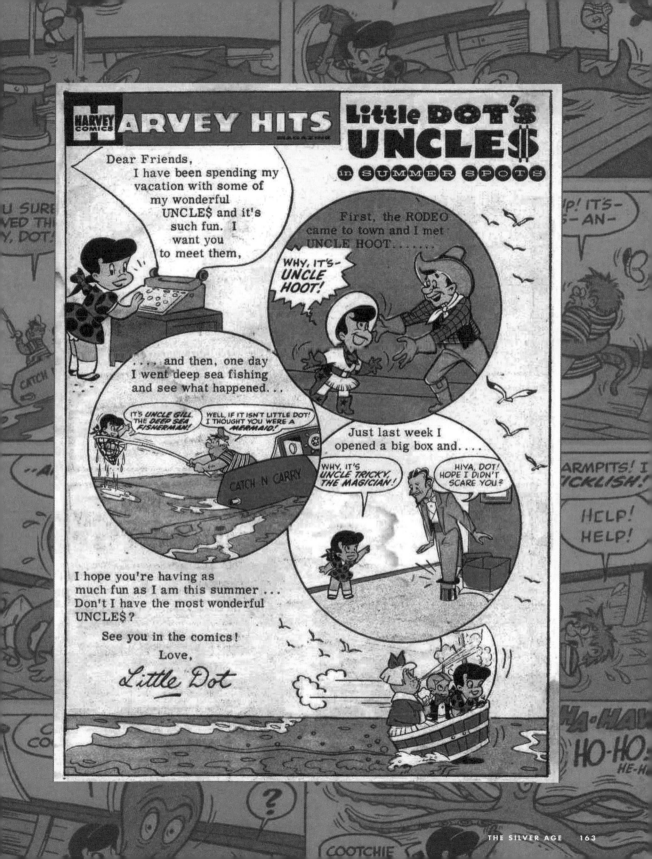

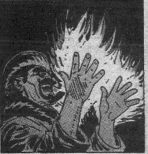

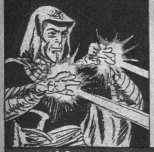

MAGICMASTER

"At last, once again the potency of all magic is mine to unleash!"

BOY MAGICIAN JIMMY APOLLO packed a lot of tricks up his sleeve. He could produce keys and coins as if from thin air, escape from the tightest bonds, pick the toughest locks, and appear to lift elephants above his head with ease. It was all stagecraft and sleight of hand, of course, as befits the son of the greatest stage magician on Earth, the Mighty Apollo. But his greatest trick involved scoring a sidekick whose magic powers were real and seemingly limitless: the ancient sorcerer known as Magicmaster.

After Jimmy's father is murdered by a rival magician named Infernus, Jimmy seems disinterested in revenge—at first. Instead, he vows to carry on his father's work, aided by "the world's greatest collection of magic paraphernalia and books on the occult arts," which his father had assembled in the family library.

One of the books—in fact, the first Jimmy removes from the shelf—contains directions for summoning a mighty sorcerer from the past. This is Shamarah (or Kazzam, according to his second appearance), the fabled Magicmaster! And he's been sent to avenge the death of Apollo! Wow, it was lucky that Jimmy picked out that book!

With the aid of the "magic dagger of Dharath," without which he loses his sorcerous skills, Magicmaster shows off the powers of levitation, invisibility (thanks to a magic cloak), and hypnotic illusions. Other assorted abilities are made available by the dagger, too. Jimmy really hit the jackpot here.

Despite Magicmaster having all the trappings of a headlining hero, Jimmy is very clearly the CEO of this particular twosome—when he isn't taking a break to teach the readers how to perform simple magic tricks, that is. These educational asides were consistent in the Magicmaster stories, although they prepared the readership for little magic beyond palming a coin.

In their second appearance, Jimmy has whittled down the incantation that summons Magicmaster to "Presto Mercuro!" This brings the blue-skinned subaltern running in a flash, which is fortunate because it turns out that many more evil stage magicians are out there besides Infernus. Two appearances were all that Magicmaster and Jimmy could manage, though, so the duo vanished from the stage without an encore.

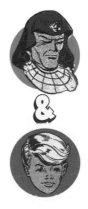

Created by:
France Herron,
Jim Steranko, and
Bob Powell

Debuted in:
*Double-Dare
Adventures* #1
(Harvey Comics,
December 1966)

Partnered with:
Jimmy Apollo

**Proves that the
true magic is:**
Friendship. Also the
dagger of Dharath.

© 1966 by Harvey
Comics

THE MONSTER MEN

"You underestimate the supremely macabre powers of your deadly antagonist!"

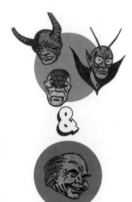

Created by:
Jerry Siegel and
Paul Reinman

Debuted in:
Fly Man #39
(Archie Comics,
September 1966)

Henchmen to:
The Monster
Master

Licensed to drive:
Monster trucks

© 1966 by Archie Comics

WHEN YOU CAN'T COUNT on quality, quantity is your best alternative. This is the philosophy of the malicious Monster Master when he creates his army of Monster Men to aid him in his battle against comics' *other* "Man of Steel," Steel Sterling. Tough as his namesake, the "crusading nuisance" (as the Monster Master calls him) was a tireless champion of right. That seems as good a reason as any for villains to take an occasional potshot at the fellow.

Using his super-advanced Robot-Brain, the Monster Master creates a sextet of sinister slimeballs. "I have six super-monsters capable of defeating . . . Steel Sterling," he crows. But in fact he sends seven creeps into battle. Perhaps he was ashamed of one?

First Sterling faces **Snakeman**, who fails to crush the hero with his "fatal coils" (aka his arms). **Ram-Man** enjoys an equally humiliating defeat, breaking his horns on a brick wall. The Monster Master next sends **Grasshopper-Man** and **Kangaroo-Man**. This ends predictably but paves the way for the two most unusual underlings: the gruesome **Octopus-Being** and the **Winged Wolf-Monster** (whose name says it all). Finally there's **Reptile-Man**—the Monster Master's forgotten seventh monster—whose only contribution is standing still while Steel uses him as a staircase.

At least the defeated monsters take their loss in stride. Stepping into a whirling vortex of energy, they issue gracious farewells to Sterling as they chant in unison, "We have failed the Monster Master! Now, it's time for us to go . . ."

For his second set of hench-creatures, the Monster Master considers a paralyzing Mr. Medusa, a Barbarian Ghost, and a delirium-inducing satyr dubbed Pan-Pan the Terrible. Ultimately, he decides upon Sea Demon, who is handily dissolved by Steel's pocketed sample of radioactive Hexite ("whose emanations repel incarnate evil," he explains helpfully).

Monster Master's ultimate monster turns out to be . . . himself! That is, a version of him that is transformed into an antennae-sporting super-baddie on the advice of his Robot-Brain. "I tricked my master into transforming himself into the antennae creature so I could maneuver him into using both antennae simultaneously and thus transmute him into a helpless photograph," the Brain explains, clarifying little.

The Robot-Brain is "adopted" by Steel Sterling as his ally in the war against evil. Steel should probably sleep with one eye open, though. The technological turncoat already betrayed one master.

NAMELESS

"I wish I had a n-n-name! So I could hear you s-s-say it j-j-just once!"

T'S CONCEIVABLE THAT ARTIFICIAL INTELLIGENCE of the future will no longer be restricted to simple commands and preprogrammed routines, but may develop preferences, priorities, and even . . . love?

Love was certainly behind the invention of Nameless, a female automaton built by one of the robotic Metal Men. This crew of six crusading androids were themselves the creation of brilliant inventor Dr. Will Magnus. Their members are courageous Gold, hypercompetent and lovelorn Platinum, trustworthy Iron, redoubtable Lead, quick-tempered Mercury, and, lastly, insecure, stuttering Tin.

Tin suffered from tragically low self-esteem, made worse by near-constant abuse from his teammate Mercury (the pair were more than a little reminiscent of Abbott and Costello). While Tin broods on his awkwardness, his artificial eye is captured by a Do-It-Yourself Robot Kit in a shop window. He takes it home, outfits it with a spare Responsometer—the device that allows the robotic Metal Men to affect individual personalities—and produces a "b-b-beautiful!" girl companion.

It's love at first sight, and the two robots begin a shy romance. However, she doesn't have a name! Lacking inspiration, Tin takes an unusual path toward christening his affectionate invention. Breaking the fourth wall, he asks the readers of the comic to write in with their suggestions. In the meantime, the team took to calling her Nameless, although Tin expressed a different preference. "Mind if I call you b-b-beautiful until the readers name you?"

Nameless vanishes from the Metal Men's company without explanation. Years later, it's revealed that she had been believed destroyed, and Doc Magnus—unwilling to subject his creations to the torment of losing a beloved teammate—erased the Metal Men's memories of Nameless.

But memories of love can't be made silent. "Last month," relates Tin to his creator, "I found an old f-fan letter, suggesting a name for b-b-beautiful!" He goes on: "How c-could I f-f-forget her, Doc? I l-l-loved her!"

Nameless is found alive, but the couple's reunion is bittersweet. She insists that the two get married immediately, and when the ceremony is barely over, a menace from the Metal Men's past threatens to destroy the group (and Batman, who's been tagging along). Nameless sacrifices herself to save the Metal Men, leaving the romantic robots bereft. "At least she died with a name," says slow-witted Lead. "Uhh . . . Mrs. Tin!"

"No," replies Tin, "she was Beautiful . . . "

Created by:
Robert Kanigher
and Ross Andru

Debuted in:
Metal Men vol. 1
#13 (DC Comics,
May 1965)

Sidekick to:
Metal Men

Fatal weakness:
True love

© 1965 by DC Comics

PEPPER

"The bottom of the barrel has been reached!"

Created by:
Dan DeCarlo

Debuted in:
She's Josie #1
(Archie Comics,
February 1963)

Partnered with:
Josie

Personality:
Salty

© 1963 by Archie Comics

EW COMIC-BOOK FRANCHISES HAVE as much spin-off power as that of America's favorite teenager, Archie Andrews. Besides a plethora of Archie-related titles—*Life with Archie, Archie's Pals 'n' Gals, Everything's Archie*, and literal dozens more (see Little Ambrose, page 161)— Reggie, Betty, Veronica, and Jughead have each fronted one or more titles. Alongside those familiar faces are later additions like Sabrina the Teenage Witch, Kevin Keller, and, of course, Josie and the Pussycats.

Josie and her cohorts have repeatedly proven to be one of the Riverdale gang's most successful properties. A pair of animated series, a live-action film, and appearances on the *Riverdale* TV show have cemented Josie, Melody, and Valerie in at least a distant corner of the public imagination. But whatever happened to Pepper?

When redheaded, bouffant-sporting Josie McCoy first debuted—preceding the Pussycats incarnation by half a dozen years—she was accompanied by two of her dearest gal pals. Melody was a platinum blonde with irresistible appeal and a musical voice. Pepper was a quick-witted, well-read and cynical young brunette whose cat-eye glasses and conservative hairstyle contrasted nicely with the more fashion-forward look of her cronies.

Pepper brought more than sharp retorts and well-thought-out conviction to the gang. She was introduced as a package with her well-meaning but lunk-headed boyfriend, Socrates (aka "Sock"). For any series—particularly for a humor/romance title—this type of pair is a valuable addition. In this case, conflicts and arguments between the two lovers, their inevitable reconciliations, and general relationship complications made for good stories.

But poor Pepper was silently escorted out of the Josie-verse when a much-needed dose of diversity was added. Valerie, lead singer of their newly formed band, was not only the first prominent African American character in the town of Riverdale, but the first female African American animated character on Saturday morning television. Her appearance was long overdue, but it came with casualties. Bright, analytical Pepper vanished from the book (along with Sock and Josie's beatnik boyfriend, Albert).

What happened to Pepper after her departure has never been directly addressed; she's only appeared in various reprints and a recent, brief cameo. Let's assume that the madcap antics and slapstick farce of the accident-prone *Josie* cast proved too lowbrow for her well-educated mind, so she departed in search of more refined climes.

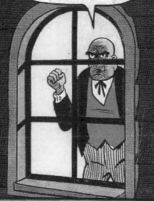

QUISP

"Zooks!"

DC COMICS BOASTS a long, proud tradition of providing their greatest heroes with impish adversaries from magical dimensions, dating back to Superman's pixie antagonist Mister Mxyzptlk (although Supes had faced other-dimensional imps before, such as the invisible Ogies). Since then, a broad selection of genies, fairies, sprites, nymphs, and other mischievous spirits have populated comic pages. Among this number is Quisp, a green-coiffed water sprite who makes a nuisance of himself around Aquaman and Aqualad.

Like the more famous Mxyzptlk, Quisp was a mischief addict. In fact, he introduces himself with an array of antics meant to amuse and baffle. A fossil dances before the amazed crime fighters' eyes, a wooden seahorse bounces around like a pogo stick, and Aquaman's poor octopus sidekick Topo ends up with his tentacles tied into knots.

Once Quisp finally appears in all of his diminutive glory ("A little man . . . only two feet high," exclaims Aquaman perceptively), he appeals for assistance with an invasion in his subaquatic homeland. "We sprites live in a secret sea beneath the bed of your oceans," Quisp explains, describing the destruction visited by fire trolls—terrible, giant ogres from undersea volcanoes who burn all they touch.

Aquaman and Aqualad help defeat the fire trolls, with Quisp accounting pretty well for himself. Possessing "great powers with water," Quisp can make water spouts, disassemble tidal waves, and even act as an outboard motor. But he's not the only water sprite to appear. Quisp's twin brother Quink—serious and responsible, in contrast to Quisp's frivolity—pursues a criminal named Quirk to the upper oceans. A fourth sprite named Quilp instigates a so-called War of the Water Sprites (which seems to involve only a few of them).

Most prominent among them, though, is Quisp, who aids Aquaman and Aqualad in their war against aquatic crime. Which is to say, he sticks around until someone better comes along. By the time Aquaman is introduced to his eventual bride Mera, Quisp has taken to idly hanging out with the Atlantean duo. His removal from the series happened so quietly, fans may not even have noticed.

Quisp has made infrequent visits to the DC universe since then. As is common in contemporary comics, his Silver Age innocence has been traded in for dark postmodern revisionism. It's an unfortunate turn for a sprite who only wanted to cause a little mischief.

Created by:
Jack Miller and
Nick Cardy

Debuted in:
Aquaman vol. 1
#1 (DC Comics,
February 1962)

Sidekick to:
Aquaman and
Aqualad

Most resembles:
A soaking wet
troll doll

© 1962 by DC Comics

RICK JONES

"Cool it, man! The kids bet me I wouldn't have nerve enough to sneak past the guards . . ."

Created by:
Stan Lee and
Jack Kirby

Debuted in:
The Incredible Hulk
#1 (Marvel Comics,
May 1962)

Partnered with:
Hulk, the Avengers,
Captain America,
Captain Marvel,
ROM, Genis

**Availability to
partner with a
new hero:**
He can probably
pencil you in

© 1962 by Marvel
Comics

ARVEL COMICS' MOST PERSISTENT sidekick is a living example of "always a bridesmaid, never a bride." Except Rick Jones has, on occasion, been the metaphorical bride. Oh, and by bride, I mean spandex-clad superhero. Or just a regular, unpowered hero. Or a monster. Or a seat-warmer for a more prominent superhero. Rick Jones has done it all, playing almost every role that a supporting character in a comic book universe can play. But for the lion's share of his lengthy career, he's been a sidekick.

Jones debuts alongside one of Marvel's earliest feature players, the Incredible Hulk, playing a pivotal role in the transformation of Dr. Bruce Banner into the aggressive, immensely powerful brute. Over the subsequent months, he runs interference between the Hulk and the U.S. military, helping seek a cure for his onetime savior's gamma-irradiated transformations and attempting to quell the unhappy green giant's terrifying rages.

Soon his verdant pal is an unlikely founding member of the newly formed Avengers. When the Hulk splits with the rest of the team, Rick stays on as the group's "mascot." Running with the Avengers introduces Rick to Captain America, who, still stinging from the apparent death of his wartime sidekick, Bucky, is reluctant to adopt a new partner. Rick perseveres and establishes a short run as the modern-day Bucky before Cap puts a kibosh on the program.

Rick is unemployed only briefly, though, and he soon finds himself acting as an occasional stand-in for extraterrestrial hero Captain Marvel (actually "Captain Mar-Vell" of the space-spanning Kree empire). Rick is able to briefly free the alien Avenger from the ominous Negative Zone. Unfortunately, he must take the hero's place, a sacrifice that sits poorly with the teen adventurer.

Rick returns to the Hulk's side several times. He also becomes an associate of fondly remembered licensed Marvel superhero ROM: Spaceknight and later mentors Captain Marvel's son Genis.

Is it possible to be destined not for greatness, but to stand near greatness? Rick has gained gamma-infused superpowers, used hidden psychic abilities, and become a white-hat hacker for espionage agency S.H.I.E.L.D. In his younger days, he founded the Teen Brigade—a nationwide network of adolescent HAM radio enthusiasts who reported on danger that required superheroic intervention. But as often as he forges his own path, it's very likely that Rick Jones will end up playing sidekick once again.

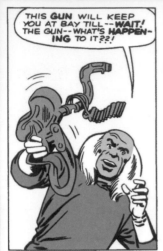

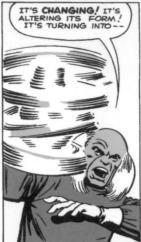

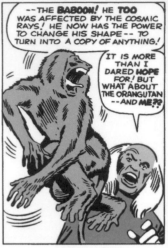

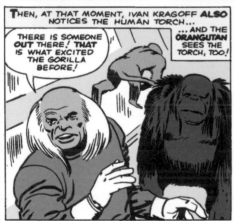

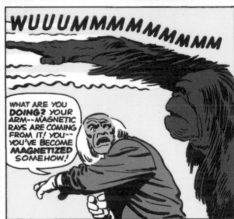

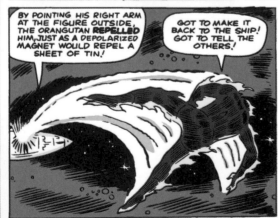

SUPER APES

"Your rather slavish devotion to your studies has forced our paws, as it were."

BY THE EARLY 1960S, the space race had reached a fever pitch. Nations were sending almost everything they could get their hands on into orbit. The Americans famously launched Ham the chimpanzee, the French sent Félicette the cat, and the Argentinians sent a rat named Belisario.

As for the Soviets, they launched a baboon, a gorilla, and an orangutan, all of whom gained amazing superpowers! At least that's what they did in comics. Along the way to the Moon, gleeful, curmudgeonly cosmonaut Ivan Kragoff plans to attain superpowers in much the same way as the famous heroic quartet the Fantastic Four: by exposing himself to mutagenic cosmic rays that buffet all ships leaving Earth's atmosphere.

In an apparent bid to achieve perfect symmetry, Kragoff loads his ship with a trio of apes, intending for them to gain superpowers as well. The simian commies are expertly trained to obey Kragoff's commands and perform (relatively) simple tasks. A gorilla named **Mikhlo** is capable of operating the spaceship, and the orangutan **Peotr** can use tools and effect repairs.

As for **Igor**, a vicious baboon, Kragoff has trained the violent primate to fire a machine gun. In what is possibly the most sublime single panel in superhero history, Igor is depicted firing a tommy gun in a makeshift firing range while Kragoff bellows grim encouragement. "Good—good!" he hollers. "Your heart is filled with hatred! Soon I may allow you to fire your weapons at a *real* target!" It's a stunning depiction of weird violence and a good example of what makes superhero comics such a strange and unique storytelling medium.

The cosmic rays do their job, giving Kragoff the power of intangibility and the inspiration to redub himself the Red Ghost. Mikhlo's already considerable strength is multiplied tremendously, allowing him to overpower the Fantastic Four's resident strongman, the Thing. Peotr develops "magnetic" powers that allow him to repel or attract objects and persons. Igor acquires the ability to change his shape at will. Naturally, for his first transformation, he becomes a gun.

The fearsome foursome still occasionally pop up in assorted corners of the Marvel Universe, despite a losing record a mile long. Their Soviet masters may be no more, but the Red Ghost and his Super Apes seem here to stay.

Created by:
Stan Lee and Jack Kirby

Debuted in:
Fantastic Four vol. 1 #13 (Marvel Comics, April 1963)

Partnered with:
The Red Ghost

Missed opportunity:
Not calling their group the Bananatastic Four

© 1963 by Marvel Comics

SUPER-HIP

"Down with Lawrence Welk!"

Created by:
Arnold Drake and
Bob Oksner

Debuted in:
*The Adventures of
Bob Hope* #95 (DC
Comics, October-
November 1965)

Partnered with:
Bob Hope

Raison d'être:
To keep Hope alive

© 1965 by DC Comics

WHO'S THE UNDISPUTED KING of the swingers, sworn enemy of all squares? Who's the ginchiest, the grooviest, the most far-out, the fabbest of the fab? The most marvelous mod to ever stride a scooter? It's Super-Hip, the coolest superhero in history! And we'd never have heard of him if not for your grandad's favorite comedian, Bob Hope.

Licensed comics starring celebrities of stage and screen were a common sight through the Silver Age. Dozens of celebrities, from Abbot and Costello to Jerry Lewis to Buster Crabbe, starred in eponymous comics. And for a considerable time, *The Adventures of Bob Hope* was one of the most successful of the bunch. But near the end of the series, the formula was beginning to age, and rather poorly. How to keep Hope afloat? Introduce a new factor that reflected contemporary youth culture. In other words: Super-Hip.

It all begins when Hope makes room in his suburban home for Tadwaller Jutefruce, the offspring of a college buddy. Tad prefers science to sports, poetry to prom, and psychology to socializing, looking down at his less-refined peers with their "parties" and "dates" and other such nonsense.

But the tightly wound Tadwaller can't control his temper. "I mustn't get angry!" he insists as his rage boils over. Whenever Tadwaller blows his lid, he is transformed into the lantern-jawed, mop-topped swinging Super-Hip, aka "the patron super-hero of all swingers!"

Super-Hip explains his transformation this way: "I don't swing at all unless [Tad] gets real angry and tries to bury it! That whacks up his glandular system—and *cool-o*—I'm here!"

While possessed of Super-Hip's tremendous powers—of which he has no memory once the transformation is reversed—Tad is capable of flight, superstrength, incredible toughness, and, well, anything else he imagines. He frequently changes shape into an array of absurd objects—a giant ice cream scoop, a lemon meringue pie, and many more. Super-Hip also boasts a Super-Guitar, as well as a terrible vulnerability: even a snippet of a Lawrence Welk song sends him into near-fatal collapse. "My heart! My brain!" he cries. "Can't see! Everything's growing very black—*and square!*"

Ultimately, the boost that Super-Hip gave to *The Adventures of Bob Hope* failed to last, and the title was cancelled. Super-Hip was capable of saving the party, but he couldn't save his series.

PART 2 "The 'COONSKIN CAP CAPER!'"

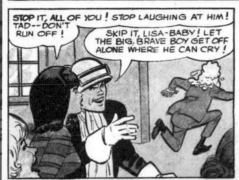

STOP IT, ALL OF YOU! STOP LAUGHING AT HIM! TAD--DON'T RUN OFF!

SKIP IT, LISA-BABY! LET THE BIG, BRAVE BOY GET OFF ALONE WHERE HE CAN CRY!

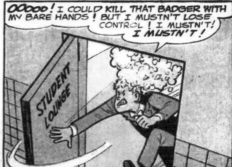

OOOOO! I COULD KILL THAT BADGER WITH MY BARE HANDS! BUT I MUSTN'T LOSE CONTROL! I MUSTN'T! I MUSTN'T!

STUDENT LOUNGE

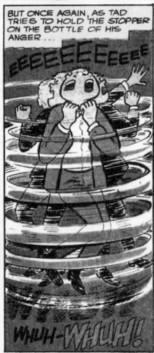

BUT ONCE AGAIN, AS TAD TRIES TO HOLD THE STOPPER ON THE BOTTLE OF HIS ANGER ...

EEEEEEEEEEE

WHUH--WHUH!

AND OUT OF THAT WAILING, WHIRLING PSYCHONEUROTIC FRUG APPEARS...

ME! SUPER-HIP! THAT WINNING NUMBER IN THE GAME OF HUMAN BINGO! THAT WHIPPED CREAM TOPPING ON THE CHOCOLATE PUDDING OF LIFE! THAT GLEAMING CHAMPAGNE GLASS IN A WORLD OF DIRTY DIXIE CUPS!

SUPERMAN JR.

"Golly, Dad, this sure is a super-picnic!"

JOHNNY KIRK JUST CAN'T catch a break.

His brilliant but misguided scientist father, Professor Morton Kirk, observes an asteroid barreling mercilessly toward Earth. Certain that this spells doom, Professor Kirk borrows a page from comicdom's most-famous origin story and launches *his* son into space, nestled safely inside an experimental rocket.

The Man of Steel's teenage incarnation—Superboy—saves Earth, but Kirk is left wracked with guilt. On his deathbed, the professor wrings a promise from the Boy of Steel: should lost Johnny someday return from the vastness of space, Superman would adopt him.

Inevitably, Johnny does return, more than a decade later. A man of his word in addition to a Man of Tomorrow, Superman abides by his promise and becomes Johnny's legal guardian. They have lots in common, because during his lengthy space journey Johnny acquired superpowers. Soon the boy dons a costume resembling a bellboy uniform from a Superman-themed hotel, and the pair flies into action as Superman and . . . Superman Jr.!

But Superman's powers have been rapidly failing; the radioactive space cloud that gave Junior his abilities also turned him into a super-sponge, draining the superpowers of his spandex-clad super-dad (much like ordinary children drain the energy of their ordinary parents). Refusing to see the world robbed of its greatest champion, Superman Jr. engineers a scheme to refuel the Man of Steel. "I spotted this meteor, made of a rare metal that can absorb all my super-energy," Johnny explains. "As you hold the 'positive' end, my super-energies flow into you! It's like a 'transfusion of power' from me to you!"

The plan works, returning Superman to his original might, but Johnny is divested of his powers. No longer "super," the boy is in constant danger from Superman's foes—meaning the adoption must be nullified. You'd expect Superman to arrange for an adoption by loving parents. However, the final scene shows the Man of Tomorrow abandoning a sobbing Johnny on a darkened street corner. To add insult to injury, he delivers this awkward parting line: "I'll never *choke* forget you, *Jimmy*."

It's an ignoble ending, but very typical of the era's Superman catalog. Themes of loss, the inevitable collapse of doomed relationships, and the ultimate decrepitude of youthful vigor were as tightly woven into the fabric of the 1950s and '60s Superman tales as were Red Kryptonite, imperfect duplicates, and fifth-dimensional imps.

Created by:
Jerry Coleman and Wayne Boring

Debuted in:
Action Comics vol. 1 #232 (DC Comics, September 1957)

Sidekick to:
Superman

Real name:
Definitely not "Jimmy"

© 1957 by DC Comics

THE MANY SIDEKICKS OF
SUPERMAN

BEING THE WORLD'S GREATEST SUPERHERO would seem to preclude Superman from ever needing a sidekick. After all, what could even a superpowered partner do that the Man of Steel couldn't handle himself? Nonetheless, Superman has boasted dozens upon dozens of sidekicks and junior partners over the years. Besides his famously freckle-faced cub-reporter pal Jimmy Olsen, for instance, he has also enjoyed the crime-fighting company of his cousin Supergirl, his boyhood pet Krypto, and a teenaged cloned "little brother" named Conner Kent—aka Superboy.

So persistent is the need for Superman to have an apprentice that these super-identities are frequently repurposed. Superman has allied himself with a number of Supergirls (and Super-Girls) over the years, ranging from an unpowered but courageous teenaged regent, to a protoplasmic entity from another dimension, to a real-life angel, to the product of a magic wish, to his alleged daughter from the near future!

Speaking of daughters, assorted imaginary stories have gifted Superman with dozens of speculative descendants. A domesticated Man of Tomorrow has played superpowered pappy to a veritable legion of sidekicking Supermaids,

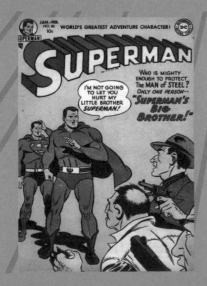

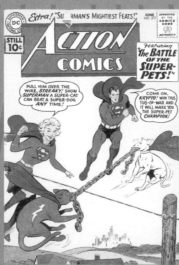

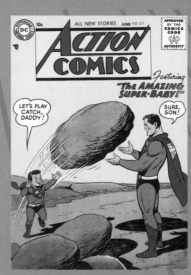

Superlasses, and Superman Juniors (such as the Super-Sons of Superman and Batman), not to mention a dizzying array of Clark Kent Juniors and Jor-El IIs.

He is also at times aided by the ant-sized agents of the Superman Emergency Squad, shrunken Kryptonians who emerge from the bottle city of Kandor to help out, and whole storerooms packed to the gills with lifelike Superman robots. Nor is his dog Krypto the only super-pet to fight at his side. In fact, Krypto was briefly partnered with an occasionally superpowered greyhound named Swifty! Even Superman's sidekicks get sidekicks.

Many of these characters have fallen by the wayside or been forgotten, owing to inevitable series reboots, deaths, or cosmic cataclysms. This may bode poorly for Superman's current kid sidekick—his biological son Jonathan Kent, the new Superboy. When you're a super sidekick, one month of flagging sales is the true kryptonite.

———

All artwork © DC Comics

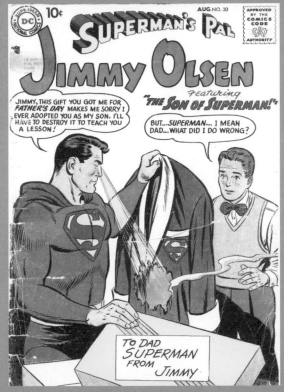

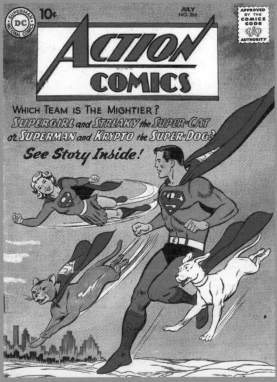

TABU

"Is it not comforting to know that one such as Thunderbolt is ever near . . . ?"

Created by:
Pete A. Morisi

Debuted in:
Thunderbolt #1
(Charlton Comics,
January 1966)

Partnered with:
Peter Cannon,
Thunderbolt

Fighting style:
Passive-aggressive

© 1966 by Charlton
Comics

SIDEKICKING IS PARTICULARLY DIFFICULT when your heroic partner is as reluctant to don his superhero togs as is Peter Cannon, alias Thunderbolt.

Cannon and his valet slash roommate, Tabu, were orphans raised in a Himalayan lamasery and trained in the arts of mental and physical excellence. Peter, however, surpassed his childhood friend, moving on to study ancient scrolls that contained the secrets of "the mysteries and power of the mind!" This allowed Peter the ability to super-actualize his intentions, overcoming any odds or obstacle with the mantra, "I can do it . . . I must do it . . . I will do it!"

Having attained the rank of Chosen One, Peter is sent to live in America, the country of his parents' birth, despite Peter's protestations. "I want no part of civilization," he complains, bitterly adding, "I will leave here with regret." Easing his decision is the fact that Tabu chooses to join him.

Peter and Tabu quickly settle in an abandoned mansion—festooned with secret passages—and Peter's freelance writing career provides a steady paycheck (perhaps the most preposterous element of the whole story). But when trouble calls, Peter adopts the red, black, and blue disguise of Thunderbolt!

Which is to say, Tabu makes him do it. He's very much the Alfred to Peter's Batman, providing that Alfred spent almost all of his time browbeating the Caped Crusader into doing his job.

Peter prefers to avoid any interaction with the cruelties of Western civilization. Fortunately Tabu proves to be a master of passive-aggression. He consistently raises the subject of superheroics. He places news bulletins of interest under Peter's nose and packs the Thunderbolt costume in Peter's luggage when they travel. In fact, the entire idea of Peter adopting the Thunderbolt disguise was Tabu's.

He also deploys unfettered guilt trips. When Peter balks at danger, Tabu chides him. "Your parents had no such feelings when they sacrificed their lives in the Himalayas! Neither did the ruling high abbot who saw to your development and entrusted you with the knowledge of the ancient scrolls . . . !" During a nearby catastrophe, he merely buzzes in Peter's ear: "Could not a Chosen One be of some assistance, friend Peter? . . . Can you deny the need of a vulnerable people?"

In all honesty, Tabu's name probably should have been foremost in the masthead. Without him, there never would have even been a Thunderbolt.

THE FOLLOWING DAY, PEACE REIGNS, IN A HILLTOP MANSION!

THE TABLOIDS, CONTAIN GLOWING REPORTS, OF YOUR RECENT ACTIONS, FRIEND PETER.

MMM...WHATEVER YOU DO, OLD BUDDY, *DON'T START READING OUT LOUD!* I DON'T THINK I CAN STAND A DITTO, RIGHT NOW!

THE CHILD, I WAS CONCERNED WITH, WAS SUCCESSFULLY ATTENDED TO, BY ONE OF THE CAPTIVES·YOU RELEASED, AND WILL RECOVER!

THAT IS GOOD NEWS! ACTUALLY THINGS WORKED OUT PRETTY WELL, FOR ALL CONCERNED...EXCEPT THE COBRA!

WHAT OF HIS FORMULA, AND THE SLAVES, PREVIOUSLY SOLD INTO BONDAGE?

THE POLICE LAB CAME UP WITH AN ANTIDOTE, AND THE ORIGINAL FORMULA HAS BEEN DESTROYED! FORTUNATELY, *THE COBRA,* KEPT A COMPLETE SET OF RECORDS, WITH THE NAMES AND ADDRESSES, *OF ALL HIS BUYERS!*

YOUR DISPLAY OF PLEASURE IS INDEED, MOST HEARTENING! DO YOU ACCEPT, NOW, YOUR DUAL ROLE, AS *THUNDERBOLT?*

NO THANKS, PAL! FROM HERE ON IN, I'LL TAKE MY ACTION IN TV FORM...MINUS THE TRAVELOGS, *THAT FEATURE SNAKES!*

IT WILL BE, AS YOU WISH, THEN! I WILL PREPARE MORE COFFEE, AND ATTEND TO THE DETAILS, INHERIT, IN THE *THUNDERBOLT* CASE BOOK!

YOUR TAKING IT LIKE A REAL CHAMP, TABU! JUST SAVE A LITTLE SPACE WHERE YOU CAN SCRIBBLE THE WORDS..."*THE END!*"

WITH DUE RESPECT, FRIEND PETER...I'VE ALREADY INSCRIBED THE WORDS..."*TO BE CONTINUED!*"

END

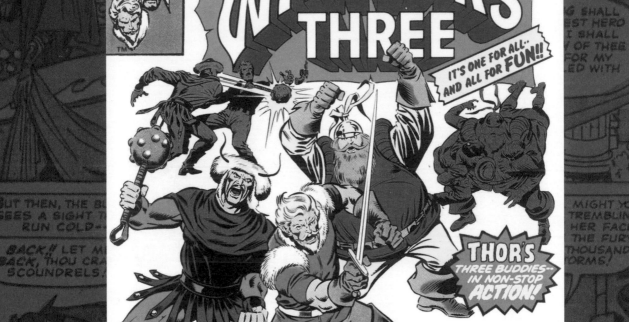

VOLSTAGG THE VOLUMINOUS

"The mere sight of my noble self makes strong men tremble!!"

THE MYTHICAL WORLD OF Asgard is robustly populated. In addition to the figures imported from Norse tradition—like Odin, Balder, Hel, Sif, and, of course, Thor and Loki—there's seemingly no end of original characters inhabiting the regal realm. Chief among the latter are the Warriors Three, who have enjoyed a lengthy career as boon companions of Thor, God of Thunder. And among the three, the most noticeable and unforgettable must be Volstagg, Lion of Asgard.

Along with voluminous Volstagg, the trio consists of grumpy mace-wielder Hogun the Grim and swashbuckling swordsman Fandral the Dashing. While Marvel's Thor comics were ostensibly based on Norse legends, the Warriors Three bore immediate resemblance to Alexandre Dumas's titular *Three Musketeers*, and Fandral in particular seems cosmetically modeled on sword-swinging Hollywood icon Errol Flynn. But it's Volstagg who steals the show, which is appropriate considering that Shakespeare's John Falstaff was the inspiration for the often-buffoonish, larger-than-life, big-bellied warrior. Volstagg, as the saying goes, is "large and contains multitudes." Often portrayed as a clumsy, fearful, bragging oaf, he's also capable of great bravery, and his boasts often held some truth.

And you can't accuse Volstagg of lacking self-confidence. On one occasion, at the site of a full-fledged battle, Volstagg shouts from the safety of a parapet to his friend Thor: "Fear not, Thunder God! Thou hast the support of invincible Volstagg!" Practically buried under his opponents, Thor snaps back: "A few stout blows from thy hand would not be amiss either, enormous one!"

Nonetheless, Volstagg proves time and again to be a mighty warrior, well worthy of his own spiel. That so many of his victories involved him tripping over, stumbling through, or sitting on his foes is irrelevant. He has defeated villains such as Zarko the Tomorrow Man, the Grey Gargoyle, and hosts of Asgardian menaces—so he must be doing something right!

Volstagg's greatest acts of heroism were inspired by his great, soft heart. On several occasions, he proves willing to sacrifice himself on behalf of his friends and undertakes terrifying adventures on their behalf (complaining all the way). Additionally, despite siring a brood of fifteen very active children, he does not hesitate to adopt two orphaned Earth children in their hour of need. In many ways, Volstagg is a classic hero relegated to sidekick status: packed with plentiful faults and shortcomings, but happily possessed of an indomitable and noble spirit.

Created by:
Jack Kirby and Stan Lee

Debuted in:
Journey into Mystery #119 (Marvel Comics, August 1965)

Sidekick to:
Thor; the other two Warriors Three

Waist measurement:
200+V

Shirt size:
20XL

Cap size:
Actually, it's normal size. Weird.

© 1965 by Marvel Comics

WILLIAM

"I hate to do this, sir . . . but it's this . . . or a bullet!"

Created by:
D. J. Arneson and
Tony Tallarico

Debuted in:
Frankenstein #2
(Dell Comics,
September 1966)

Partnered with:
Frankenstein

Butlering duties:
Answering the door,
light dusting, gorilla
control

© 1966 by Dell Comics

A **DEBATE HAS BEEN RAGING** ever since the theatrical release of *Frankenstein* in 1931 (if not since the original book was published in 1818): Is the creature "Frankenstein" or "Frankenstein's monster"? For that matter, would the creature's personal butler be "Frankenstein's monster's gentleman's gentleman"?

The Frankenstein in question here isn't the literary or cinematic figure, but rather a short-lived superhero—who, along with a spandex-clad Dracula and an espionage-savvy Werewolf, constituted a significant portion of publisher Dell's very limited catalog of superhero comics. This Frankenstein wakes in an abandoned laboratory in the year 1966 as a confused creature who ponders the mystery of his existence. Being a superhero comic, of course, these existential conundrums have a simple answer: start fighting crime!

Soon, Frankenstein saves the life of a fragile old man who also happens to be tremendously wealthy. This benefactor leaves Frank his considerable fortune and, along with that, his trusted manservant and family factotum William.

Among normal folk, the green-faced golem disguises himself with a life-like rubber mask and takes the transparent pseudonym Frank Stone. William serves his master for a short time before stumbling onto his secret identity—rather literally. One day when he thinks William is out, Frank wanders around with his mask off. Spying his master's pale-green profile, William connects two and two. And like the best valets, he chooses to assist his employer in both of the stitched-together titan's identities.

Most of William's responsibilities lie in keeping Frankenstein's secret safe from the prying, persistent Miss Ann Thrope (you read that correctly). When he saves her from a rooftop assault, Ann immediately—somehow—intuits that husky Frank Stone may be the heroic Frankenstein.

In the course of his service, William chauffeurs the hero, takes his lumps from assorted bad guys (including Bruto the gorilla) and even disguises himself as Frankenstein to throw an evil computer off their scent. On one occasion, William musters considerable strength and bravery and conks Frankenstein on the head with a pipe wrench when the horrific hero is briefly mind-controlled. This is all above and beyond the call of duty, surely. One hopes that William draws hazard pay.

EDITOR'S NOTE

Dell's other monster superheroes also boasted sidekicks. Dracula shared the company of socialite and judo expert B. B. Beebe—alias Fleeta. Werewolf was accompanied on his adventures by Thor, a feral wolf.

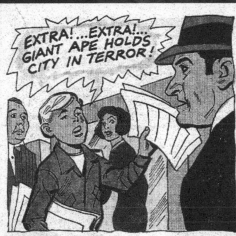

EXTRA!...EXTRA!... GIANT APE HOLDS CITY IN TERROR!

MR. STONE WILL WANT TO SEE THIS. HE IS A STRANGE MAN... ALMOST AS IF HE WERE SOMEONE ELSE.

MR. STONE... WHAT? WHO ARE YOU!

WILLIAM! YOU WEREN'T DUE BACK FOR AN HOUR!

WILLIAM IS INCREDULOUS AS HIS EMPLOYER RELATES A STRANGE TALE...

I..I DONT BELIEVE IT. YOU... YOU ARE...

YES, WILLIAM, I AM FRANKENSTEIN. BUT MY SECRET MUST BE KEPT AT ALL COSTS. THE SAFETY OF THE ENTIRE WORLD MAY DEPEND ON IT.

IT'S TERRIBLY HARD TO BELIEVE ...BUT I'LL DO WHATEVER YOU SAY.

GOOD, WILLIAM. HURRY. WE MUST LEAVE FOR SEA-BOARD CITY, THE LAST PLACE THE BEAST WAS SEEN.

DETECTIVE COMICS

FORGET IT, LITTLE FRIEND! NOW GO BACK TO THE HIDEAWAY--AND MAKE SURE YOU DO!

IT'S TIME I REPORTED FOR DUTY AS DETECTIVE JONES!

BUT SHORTLY, AS ZOOK STARTS BACK ALONE, HE IS SPOTTED BY PATROLWOMAN DIANE MEADE...

WHY, ZOOK! HOW NICE TO SEE YOU AGAIN! WHERE ARE YOU GOING?

BACK TO HIDE-OUT WHERE MANHUNTER TELL ME!

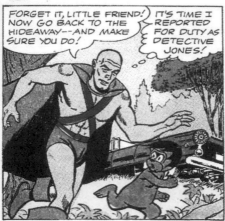

OH, YOU CAN GO THERE LATER! COME ON, I WANT YOU TO MEET THE CHIEF AND DETECTIVE JONES!

BUT... BUT...

LATER, AT HEADQUARTERS...

I'M VERY HAPPY TO MEET YOU, ZOOK!

AND HERE COMES DETECTIVE JONES NOW!

BUT AS THEY COME FACE TO FACE...

EEKS!

NEXT INSTANT...

WHY-- LITTLE ZOOK DIDN'T SEEM TO LIKE YOU ONE BIT, DETECTIVE JONES!

HMM... THAT'S NOT THE REASON! HE MUST HAVE RECOGNIZED ME AS THE MANHUNTER-- AND BEAT IT BECAUSE HE DISOBEYED MY ORDERS!

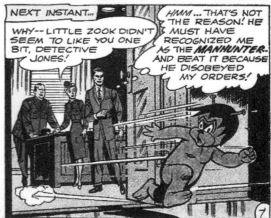

7

ZOOK
"Emanations getting stronger!"

BOASTING AN ARRAY OF SUPERPOWERS, J'onn J'onzz—aka the Manhunter from Mars—seems to have little need for a sidekick. Besides super-strength and the ability to fly, J'onzz was nearly invulnerable; he could walk through walls, become invisible, and change shape. He made Superman seem practically like a weakling . . . except for his aversion to fire in all forms.

Perhaps that's why the Manhunter picked up a fireproof pal. Standing no taller than a toddler, the alien Zook boasted his own astonishing range of powers. In his first appearance, Zook astounds J'onn J'onzz by flattening himself like a deflated balloon and using his temperature powers to burn the feet of other-dimensional criminals. Zook additionally possessed a unique tracking ability, thanks to the antenna-like "ears" jutting from the top of his head. He explains, in a halting and inconsistently eloquent patois: "See ... I receive—uh—electrical emanations all people give off! I 'remember' with me ears! Then I can 'tune in' on person when I want to!"

That's an impressive monologue considering that Zook came to Earth from an alternate dimension speaking only his native language. One of a species of "mischievous little animal(s)" native to another plane of reality, Zook was accidentally left behind when a temporary space portal closed permanently.

Luckily, J'onzz takes to Zook immediately, "adopting" the inarticulate orange alien as a pet and confidante. He teaches Zook to speak English, although the little fellow's dialect is a curious concoction. Given to exclamations like "Okey Dokey!" and sporadic repetition ("That the truth . . . that the truth!" he affirms on one occasion), Zook can nevertheless expound at greater length on complicated topics. Zook is complicated.

Despite his small stature and childlike nature, Zook is instrumental in helping J'onn J'onzz defeat everything from bank-robbing robots to cosmic monsters, not to mention plain ol' vanilla crime lords and crooks. His assistance was most vital, though, when battling the Idol-Head of Diabolu, an ancient Babylonian artifact that released an inventive series of magical menaces and dominated the book's storyline for several months.

But once Diabolu had been defeated, Zook's star quickly faded. The curious little creature vanished unceremoniously, without explanation or further mention. It seems a disappointing departure for a character who provided such a valuable service to an almost all-powerful superhero. But as Zook might say: "Okey Dokey!"

&

Created by:
Jack Miller and Joe Certa

Debuted in:
Detective Comics vol. 1 #311 (DC Comics, January 1963)

Partnered with:
J'onn J'onzz, the Martian Manhunter

Possible lineage:
A Smurf crossed with the Great Gazoo

© 1963 by DC Comics

THE MODERN AGE
1970 - PRESENT

BY THE 1970S, COMICS WERE considered to have grown up. The stories were concerned with social movements, cultural touchstones and traditions, criticisms of the status quo, and hard, unflinching looks at what it meant to be a superhero in a world of moral ambiguity. Heroes were more likely to kill, villains were more likely to have sympathetic backstories. There simply should not have been room for junior partners or thematically costumed goons in a world like this. And, yet—there was! Sidekicks and henchpersons continued to thrive and multiply in this increasingly grim era.

Admittedly, many of these partners and minions were intended as tools for wry and incisive satire. The helpless, sometimes needless kid sidekick was a convenient instrument for lancing the entire concept of superheroes. Likewise, a throng of lackeys dressed like lightbulbs or musk ox drew a defining line under the simplistic giddiness of comic-book supervillainy. Often, though, these familiar archetypes were revived out of pure affection. Comics of this era exhibited little patience for kitsch, but even the most parodic sidekick incarnations were scripted with some degree of warmth and fondness.

What does tomorrow hold for sidekicks—comicdom's second bananas, the unpaid interns of the long-underwear crowd? Perhaps unsurprisingly, their future seems secure. These supporting characters continue to thrive in a modern environment that on the face of things seems toxic to their survival. And that suggests they'll play their part in comics for the foreseeable future, providing invaluable—if sometimes regrettable—assistance.

THE BLACK MUSKETEERS
"All for one, and one for all!"

Created by:
Jack Kirby

Debuted in:
Black Panther vol. 1
#9 (Marvel Comics,
May 1978)

Partnered with:
Black Panther

Specialties:
Monster fighting,
squabbling,
wondering when the
king will be back

© 1978 by Marvel
Comics

MARVEL'S LONG-RUNNING AFROFUTURIST SUPERHERO Black Panther has developed a rich backstory and supporting cast since his 1966 debut. This will serve him well as a newer member of the sprawling Marvel Cinematic Universe, but it's unlikely that his Black Musketeers will ever find themselves immortalized on film.

As regent of the super-advanced civilization of Wakanda as well as a globe-trotting superhero, Black Panther, alias T'Challa, has a full plate of responsibilities and sometimes is called away from the borders of his hidden kingdom. When that happens, it's time to call in the Black Musketeers.

Each of this quartet of stand-in Panthers shares T'Challa's bloodline. In times when the kingdom faces extreme danger, they're obligated to—at least temporarily—adopt Black Panther's mantle. When T'Challa's half-brother Jakarra is transformed into a rampaging monster, the task of stopping Jakarra falls to four of the Panther's relatives—not one of them truly suited for the superheroic lifestyle.

Handsome, athletic **Khanata** overtly refuses to stand in for the missing king. "I simply drive fast cars," he explains. Dignfied **Ishanta**, an "aging financier," considers himself too old to enter battle. "Can you imagine me dashing about with spear and shield?" he asks incredulously. Youthful **Joshua Itobo** (also Joshua M'tobo), a medical doctor, prefers to use his skills to heal rather than fight. Nonetheless, he's brave enough to battle his monstrous cousin using only a burning magazine. Lastly, bombastic, powerful, and proud **Zuni** is derisively referred to as "a female grown too fat" by the much-put-upon adviser to T'Challa.

Individually they're found wanting. But together, the royal cousins make for an exceptionally effective group of substitute champions. "Are we not of the ruling family?" summarizes Joshua, proud of having routed Jakarra during the man-monster's initial rampage. "Are we not kin of mighty T'Challa?" In fact, it's Joshua's "Anti-Sonic Toxin" that ultimately defeats the rampaging mutant, albeit wielded by the original Black Panther (who returns to Wakanda just in the nick of time).

With T'Challa reinstated on the throne, the need for the Black Musketeers vanished. But certainly the group's excellent teamwork makes them suitable for occasional support. After all, per their version of the classic "One for all and all for one!" cry: "We're alive because each of us did his part for the other!"

THE BRAT PACK

"Okay, okay. Let's see what this 'painful truth' s--- is all about."

WHEN REFLECTED UPON WITH the benefit of analytical distance, the kid sidekick inherently seems like a bad idea. In a sane world, adult vigilantes who dress young people in colorful costumes and sic them on spies, saboteurs, enemy agents, crooks, crumb bums, gangsters, racketeers, alien invaders, robot monsters, and vile villains of all stripes would be a matter for the police. But superhero comics embrace a sublime innocence in which the impossible happens with noble optimism. This is true of almost every era—except the 1980s.

In the '80s, creators unleashed uncompromising, brutal, and highly satirical deconstructions of de facto superhero tropes. Books like *Watchmen* and *The Dark Knight Returns* made hay of the unlikely origins and muddled morality that lurked beneath the comics of previous eras. Meanwhile, fans actually ordered the demise of Batman's second Robin, Jason Todd, by calling a phone number and voting.

The apparent bloodthirstiness of the crowd and corporation who dominated the comics world directly informs the content of artist and writer Rick Veitch's *Brat Pack*. His violent, narcissistic quartet of second-generation sidekicks were a grotesque parody that lampooned not just familiar and noble comic book heroes, but the readership and the environment that bred them.

Who were the Brat Pack? **Chippy**, arguably the leader, was the skittish sidekick of the sybaritic Midnight Mink. Their relationship was a knowing callback to anti-comics crusader Frederic Wertham, who criticized what he considered to be distasteful sexual overtones in the undeniably chaste adventures of Batman and Robin.

Kid Vicious was the steroid-riddled sidekick to Judge Jury. Together they were stand-ins for ultra-patriotic superheroes like Captain America and Bucky, reimagined as white supremacists and overt fascists.

Luna was subordinate to Moon Mistress, a man-hating woman warrior who claimed her enemies' testicles as trophies. Struggling to fit the expectations of thin, beautiful teenage superheroes, Luna binged and purged to maintain her figure.

Lastly, there was **Wild Boy**, whose relationship with thrill-seeking multimillionaire King Rad directly recalled the partnership of Green Arrow and Speedy—particularly the latter's infamous story arc as a heroin addict.

The Brat Pack were more hostile to one another than to their opponents, arrogant and brutal—much as, it appears, fans at that time wanted.

Created by:
Rick Veitch

Debuted in:
Brat Pack #1 (King Hell, August 1990)

Partnered with:
The heroes of Black October

Is Molly Ringwald in this?
Wrong brat pack

© 1990 by Rick Veitch

CHEEKS THE TOY WONDER
*"Your mother darns socks in hell!"**

Created by:
Robert Loren
Fleming and Keith
Giffen

Debuted in:
Ambush Bug vol. 1
#1 (DC Comics,
June 1985)

Partnered with:
Ambush Bug

Kind of partner:
Silent

© 1985 by DC Comics

BY THE 1980S, THE TRADITIONAL junior superhero had become laughably anachronistic. The strategy of stuffing kid assistants into Halloween costumes and sending them into battle against gun-wielding goons and world-conquering maniacs had apparently run its course. In this tongue-in-cheek spirit, Cheeks the Toy Wonder was born.

Silent, unseeing, and in fact just a discarded plastic doll, Cheeks didn't do much in the way of saving the day. His senior partner and "adoptive father" was Ambush Bug, an absurdist, chaotic character whose stock in trade was satirizing the sillier corners of the DC Comics universe while embarking on frenetic, increasingly nonlinear adventures of his own. His enemies included everything from an evil sock to a forty-foot-tall radioactive koala. But the *Ambush Bug* comic trafficked more in slapstick than in superhero battles. This made Cheeks his perfect sidekick.

When a passing garbage truck hits an unexpected pothole, a tossed-away toy baby doll—resembling the then-prominent Cabbage Patch Kids—crashes through the window of Ambush Bug's unsuccessful detective agency. "It's an omen!" he declares with great certainty. "You'll be my ward and my partner in the lonely fight against crime!"

Being an inanimate object, Cheeks was called on to do little more than be tossed from one place to another or sit on the sidelines. Of course, this was part of the gag. Cheeks was no less useful than many of the kid sidekicks whose careers largely comprised being captured by bad guys or requiring rescue by their respective heroes.

Not that Cheeks didn't enjoy a storied existence. In the unpredictable pages of assorted Ambush Bug miniseries and one-shot issues, Cheeks seems to live a thousand lives. Presumed dead after failing to defuse a time bomb, he returned often in different roles: revived from death as a cannibal zombie (meaning he ate other dolls); serving as a combat medic in World War II; possessed by both the devil and the dreaded OMAC virus. He even spent time as a decapitated hunting trophy hanging on a wall. It's not always glory in the world of sidekicking.

The irony of Cheeks is that he achieved greater longevity and popularity than some of DC's lesser-known junior superheroes, despite their ability to move, speak, and think.

*Spoken by Cheeks while possessed by the devil; otherwise, Cheeks did not speak.

♪ HERE HE *COMES*, HERE HE *COMES*, THAT *CUTE* LI'L CUT-UP CALLED ♪

CHEEKS

The **TOY** ♪ **WONDER**

ONE COLD AND BLUSTERY DAY, CHEEKS WENT OUT TO PLAY IN THE SNOW.

HE PLAYED HIDE-AND-GO-SEEK WITH FLATFOOT, THE FRIENDLY NEIGHBORHOOD COP.

HE PLAYED SO HARD THAT HIS TUMMY BEGAN TO RUMBLE.

THEN A COPY OF WHO'S WHO FELL OUT OF A STOREY MAN AND HIT CHEEKS RIGHT IN THE HEAD!

POOR LITTLE CHEEKS DIDN'T KNOW HOW TO READ...

...BUT HE KNEW ENOUGH

YUMMY, YUMMY!! CHEEKS SAID

CHEEKS DECIDED HE'D TRY TO LOCATE THIS LARGE PLAYMATE.

CULT OF THE CLAW

"Hail America . . . and hail to the Claw, he who will save it!!"

IN THE 1970S, THE SO-CALLED Bronze Age of comics introduced gritty realism to the genre. From this point on, the comics landscape resembled the front page of the daily newspaper. Superheroes faced drug runners, teenage runaways, street gangs, cults, pollution, protests, political corruption, and an array of other late-twentieth-century ills and menaces. And nowhere were these conflicts concatenated more than in the pages of *Hell-Rider*, whose eponymous star was known as "the NOW super-hero!"

The cover of Hell-Rider's first issue could not be more garish and gruesome. The book's leather-clad hero jumps his motorcycle over a sand dune while two beauties in bikinis cling together in the background. A hooded man fires his handgun at the hero, who at the same moment blasts two armed, costumed cultists with the bike's front-mounted flamethrower. "Hell-Rider battles the heroin-spawned terror of . . . the *Claw*," reads the blurb beneath the action. Subtlety is not the book's strong suit.

The burn-victims-to-be depicted on the cover are, in fact, cultists under the command of the hooded Claw—and burning is the kindest thing done to them in this book. Dressed in cat costumes, the unlucky henchmen are at various points run over, crushed under a bookshelf, thrown from a helicopter, and beaten within an inch of their lives. This should be required reading for anyone considering a career in the henching arts.

On the other hand, if anyone deserves that sort of treatment, it's these fellows. The underlings are assigned to recover a pair of boots which have "a million dollars' worth of raw heroin sewn into the lining." This is part of the Claw's plan to encourage mass overdoses among the drug-happy subculture of the era while funding his campaign to conquer America—on behalf of America.

"These . . . are the very vermin which are eating out the heart of our country," the Claw declares. "And it is they and the thousands like them who must be destroyed . . . if America is to remain the Home of the Free!" This results in a cheer and salute from the crypto-fascist kitty cats of the Claw's cult.

Ultimately, what leads to the cultists' defeat is not the terrific amounts of abuse they endure but, instead, poor economics. When the missing heroin causes a temporary inability to issue paychecks to his hirelings, the Claw is abandoned and left to fight his foes alone. There seems to be a lesson in there, somewhere.

Created by:
Gary Friedrich

Debuted in:
Hell-Rider
#1 (Skywald
Publications,
August 1971)

Henchmen to:
The Claw

Taxable status:
501(c)(3), probably

© 1971 by Skywald
Publications

D-MAN

"Cap! Oh man, am I glad to see you!"

Created by:
Mike Carlin and
Ron Wilson

Debuted in:
Captain America
#328 (Marvel
Comics, April
1987)

Partnered with:
Captain America

Costume choice:
D-rivative

© 1987 by Marvel
Comics

OSING HIS SIDEKICK BUCKY to the deadly schemes of a Nazi villain haunted Captain America for much of his subsequent career. Following Cap's revival in the 1960s, he was slow to accept new allies and partners. Nonetheless, he adopted more than a few in his crusade against crime (see page 204 for a few examples). One of these subsequent subordinates was D-Man, a superstrong wrestler with a yen for wearing other heroes' costumes.

This tendency was called out in D-Man's first appearance. "Daredevil?" asks the cover copy. "Nope! Wolverine? Uh-uh! It's D-Man!" His costume was in fact a deliberate mash-up of the original togs of sightless vigilante Daredevil, with a mask resembling the flared cowl of popular X-man Wolverine. The reason for the mash-up: he was a fan. Or an early adopter of the cosplay aesthetic, if you prefer.

Genetically enhanced super-wrestler Dennis Dunphy had been hanging around the Marvel Universe for a while before adopting his costumed alter ego of Demolition Man (aka D-Man or Demo for short). A football hopeful who'd undergone mysterious scientific treatments to enhance his strength to incomprehensible levels, the stocky rookie spent a few years in the wrestling ring, facing inhumanly powerful opponents like the Fantastic Four's strongman the Thing and a nearly omnipotent cosmic meddler called the Beyonder. Captain America tutored the burly bruiser, but you'd be forgiven for thinking that the captain could have been more enthusiastic about his new, wildly powerful partner. Cap frequently responds to D-Man's lengthy, occasionally rambling questions and comments with terse, one-sentence replies. When D-Man asks Cap's opinion as to whether his superhero name passes muster, the living legend of World War II replies economically, "That's fine."

Whereas most superheroes—sidekicks or not—have experienced a traumatic or defining event that sets them on the road to a costumed career, D-Man seems to adopt the role only because he likes to feel useful and to be of assistance to those in need. On occasion, this has been to his credit: he's sacrificed home and hygiene to protect a homeless community of so-called Night People. However, his good nature also leads him into situations in which his powers can be used for unsavory purposes by evil people. Despite Captain America's tepid affection for his onetime partner, D-Man seems like a sidekick who desperately needs a senior partner's advice and guiding hand.

THE MANY SIDEKICKS OF CAPTAIN AMERICA

DESPITE THE LOSS OF his good friend and confidant Bucky in the final days of World War II, Captain America continues to populate his professional career with sidekicks, partners, and superhero trainees. Perhaps his strong sense of duty compels him to prepare the next generation of heroes. Or perhaps being a captain is no fun if you don't have someone to boss around.

For many years, Captain America shared an equal partnership with Sam Wilson, also known as the high-flying Falcon. This was evidenced in the masthead when the Falcon shared bill-ing with the veteran superhero. In recent years Wilson even took on the Captain America persona, albeit temporarily, and he's also made the leap into the Marvel films alongside his fellow Avengers.

Prior to that, Cap reluctantly taught perennial sidekick Rick Jones to adopt the role of a shiny, new Bucky for a new generation. Like most of Jones's associations, this was a relatively short one (see page 174).

The gritty Nomad, aka Jack Monroe, had the opportunity to sidekick for not one but *two* Captains America. Besides partnering as Nomad with the classic Steve Rogers cap-

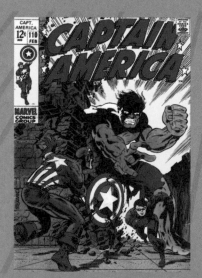

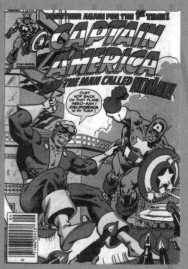

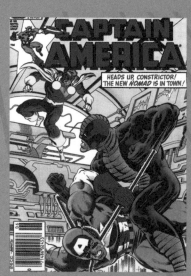

tain, Monroe began his career as a sidekick to the commie-bashing Captain America of the 1950s. This was a replacement Cap, fighting evil while the original was frozen in an ice floe. After undergoing suspended animation, Monroe emerged in modern times to partner up with today's Cap (the original, now unfrozen). Confused? Consider that the first Nomad was Captain America himself; he created that persona when he temporarily abandoned his flag-clad identity.

Many more have been taken under Cap's shield-bearing wing. Patriotic tryhards like Jack Flag, Free Spirit, and Vagabond have tested their mettle as Cap's number two, and another replacement Captain America enjoyed adventures in the late '40s in the company of a romantically inclined superheroine named Golden Girl. It's also worth mentioning that the star-spangled hero led a version of the Avengers informally known as "Cap's Kooky Quartet," in which he taught former baddies Hawkeye, the Scarlet Witch, and Quicksilver to be heroes. And as many know, in the modern era Bucky has returned as the Winter Soldier, a popular and high-profile fixture of the Marvel Cinematic Universe. With so many amateur Avengers and would-be heroes-in-training coming to Captain America to improve their skills, it's fair to say that Captain America could hardly be better sidekicked.

All artwork © Marvel Comics

THE 8-BALL GANG

"B-boss, who is this guy? H-he looks freakier than we do!"

T HE BEST HENCHMEN ARE thematic. It's just common sense: dressing your criminal subordinates in matching costumes, assigning them a selection of coy code names, and arming them with identical weaponry raises your status as a supervillain. And when your sinister gimmick is that you have the head of an 8-Ball, then the theme for your goons is already cued up!

How the criminal known as 8-Ball chose which numbers to assign to his trio of henchballs—specifically, Six, Nine, and Eleven—isn't revealed. Perhaps he was merely establishing the foundation for an eventual full rack of fourteen minions (the maximum that a billiards theme allows, not counting the cue ball, which would be ridiculous to include). At least he featured in his initial team of assistants one stripe and one solid, which are required for the corners of the rack at the start of a game. Chalk it up to an eye for detail.

When we meet 8-Ball, he is a largely law-abiding citizen named Jeff Hagees who designs propulsion systems for an American defense contractor. When he racks up severe gambling debts, his employers worry that he might sell trade secrets to raise cash and so they give him the shaft. This bad break sinks his reputation, so 8-Ball decides to table a difficult job hunt. Instead he develops a force-increasing pool cue and begins his absurd new career as a billiards-themed supervillain.

Where 8-Ball recruited his assistants is unrevealed, but at least one of them is exceptionally enthusiastic about the position: Nine, decked out in lurid yellow, is a constant booster to his boss's every utterance. He's also trigger-happy. When their bank robbery is foiled by the other-dimensional super-cop Sleepwalker, Nine panics and launches an explosive pool ball—a "ball bomb"—at his foe. It's not a very good bank shot (even though it occurs in a bank).

Eleven and Six don't speak, but one assumes they provide valuable moral support simply by their presence and carry the bags of stolen loot. Once the robbery is over, they join 8-Ball and Nine in the flying "hover-rack" and escape.

As often happens, the henchmen are later dropped from the act, though 8-Ball makes several return appearances. What happened to his crew is a mystery. Perhaps he keeps them in the corner pocket.

Created by:
Bob Budiansky and
Bret Blevins

Debuted in:
Sleepwalker #2
(Marvel Comics,
July 1991)

Henchmon to:
8-Ball

**Current
whereabouts:**
Waiting for their cue

© 1991 by Marvel
Comics

ELF WITH A GUN

"You're lucky my curiosity got the better of my homicidal tendencies, you bozos."

Created by:
Steve Gerber and
Sal Buscema

Debuted in:
The Defenders
vol. 1 #25 (Marvel
Comics, July 1975)

Henchman to:
The Tribunal
(maybe; see below)

**Modus operandi,
mission, and
motive:**
Random, confusing,
absolutely baffling

© 1975 by Marvel
Comics

BACK IN THE '70s, Marvel Comics' *The Defenders* was a wild and interesting series. A rosterless "non-team" mixing third-tier heroes with A-listers, the Defenders faced off against evil self-help cults, demonic deer, trademark infringement, a man dressed as a walrus, and—as frequently as anything else—one another. The book entertained a lengthy subplot wherein the Hulk obsessively sought out and consumed his favorite food, canned beans. Very little seemed too outré or bizarre. Which brings us to the Elf with a Gun.

This homicidal sprite in a pointed cap appeared sporadically throughout a handful of individual issues of *The Defenders* during the 1970s. Popping up from nowhere in short scenes divorced from the main plotline, the elf would aim his evidently ordinary revolver at random individuals and then vanish without explanation. In the space of twenty issues, he ended the lives—off-panel, for decorum's sake—of Vegas tourists, musical homebodies, and harmless hikers, with no apparent rhyme, reason, or connection among the murders.

The elf's role has always been a matter for debate. Perhaps he was meant to lampoon the random and meaningless violence that typified the superhero genre. But he might have merely been an absurdist interjection into the well-trod good-versus-evil formula that is so often embraced by comic books. Or maybe he was a gimmick intended to wind up fans; letters printed in *The Defenders* reveal that the elf was a frequent topic of conversation—and consternation—among the readership.

Whatever the intended payoff, the audience was denied a definitive answer. In his final appearance, while aiming his weapon at one last target, a newspaper boy in mid-delivery, the elf is unceremoniously flattened by a passing truck.

Generally, comics leave few plot points unexplained. Years after this unsatisfying (although strangely fitting) conclusion, the elf was retroactively revisited, and his role as henchman to a cosmic agency was revealed. A new writer created an entire cadre of fully armed elves, who traversed the timeline on behalf of an institution called the Tribunal, tasked with removing seemingly innocent entities from reality in order to prevent a cosmic catastrophe. But then a *third* writer came along and declared that the Tribunal and its mission were nothing but a tremendous hoax. And so the absurd mystery carries on . . .

VAL, OF COURSE, HAS ALREADY BEEN RESCUED, SO LET'S SKIP THE SCENE IN WHICH THE TEAM DISCOVERS THAT--

TRAILER CAMP

--AND TURN OUR ATTENTION INSTEAD TO THIS MOBILE HOME PARK IN THE WOODLANDS OF CALIFORNIA.

IN PARTICULAR, LET US FOCUS ON THE HOME OF YOUNG TOM PRITCHETT AND WIFE LINDA.

--TAKE ME HOME, COUNTRY ROADS--

--WHOSE QUIET EVENING IS SUDDENLY INTERRUPTED.

NOK NOK

OH, NO.

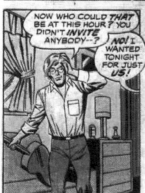

NOW WHO COULD THAT BE AT THIS HOUR? YOU DIDN'T INVITE ANYBODY--?

NO! I WANTED TONIGHT FOR JUST US!

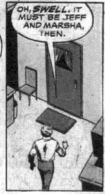

OH, SWELL. IT MUST BE JEFF AND MARSHA, THEN.

THEY'RE THE ONLY ONES I CAN THINK OF WHO'D DROP IN WITHOUT CALLING FIRST.

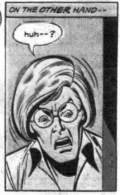

ON THE OTHER HAND--

huh--?

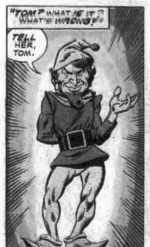

"TOM? WHAT IS IT? WHAT'S WRONG?!"

TELL HER, TOM.

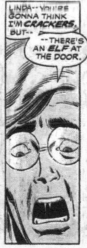

LINDA-- YOU'RE GONNA THINK I'M CRACKERS, BUT--

--THERE'S AN ELF AT THE DOOR.

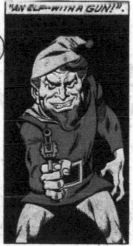

"AN ELF-- WITH A GUN!"

BLAM

17

FAST WILLIE JACKSON'S FRIENDS
"You gotta be jiving!"

THE TEEN HUMOR COMIC is a long-standing and fruitful tradition. Along with, obviously, Archie Comics titles, successful examples include the long-running *Swing with Scooter*, *Binky's Buddies*, and *Date with Debbi* from DC Comics. Likewise, Marvel Comics titles such as *Millie the Model* and *Patsy and Hedy* produced characters that still pop up to this day.

Not as often remembered is *Fast Willie Jackson*. Fitzgerald Periodicals largely focused on educational titles that explored African American history. But their teen-humor venture occupied a space that comics rarely explored, having an almost exclusively African American cast that was peppered with other underrepresented identities.

Fast Willie was the Archie of the group, a luckless but good-hearted all-American kid. His supporting cast was a daffy bunch defined by exaggerated characteristics; some served as sidekicks, others as rivals, and these roles could shift from one story to the next. His Jughead was **Jo-Jo**, who took every obstacle in stride. Willie's primary rival, **Frankie**, attracted the attention of every girl in town, including **Dee Dee Williams**, the strip's Betty/Veronica hybrid character. Their musclebound Moose was beefy **Hannibal**; authority figures included **Officer Flagg** (called either "the man" or "the sheriff" by Willie's friends) and teacher **Ms. Jane Fronda**. The gang hung out at a soda shop owned by the put-upon **José Martinez**. They even had a Sabrina of sorts in the form of local fortune teller Sister Zola's Caribbean niece **Cleo**. And utterly unique to the world of *Fast Willie Jackson* was **Jabar**, a black militant whose constant comedic outrage provided some of the more questionable laughs in the series.

Unfortunately the book lasted seven issues, only briefly filling a sorely felt vacuum. Archie Comics had just recently added their first African American character, Valerie (see Pepper, page 170). And the most prominent African American teen-humor personalities of the decade, *Fat Albert and the Cosby Kids*, would not make their Saturday morning debut for another year.

For all their flaws, Fast Willie and his sidekicks brought this genre of stories to an audience who had never been represented in this way. But in the grand scheme, the comic never made a splash, which is genuinely regrettable.

Created by:
Bertram Fitzgerald
and Gus Lemoine

Debuted in:
Fast Willie Jackson
(Fitzgerald
Periodicals,
October 1976)

Partnered with:
Fast Willie Jackson

Not intended for:
Jive turkeys

© 1976 by Fitzgerald
Periodicals

THE F-MEN

"That girl—she has antennas! She must be a mutant!"

Created by:
Nicola Cuti and Joe Staton

Debuted in:
E-Man vol. 2 #2
(First Comics, May 1983)

Henchmen to:
Ford Fairmont, PhD

They're after:
The E-Men

© 1983 by Nicola Cuti and Joe Staton

N THE 1980S, FEW COMICS PROPERTIES were more popular than *The Uncanny X-Men.* The book had been relaunched under a new creative team, and fans couldn't get enough. So the X-Men were due—and were popular enough to withstand—a little bit of parody.

One of the many books of the era that satirized them was, alphabetically enough, *E-Man.* Always with tongue firmly planted in cheek, the comic had begun as an appealing but otherwise straightforward science-fiction/ superhero title. As the book evolved, it mixed farce with soap opera, creating an environment that could embrace an over-the-top lampoon of comics' most popular team.

Deluded scientist Ford Fairmont, PhD (transparently modeled on celebrated X-Men scribe Chris Claremont) uses his Mutant Energizer to transform abducted teens into his sort-of minions, as real-life versions of the heroes of his popular comic book *The Unhappy F-Men.* These included the tortured **Zitpops,** whose "mutant pimples" produced devastating beams of concussive force, and the husky man made of organic concrete, **Clodhoppus.** Wolverine was parodied in the form of the saber-toothed **Weasel,** their Storm was the less-impressive **Drizzle,** then-junior X-Man Kitty Pryde was the model for **Airhead,** and Nightcrawler inspired the drooling, far more terrifying **Slime-squirmer**.

Much of the humor poked fun at author Claremont's signature style of dialogue, which was dense and riddled with pathos. Any sentiment that could be expressed in a single sentence was expanded to a paragraph, and every emotion was plastered on the page. Considering his newly mutated crush, E-Man's partner Nova (who has been transformed into the all-powerful F-Man Jean Beige, aka **Albatross**), Zitpops muses, "Jean is everything to me, as necessary as the air I breathe, the water I drink, the Phiso-Hex that keeps my face from looking like a pizza with cancer. Oh, Jean . . . Jean . . . I love you." The brooding Jean thinks, "I can tell he's so hung up on me, he'd put his head in a Cuisinart if I asked him to." Not that all of the parody was easy to laugh off; several of the X-Men's creative and editorial team were portrayed as vacuous, risible excoriations.

In the end, E-Man and friends manage to rescue Nova, free the transformed F-Men and allow them to return to their normal lives, and leave the creators who caused the whole mess trapped in the one prison from which they could never escape: contract negotiations.

FROBISHER

*"Sorry I frightened you, Doc.
Here—GLERB—have a fish!"*

BRITISH SCIENCE-FICTION CLASSIC *Doctor Who* has enshrined the concept of "the companion" into popular culture. Resembling a traditional sidekick, the various tag-alongs in the Doctor's television adventures provide the hero's many incarnations with an opportunity to explain complicated (and often wholly fabricated) alien technology and relevant plot devices. They also, as a general rule, spent a lot of time screaming and running down hallways.

Literally dozens of companions have joined the Doctor across a multitude of media, including audiobooks, novels, and, naturally, comic books. The Doctor has traveled with space barbarians, robot dogs, alien assassins, and immortal time cops. But if any of his companions strike a compelling figure, it's Frobisher, the shape-changing penguin!

Actually a chameleon-like Whifferdill from the planet Xenon, Frobisher serves as a sidekick to the Sixth Doctor in the pages of the Time Lord's long-running comic book and fan magazine. Occasionally pairing up with the Sixth Doctor's most famous companion, Peri, Frobisher accompanied the British sci-fi icon on adventures across time and space.

Despite having any imaginable shape available to him, the alien chooses the black-and-white body of an Antarctic waterfowl. Frobisher's reason for adopting the appearance of a penguin is a heart-wrenching tale. "I'm staying a penguin for a while for . . . personal reasons," he explains. "D'you know I once spent fourteen years as a till on a checkout counter in a supermarket in Walthamstow? I did it for love," he sighs. "But she thought I was only in it for the money."

That sort of wry pathos and shaggy-dog humor may explain Frobisher's continued popularity, despite his infrequent appearances. In Doctor Who fandom, the original novels and audiobook adventures are considered second only to the television series in importance and entertainment value. The audio adventures in particular—essentially radio plays, complete with sound effects and dramatic music—are popular with fans. Frobisher has proven equally so, appearing in a pair of dramas and at least one novel to date.

Affection for Frobisher runs so deep in this fandom that the character has been given chances to appear with three different reincarnations of the Time Lord (he's met the Sixth, Eighth and Tenth Doctors), which puts him in the rarified company of companions who've skipped sequential generations.

Created by:
Steve Parkhouse
and John Ridgway

Debuted in:
*Doctor Who
Magazine* #88
(Marvel Comics,
May 1984)

Partnered with:
The Doctor

Mood:
Fowl

© 1984 by IDW

GOODY RICKELS

"Hey! You're stepping on my lines, fella!"

Created by:
Jack Kirby

Debuted in:
*Superman's Pal
Jimmy Olsen* #139
(DC Comics, July
1971)

Sidekick to:
Jimmy Olsen

Primary power:
Insult comedy

© 1971 by DC Comics

ERE'S WHAT MAKES SUPERHERO comics so delightful: Open any book on the rack and you'd be hard-pressed to predict what you might find inside. A furniture-eating creature, a horned planet full of miniature movie monsters, a would-be emperor riding a blimp into his volcano headquarters . . . maybe even the goody-two-shoes double of legendary insult comic Don Rickles!

"Are you ready for defoliants in your succotash?" cries the cover blurb. "Are you ready for landmines in your lunchbox? Are you ready for this? TWO RICKLES!" The introduction of Goody Rickels takes place during iconic creator Jack Kirby's celebrated tenure on what was then DC Comics' worst-selling title, *Superman's Pal Jimmy Olsen*. "King" Kirby knew low sales meant he could enjoy free rein. And over fifteen issues, amidst more absurdity and inspiration than can be documented here, he introduced characters like mogul Morgan Edge, high-tech crime organization Intergang, and evil alien god-tyrant Darkseid into the DC universe, among many, many others. He also paired Superman's pal Jimmy with Goody Rickels.

Flamboyant, grandiloquent, and constantly kvetching, Goody was the polar opposite of his more famous twin. Whereas Don Rickles was ironically known as "Mr. Warmth" for his infamous brand of insult comedy, Goody was "a sweet, lovable soul" from Metropolis television network WGBS, a bit of a talker, and a buffoon.

"Nature gave me a small liver—but a big, big heart!" he breathlessly rants to his boss, dressed like an ersatz superhero on his coworkers' advice. "They told me to wear this funny suit, sir! They said a producer would see me about a pilot film!" After the briefest pause, he adds, "They're animals, sir! *Animals!*"

All of his chatter earns Rickels an assignment to cover "a page one story," which is where the trouble begins. He accidentally launches Clark (Superman) Kent into another dimension and stumbles his way through a battle with alien soldiers. Worse yet, he, Jimmy, and the hero Guardian are force-fed a meal laced with the deadly explosive Pyrogranulate! (They recover.)

Fans were violently split on the appeal of Goody Rickels, but editor E. Nelson Bridwell had this to say: "Kind of reminds us, though, of some critics in the eighteenth century who thought it was terrible that Shakespeare included comedy relief in *Hamlet*! We say, if Hamlet could have his humorous gravediggers, Jimmy can have Goody Rickels . . . "

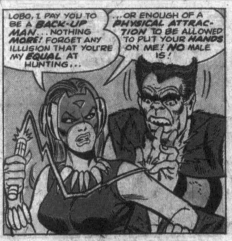

LOBO, I PAY YOU TO BE A *BACK-UP MAN*... NOTHING *MORE!* FORGET ANY ILLUSION THAT YOU'RE MY *EQUAL* AT HUNTING...

...OR ENOUGH OF A *PHYSICAL ATTRAC-TION* TO BE ALLOWED TO PUT YOUR *HANDS* ON ME! *NO MALE* IS!

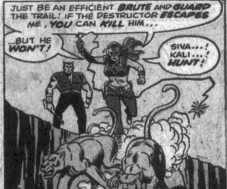

JUST BE AN EFFICIENT *BRUTE* AND *GUARD* THE TRAIL! IF THE *DESTRUCTOR ESCAPES* ME, *YOU* CAN *KILL* HIM...

...BUT HE *WON'T!*

SIVA...! KALI...! *HUNT!*

MEANTIME, JAY FINDS THE VALLEY SMALL, *LIMITED*, STRANGELY LACKING IN GAME OR LIFE... OR A WAY *OUT!*

EACH DIRECTION I'VE TRIED... I HIT *CLIFFS!* THEY'RE TOO BLASTED *SMOOTH* TO CLIMB...

BUT IF I PUT EVERY-THING I'VE *GOT* IN-TO A *LEAP*...

AND UNDER HEIGHTENED SENSES AND POWER, *EVERYTHING* IS *CONSID-ERABLE!* YET AS THE DESTRUCTOR SOARS TOWARD *ESCAPE*...

:ZDAK!:

UNGHHHH!

LIKE RUNNING INTO AN *ELEC-TRIC FENCE*...! SOME KIND OF *FORCE FIELD*... OVER THE WHOLE *PLACE!*

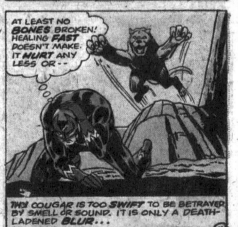

AT LEAST NO *BONES* BROKEN! HEALING *FAST* DOESN'T MAKE IT *HURT* ANY LESS OR --

THIS COUGAR IS TOO *SWIFT* TO BE BETRAYED BY SMELL OR SOUND. IT IS ONLY A *DEATH-LADENED BLUR*...

HUNTRESS AND LOBO

"What you'll witness tonight . . . a drama of life and death, played for real."

JAY HUNTER IS LAUNCHED into heroism when gangster Max Raven slays his scientist father and Jay uses his pop's experimental serum to adopt the identity of grim, two-fisted superhero the Destructor. Possessed of "the full freedom of his senses," the Destructor counts among his powers superhuman toughness, catlike agility, ferocious speed, and an array of heightened senses.

A crime fighter packed with so many animal-like qualities practically begs to be hunted. So appropriately enough, villain-wrangler Dr. Shroud hires the Huntress, "a tracker and trainer of wild beasts," to take down the costumed crusader. Besides her cunning and ingenious traps, the Huntress is also in possession of a pair of trained cougars—Siva and Kali—and Dr. Shroud's deadly Laser-Lash. Lastly, for better or worse, she also has Lobo.

As the hairy, brutish sidekick to a henchwoman, Lobo is seated on the horns of a dilemma. On the one hand, as an ace tracker and hunter himself, he rankles at being subservient to the Huntress. But, on the other hand, he also loves her.

In a manner of speaking, they're the Nick and Nora Charles of comic-book assassins, although their dialogue has a sharper edge. "Lobo," explains Huntress, forcibly removing her manservant's hand from her shoulder, "I pay you to be a back-up man—nothing more! Forget any illusion that you're my equal at hunting," she sneers, "or enough of a physical attraction to be allowed to put your hands on me!"

Although Huntress and Lobo can't manage a romantic accord, they perform well as a team in every way that matters, tracking the hero during a staged manhunt. Unfortunately, their egos inevitably clash, sending Lobo off on an ill-advised mission to prove his worth. "She won't think of me as a stupid hulk anymore . . . ," he mutters, approaching what he believes to be the Destructor's hiding place. "Now she's *got* to love me!"

Things don't pan out for the pair. Lobo is ambushed and knocked senseless, while the Huntress plummets down a ravine to her apparent doom. The scenario is much like Romeo and Juliet, if daggers and poison were replaced with getting punched and falling off a cliff. Even though they might have survived, the subsequent demise of their publishing company sealed their fate.

Created by:
Archie Goodwin
and Steve Ditko

Debuted in:
The Destructor #3
(Atlas Comics, June 1975)

Henchmen to:
The Combine

Not to be confused with:
All the other Huntresses or Lobos in comics

© 1975 by Atlas Comics

INDEL THE ELF

"Oh my! I think I'm in trouble!"

Created by:
Unknown

Debuted in:
Multiple titles
(August 1981)

Partnered with:
Valerius, Grimslade,
and Saren

**Saving throw
against ineptitude:**
Automatic fail

© 1981 by TSR
Hobbies Inc.

THE OFTEN BRUTAL SWORD-AND-SORCERY world of the iconic role-playing game Dungeons & Dragons leaves little room for mistakes. An adventurer's misstep may land players face-to-eye with a deadly beholder, or possibly at the mercy of a blink dog or a rust monster. Menace abounds!

It's a shame, then, that the carefully assembled adventuring crew from a series of comics-style ads for the popular pastime decided to add Indel the Elf to their roster.

The quartet of Valerius the Fighter, Grimslade the Magic-User, Indel the Elf, and the mysterious Saren the Cleric starred in an ad campaign in many comics of the 1980s. Readers were treated to full-page comic strips depicting their ongoing adventures, featuring the sorts of escapades players might encounter in the course of an average D&D session.

One constant throughout their adventures: Indel was a bit of a burden. Evidently the junior partner of the group, he was also the least courageous and most accident prone. Along with a quiver of arrows (which he never uses), Indel's primary contribution was "Infravision," i.e., seeing in the dark. Arguably that should have let him identify traps. In reality, he neglects to notice a hulking menace known as a shambling mound, is almost murdered by deadly green slime, and then falls through a trap door. And that's only in the first two installments.

When not being rescued, Indel spends his free time shouting about every menace the group encounters. His cry of "Look! A shadow!" is followed by "Look out, it's dripping!" The helpfulness of these exclamations, considering that the danger was evident to everyone present, is questionable.

The group's adventures take them from deadly Zenofus Castle to the comfort of Gavin's Inn, through the Forest of Oakthorn, into the Swamp of Lobella, and toward the Mountains of Ash. And during their travels, Indel is almost killed by a werewolf's arrow. That sounds like a lot of hassle if you're not familiar with Dungeons & Dragons, but in fact it's a fairly typical series of events. It would be a disappointment if all of that *hadn't* happened.

Teasing a possible conclusion to the adventure, Grimslade uses his powers to open a Dimension Door and deposits his bruised and battered party within the safety of an ancient castle. Readers were never treated to the sights inside the mysterious structure, but it's fair to expect that Indel will find a trap door through which he can clumsily plummet.

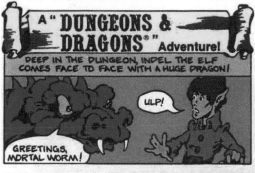

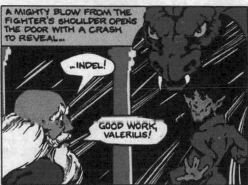

EXPLORE EXCITING WORLDS OF FUN, FANTASY & ADVENTURE WITH DUNGEONS & DRAGONS® AND ADVANCED DUNGEONS & DRAGONS® ADVENTURE GAMES. SEND IN YOUR COUPON TODAY FOR YOUR FREE CATALOG OF GAMES & ACCESSORIES. SEND TO: TSR HOBBIES, INC., POB 756 DEPT. 170-81M, LAKE GENEVA, WI 53147. IN THE UK SEND TO: TSR HOBBIES (UK) LTD, THE MILL, RATHMORE RD., CAMBRIDGE, ENGLAND, CB1 4AD

DUNGEONS & DRAGONS and ADVANCED DUNGEONS & DRAGONS are trademarks owned by TSR Hobbies, Inc • 1981 TSR Hobbies, Inc. All Rights Reserved

PLEASE SEND A CATALOG TO: M4

NAME _____

ADDRESS _____

CITY _____

STATE _____

ZIP _____

ITTY

"Is . . . is this pain?! I don't like it."

SIDEKICKS COME IN ALL SHAPES and sizes. Few, though, have come in the very peculiar shape and size of the friendly alien space-guppy nicknamed Itty-Bitty. Commonly seen sitting on the shoulder of space-faring superhero Green Lantern during a short period in the late '70s, Itty looked like a turnip stapled to a starfish.

The unlikely little creature was part of an extraterrestrial race of simple and peaceful beings called the Ayries. When an alien doomsday cult threatens to destroy their home, a deep-space structure known as Vivarium, the ring-slinging Green Lantern (alias Hal Jordan) saves them—and acquires Itty as a pet in the process.

Despite his stature, Itty could more than pull his weight. He could subsist without water, food, or oxygen and was capable of flying. More useful to the high-risk lifestyle of cosmic superheroes, though, Itty was particularly sensitive to danger. "His perceptions are different," Green Lantern muses on one occasion, pondering a silent warning offered by his shoulder-mounted companion. He adds, with some degree of awe, "Keener than mine."

Itty contained tremendous potential, even if a grim turn of events was necessary to reveal it. In one of his last adventures, Itty is discovered inert, unmoving and presumed dead. The thumb-sized alien is laid to rest in a full-size grave, complete with headstone—a tribute to the outsized nature of his heroism.

But Itty was not dead, he was growing! Emerging as a calcium-starved, teleporting, multi-tentacled monster driven to madness by hunger, the pupal Itty injures the superheroes Black Canary and Green Arrow. He recovers his senses enough to know that he poses an unconscionable threat to the humans he once befriended. Evolving to a titanic humanoid figure made of swirling gases, Itty performs one last brave act, exiling himself from Earth.

Since his departure, Itty has been off in space with his mate, repopulating the once-destroyed Ayrie race. Back on Earth, he's only infrequently recalled, his narrative reduced to the apparent absurdity of a creature that resembles a marriage between an orchid and a sausage sitting on a superhero's shoulder. It was a striking and somewhat silly image, true. But a sidekick who served so well for so long deserves greater praise.

Created by:
Denny O'Neil and
Mike Grell

Debuted in:
The Flash vol. 1
#238 (DC Comics,
December 1975)

Partnered with:
Green Lantern

Alternate uses:
Corsage, imitation
banana peel, fake
nose

© 1975 by DC Comics

JACKDAW

"Such interdimensional hopping in search of Merlin is no problem for an—hic—elf of the Order of the Chthonos!"

Created by:
Dez Skinn, Steve Parkhouse, Paul Neary, and John Stokes

Debuted in:
The Incredible Hulk Weekly #57 (Marvel UK, April 1980)

Sidekick to:
Captain Britain

Description:
Little, annoying, a little annoying

© 1980 by Marvel Comics

BY THE MID-1980s, the increasing tendency for realism in superhero comics had evolved into a practically nihilistic trend across the entire genre. This fan-labeled "grim 'n' gritty" approach was a downward spiral away from the unquestioned heroism that had typified costumed crime fighters up to that point and reached even mainstream characters like Daredevil and Batman. But one hero had them all beat by years: Captain Britain.

A distinctly British superhero for an exclusively British market, Captain Britain was invented by American creators living and working in the United States. As such, he wasn't so much a uniquely British superhero as a mash-up of clichés. But when the property transferred to regional creators, the Captain got a new coat of paint and a tune-up. And, at the time, that meant that Captain Britain went *dark*.

British comics tend to be morally muddier and grimmer than their American counterparts. In Captain Britain's case, this tendency manifested as the hero having something like a magic-induced nervous breakdown and jumping to his apparent death from a jumbo jet airliner in mid-flight. In a later adventure the captain was trapped in an increasingly unstable, violent dystopia in another dimension. Between these two events, there was Jackdaw.

An elf of Otherworld, Jackdaw was sent by the ancient wizard Merlin to serve as Captain Britain's squire of sorts. The diminutive imp was a master archer, possessed psychic powers, and was familiar with magic. On the downside, he was an inveterate drunk and somewhat unreliable.

The readership wasn't particularly enchanted with Jackdaw, but he was vitally important to Captain Britain's recovery from madness. These interim adventures lightened in tone, and Captain Britain's exploits resumed the feel of a familiar type of superhero story. Jackdaw proved so important that he even escaped death after an untimely demise and was restored to life by the magic of Merlin.

This unfortunately caught the electronic eye of superhero-assassinating "cybiote" murder-machine the Fury, who launches a destructive blast that cuts the helpful little elf in twain. This time Merlin neglected to step in.

Readers weren't precisely left broken-hearted by his death; one fan famously described it as a "mercy killing." But Jackdaw's contribution shouldn't be underrated. Captain Britain might not have survived his grisly adventures without the uplifting company of his elf companion.

JACKIE JOKERS

"This cat wanted to be an actor but he couldn't remember his lions!"

ARLY IN ITS PUBLISHING HISTORY, Harvey Comics hit on a successful formula. Several of their titles feature a cast of youngsters with distinctive characteristics and obsessions. Richie Rich was rich, Little Dot loved dots, Hot Stuff was a devil, Wendy was a witch—the motif made sense and sold books.

But later attempts to recapture lightning in a bottle were never quite as successful as those early triumphs. One of the well-intentioned efforts to find the new Casper the Friendly Ghost took the form of the show-business stripling Jackie Jokers.

Jackie debuted in his own title as the lead character, dubbed "the clown prince of show biz." He was depicted entertaining nightclub crowds, putting on elaborate (and overlong, even at a handful of pages) parodies of popular television shows and movies, and getting into entertainment-related fixes and conundrums.

Despite a robust cast of characters (Jackie came from a show-business family) and the easily digestible premise, Jackie didn't catch on. The curtain rang down on Jackie's eponymous series after four measly issues. It was then that Harvey Comics decided to give Jackie a tried-and-true boost to his popularity: bring in Richie Rich.

Jackie was rapidly demoted to sidekick status in the newly launched series "Richie Rich and Jackie Jokers," with Jackie's jokes and comedic situations taking place largely within the gilded world of the wildly wealthy Rich family. This further cut down on Jackie's time in the solo spotlight. Even Richie's many servants ended up scoring as much page time as the veteran child comedian.

Most of Jackie's contributions to the partnership took the form of hoary old jokes and trite gags, although they probably seemed fresh and funny to the book's young target audience. Even in one of Richie's frequent adventure stories, Jackie mostly provided wisecracks and smart remarks. However, his show-business training sometimes proved worthwhile. On one occasion, his familiarity with stage makeup allowed him to identify a foreign agent of a hostile government who had disguised himself as President Gerald Ford. You never know what entertainment will teach you.

But the attempt to recast Jackie into Richie Rich's popular world eventually failed, and the all-around entertainer simply up and vanished. Should Jackie Jokers ever be revived, one has to wonder whether he'd be given the chance to come back as a solo act or if he'll always play second banana.

Created by:
Ernie Colon and unknown writer

Debuted in:
Jackie Jokers #1 (Harvey Comics, March 1973)

Partnered with:
Richie Rich

Where to find him:
Opening for Doogie Horner next month at the Laff Hutt in Philadelphia

© 1973 by Harvey Comics

THE MANY SIDEKICKS OF

RICHIE RICH

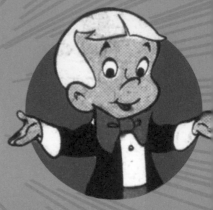

HARVEY COMICS BOASTED FEW characters who matched the popularity of the Poor Little Rich Boy, Richie Rich. And for this reason, so many new and ancillary characters were assigned in one way or another to Richie's expansive series of friends and allies.

On the more famous side of the roster, Richie often found himself engaged in adventures with Harvey's other heavy hitter, Casper the Friendly Ghost. This was the kiddie comics equivalent of a Batman/Superman team-up, uniting the two most prominent figures in the genre for shared adventures. Not that Richie was totally on board; he was given to considering these team-ups to be mere *dream*-ups, deducing against all physical evidence to the contrary that he had imagined a ghostly playmate.

But Richie had plenty of living, breathing companions. His exorbitant wealth allowed him a platoon of spectacular servants and peculiar pals, including his chauffeur Bascomb, his French chef Pierre, and his daffy on-staff inventor Professor Keenbean. More prominent than any other servant, however, was Richie's hypercompetent butler Cadbury. Not only did the surprisingly strong and courageous household helper provide everyday service to the en-

tire Rich clan, he'd also frequently rescue his young master from assorted crooks—sometimes using exceptional violence. He even briefly adopted a superheroic identity—as "Crashman" to Richie's "Rippy" or, sometimes, "SupeRichie"—to provide sidekick services to the young zillionaire.

Also in Richie's immediate circle of allies were his notably intelligent dog Dollar and his quirky robot maid Irona, but his closest partners in adventure were his girlfriend Gloria and, more important, his bosom buddies Freckles and Peewee.

In contrast to the abundant wealth of the Rich family, Freckles and Peewee lived in abject—if happy—poverty. Residing in a ramshackle cottage that appeared to lack interior walls and had only sporadic running water, they nonetheless neither received nor asked for assistance from their wealthy pal. It was implied that happiness was more valuable to the impoverished young brothers than money. But let's remember that the Rich family was happy *and* owned whole continents. Probably Richie could have spared a few billion for his best pals.

All artwork © Harvey Comics

JAXXON

"I'm more what ya call yer basic lepus carnivorous—a meat-eatin' rabbit ta you, junior!"

Created by:
Roy Thomas and
Howard Chaykin

Debuted in:
Star Wars #8
(Marvel Comics,
February 1978)

Partnered with:
Han Solo and the
Star-Hoppers

What's up, doc?
Oh, not much,
what's up with you?

© 1978 by Marvel
Comics

HAT'S SIX FEET TALL, green, and prefers T-bone steaks to carrots? Give up? Well, it wasn't a riddle. Rather, that's a description of one of the most absurd characters in the expansive (although not exactly canonical) catalog of Star Wars stories: Jaxxon, the rabbit rogue for hire.

Marvel Comics licensed the original *Star Wars* film for an adaptation that was well received, and given the rapid turnaround time of comics, the creative team found themselves outpacing the films within six months. With the plot of *The Empire Strikes Back* kept a strict secret, industry icons Roy Thomas and Howard Chaykin were left to expand the Star Wars universe for their medium.

Borrowing inspiration from Akira Kurosawa's much-adapted epic *The Seven Samurai*, a story was crafted in which Han Solo assembles a team of mercenaries on the desert world of Aduba-3, with his Wookiee partner Chewbacca—one of the most iconic sidekicks in modern pop culture—in tow.

His recruits include a comical mix of shabby heroes: humanoid porcupine Hedji, space criminal Amaiza, semidelusional lightsaber-wielding Don-Wan Kioti. Rounding out their numbers is a suspiciously Skywalker-like farmboy named Jimm who calls himself the Starkiller Kid, and Jimm's sassy, sarcastic robot companion EF-90—aka Effie.

And then there was Jaxxon. Standing at a lanky six feet, the hair-trigger hare was quick with a powerful kick and even quicker with his dual blasters. Tough as nails and fond of an irreverent quip, Jaxxon was openly modeled on Bugs Bunny. His homeworld was Coachelle Prime (as in the Coachella Valley Giant Carrot Festival, a holiday destination for the famous rabbit), and his name recalls Bugs's habit of calling people "Jackson." Jaxxon was at the heart of a very unusual type of crossover, which included references to Cervantes and Kurosawa.

To be honest, Jaxxon was no more outlandish or ridiculous than any of Solo's "Star-Hoppers." He was, however, difficult to ignore. With his abrasive personality and striking appearance, he alone has been repeatedly singled out by fans as the particularly risible member of this short-lived coterie. Jaxxon has been reintroduced into different Star Wars media at one time or another, usually as a joke. A recent Star Wars animated series revealed, in passing, the skeletal remains of a buck-toothed humanoid in a familiar red spacesuit. A little thing like being reduced to a skeleton wouldn't have stopped Bugs Bunny.

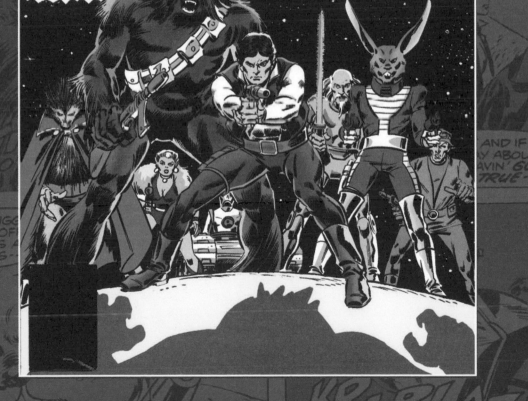

THE JUNIOR SUPER FOES

"That's murder, man—and it's not my gig!"

IF SUPERHEROES ARE GOING to form a team of costumed do-gooders, then crooks have just as much right to form their own club for crime. And if the superheroes of the DC universe are going to form the Super Friends, then the villains have the prerogative to form the Super Foes.

Facing off against the five key members of the Super Friends in the comic-book version of the Saturday morning cartoon was a quintet that featured some of the heroes' oldest nemeses. In addition to their trademark catalogs of menace, each villain acquired a super-sidekick whose powers, abilities, and identities mimicked those of their senior partners. These were the Junior Super Foes.

Toyboy was the junior partner to Toyman. Wonder Woman's nemesis the Cheetah acquired an acrobatic assistant named **Kitten**. The Human Flying Fish, one of Aquaman's weirder enemies, trained the unimpressively monikered **Sardine**. Two of the Dynamic Duo's villains showed up with pint-sized partners, both somewhat challenged in the wardrobe department. The gawky, bespectacled **Chick** was subordinate to the Penguin. Withdrawing all menace from his appearance, Chick wore a rooster costume, complete with coxcomb, feathered ruff and tunic, jodhpurs, and boots resembling chicken legs. By contrast, **Honeysuckle**—Poison Ivy's teenage associate—wore a costume consisting of less than an armful of leaves scattered strategically across her figure.

In battle, the Junior Super Foes perform surprisingly well. Toyboy incapacitates the Man of Steel with an X-ray-vision-proof lead mask, Sardine blinds Aquaman with a blast of squid ink, Honeysuckle slows Robin using "honey-covered vines," Chick wields a wicked tear gas umbrella against the Caped Crusader, and Kitten just slugs Wonder Woman from behind. Tactics aside, you have to admire their effectiveness. The Junior Super Foes are keen students of their tutors' criminal expertise—but they draw the line at murder. In the end, they turn on their senior partners in order to save the heroes' lives.

"For helping the Super Foes, you kids will have to go to court," explains a firm but fair Superman. "But since you were the ones who beat them, we'll put in a good word for you!"

"You do that, Supes," announces Toyboy, "and we'll never go wrong again!" It's a happy ending for everyone, except the bad guys.

Created by:
E. Nelson Bridwell and Ric Estrada

Debuted in:
Super Friends vol. 1 #1 (DC Comics, November 1976)

Sidekicks to:
The Super Foes

Not to be confused with:
The Super Junior Foes

© 1976 by DC Comics

KLONSBON THE FOOZLE
"The Foozle bids you farewell!"

Created by:
Steve Englehart and
Marshall Rogers

Debuted in:
Eclipse Monthly #1
(Eclipse Comics,
August 1983)

Partnered with:
Cap'n Quick

Species:
Not a bird

© 1983 by Steve
Englehart

AN UNNAMED EARTH ADOLESCENT is busily working in a basement workshop on a "'sperament" to turn a pair of common sneakers into a virtual reality device. "I'm tired of spending all my quarters playin' video games!" her idle thought explains. "I wanna get inside 'em . . . just like in the movies." It's a long shot for a kid still in grade school to invent something as advanced as reality-bending sneakers. But a nearby shadowy figure invisibly assists the future "Cap'n." The result: rather than depositing the user in a video game reality, the sneaks generate superspeed and can breach dimensions.

In this fashion the kid, newly dubbed Cap'n Quick and decked out in a beach-towel cape and leather aviator cap, makes the acquaintance of Klonsbon the Foozle. Renowned in this alternate universe for their untrustworthiness, Foozles strongly resemble birds, having black feathers and prominent blue beaks—although Klonsbon takes great exception to being referred to as such. "I ain't no bird!!" he insists, leaping on the offending party's chest and shaking them by the lapels.

Besides a Foozle, the Cap'n also attracts the attention of an other-dimensional government. Interested in the reality-hopping shoes, they abduct the Cap'n, leaving no one but Klonsbon to free her.

Klonsbon has resources, however. He assembles a ragtag team of mangy operatives: the austere Granny, who can create doughnuts out of thin air, and her devoted partner Mel, who boasts a reverse Mohawk and the ability to replicate any sound. Stat, a dim-witted purple alien who can duplicate objects with a touch, comes along, as do his employer, the Great Jones, and a mischievous flying glove named Doberman. The Cap'n's cat—inadvertently transported with its owner—rounds out the group.

Despite their numbers, the group fails to save the Cap'n from imprisonment. Instead, a breakdancing gang of street toughs called the Darklydale Dancers rescues her. All that remains is the effort of returning the Cap'n to Earth—a task that, unfortunately, is not completed. The final issue of the series was a color reprint of the original Foozle tale, and the Cap'n's fate remains unknown.

EDITOR'S NOTE

Co-creators Rogers and Englehart developed the Foozle from an unused script in which Superman was teamed with cackling antihero the Creeper. Englehart explains, "[Rogers] turned Superman into a little girl and the Creeper into the Foozle, and I rewrote dialogue as needed."

MOON-BOY

"Thunder-Horn has come to the valley! Drive him out, Devil!"

HOW GALLING IT MUST FEEL to be the member of a double act who can speak, use tools, and stand upright, and yet still not earn top billing. But this is the burden happily carried by Moon-Boy, the prehistoric pal of the paleontologically inaccurate—but nonetheless impressive—Devil Dinosaur.

Billed as "the First Human," Moon-Boy is a member of the Small Folk, the so-called Dawn Men of the evolutionary beginning of humanity. Apelike and frequently awestruck by the brutal beauty of his primitive world, Moon-Boy forms a bond with the beast he calls Devil in the most significant manner possible: he saves the creature's life.

Burned by the torches of the vicious Killer-Folk who inhabit his valley, the newborn dinosaur is cared for by his small, hirsute companion. Taking him to a cool forest glade to heal, Moon-Boy forms an unassailable bond with his mighty ally. Together, they make the prehistoric world safe for a future humanity.

Moon-Boy's sidekick duties are largely narrative in nature. Devil Dinosaur shows no ability to speak, and neither thought balloons nor captions offer insight into his inner monologue. This leaves Moon-Boy to explain his Brobdingnagian buddy's motives and meaning, to himself and to the reader if nobody else is around.

He's also Devil's biggest booster. "Devil is master of the valley! He is the mightiest of beasts!" he cheers, clapping and swinging from branches in enthusiastic delight. "Who is happier than Moon-Boy when his giant brother conquers his enemies?!" he asks. "There is safety in his shadow—and food where he trods!"

Besides facing the assorted menaces of killer Neanderthals, prehistoric titans, witches, wizards, aliens and unknowable threats from the future, Devil and Moon-Boy enjoy the occasional bout of time travel. They even briefly joined a modern-day superhero team, albeit a loosely organized one.

Devil Dinosaur's outrageous visage and inarguably unique adventures make him a popular figure, despite his infrequent appearances. Recently Devil returned to the modern day, this time as a sidekick himself to "Moon Girl" (aka exceptionally bright elementary school student Lunella Lafayette).

As for Moon-Boy's fate, he allegedly fell victim to the violent assault of the Killer-Folk. But if comics teach anything, it's that no death—not even a death that occurred in the distant past in a dinosaur-laden dimension—is permanent.

Created by:
Jack Kirby

Debuted in:
Devil Dinosaur vol. 1 #1 (Marvel Comics, April 1978)

Partnered with:
Devil Dinosaur

Stature:
About bite-sized

© 1978 by Marvel Comics

MUTANT FORCE

"Number One will have our heads for blowing this mission!"

Created by:
Jack Kirby

Debuted in:
Captain America Annual vol. 1 #4
(Marvel Comics,
November 1977)

Henchmen to:
Magneto, the
Mandrill, Mad
Dog, the Secret
Empire, the Red
Skull, and the U.S.
government

Recruit they most desperately need:
Codenamer

© 1977 by Marvel
Comics

HERE'S SOMETHING TO BE SAID for henchmen who know their place in the grand scheme of things. And such a group of dedicated underlings is the curious quintet who call themselves Mutant Force.

Over the erratic course of their sporadic careers, they've kept one thing consistent—they don't work for themselves. Mutant Force has hired out their services to everyone from misanthropic mutant mastermind Magneto to the crypto-fascist would-be world conquerors of the Secret Empire, and even to the United States government.

But they originally had loftier goals. Before taking the name Mutant Force—possibly as a marketing move to better brand themselves as a good investment for henchmen-seeking crime kings—the group represented the second incarnation of X-Men baddie Magneto's mutant-supremacist terrorist organization, the Brotherhood of (Evil) Mutants. Following a poor showing against Captain America, they largely became mutant muscle for hire.

The Force comprises five members whose pseudonyms rank among the least creative in comic-book history. Of course, as relatively small-time operators in a crowded field, they had few unclaimed names available to them. The team's de facto leader was **Peeper** (sometimes called Peepers), whose enlarged eyes boasted both inhumanly advanced vision and destructive ray beams. Brute strength was provided by **Lifter,** who could negate the gravity of any object he touched. The snakelike **Slither** seemed to have an independent career, peeling off to join the thematic criminal enterprise the Serpent Society. Lastly were **Shocker,** whose metallic claws produced deadly electrical bolts, and **Burner,** whose powers seem self-evident.

The lack of catchy code names did little to dissuade potential employers. Mutant Force briefly served the ape-faced mutant revolutionary the Mandrill and later signed on to supplement a Secret Empire operative's quest to ruin his ex-wife's second wedding. Hey, it's a job and it pays. Plus, this latter gig led the federal government to hire Mutant Force to tackle—and defeat!—the Hulk.

Mutant Force's highest-profile contract involved the team (minus Slither, who apparently had better things to do) facing off against their former government employers as the Resistants, protesting a proposed Mutant Registration Act. In fact they were being directed by the Red Skull, the prominent Nazi supervillain. It was an unsustainable chapter in Mutant Force's career. What they'll be up to next is anyone's guess, although they are likely to draw a paycheck from a bigger villain while they do it.

RAUL

"Me—I'm Raul . . . I'm a cat."

THE WORLD OF *AMERICAN FLAGG* is complicated. Set in the 2030s, the story tells of the United States government, as well as several major corporations, abdicating its earthbound responsibilities and relocating to Mars. A disruptive government called the Plex rises in its place, placating the population with subliminally enhanced entertainment, secret mass sterilization, and brutal repression. Meanwhile, parodic gangs of political activists battle in the streets with Plex-provided weaponry, while the streets are patrolled by the Plex's version of "boots on the ground": the Plexus Rangers!

It's no surprise then, with all of this complexity at the root of the series, that the hero—Reuben Flagg—would require a little assistance. In fact, Flagg was practically overwhelmed with companions. Although, to be honest, they tended to be partially dressed femmes fatale, befitting the sometimes-controversial series. But in addition to his string of lovers and love interests, Flagg's most valuable partner was Raul.

A slight orange tabby cat, Raul possessed some interesting attributes. For one thing—although no explanation for the phenomenon was ever provided—Raul could talk. And not just to other characters in the story; he would often introduce chapters, bringing readers up to speed and making snide and clever asides directly to the audience, breaking the fourth wall in a fashion not seen elsewhere in the series. Raul also shared with Flagg the ability to see the subliminal messages running in Plex television programming. This made him a valuable ally.

Raul began his association with Flagg simply as a character the hero could talk with. The conversations slyly helped explain the very complicated dystopia of *American Flagg*'s future world. As time passed, Raul's role in the stories grew. This development was assisted by the cat companion acquiring a set of mechanical hands.

"I never knew what I was missing 'til I got thumbs," he says with tremendous pride. "Typing's a breeze . . . I can open pop tops . . . 'n' Reuben says he's gonna teach me to drive next week."

Raul's ambitions eventually lead him to run for—and win—the office of Mayor of Chicago. That ends in disappointment, however, as the increasingly unpopular feline is impeached by an angry electorate. Despite that vote of no confidence, Raul continues serving as a valuable aide to the very busy hero of the title.

Created by:
Howard Chaykin

Debuted in:
American Flagg
#1 (First Comics,
October 1983)

Sidekick to:
Reuben Flagg

**Most terrifying
attribute, if it were
available in the
real world:**
Articulated
prosthetic hands . . .
for cats!

© 1983 by First Comics

RUSTY THE BOY ROBOT

"Maybe I am just a protoype—but I'm a pretty darn good one!"

Created by:
Frank Miller and
Geof Darrow

Debuted in:
*San Diego Comic
Con Comics* #2
(Dark Horse,
August 1993)

Partnered with:
Big Guy

Fighting skills:
A little rusty

© 1993 by Frank Miller
Inc. and Geofrey Darrow

SIDEKICKS HAVE A REPUTATION for fumbling the ball. Often they're as likely to spring traps, get captured, be used as hostages, or require rescue as they are to provide quantifiable assistance to their mentors. In the case of Rusty the Boy Robot, such chronic incompetence is hardwired.

The world of Big Guy and Rusty the Boy Robot is populated with alien menaces, scientific catastrophes, and mutated, antediluvian terrors that resemble the villains of 1960s Japanese science-fiction films. In their first full-length outing, a malevolent, six-limbed, fire-breathing monstrosity is loosed on Japan from an experiment gone awry, a terrible beast who seeks to re-spark the reign of the dinosaur. There is only one hope: Rusty the Boy Robot!

Inspired by the classic Japanese character Astro Boy, Rusty is a cartoon given life. Round-headed, big-eyed, and standing no taller than thigh high, he appears for all the world like a little boy—and is about as useful as one against the monster menace. Despite his "nucleo-protonic" powers, he is squashed, struck, and stepped on.

So the Japanese government calls in a favor from their American allies. Launching from an aircraft carrier in the Persian Gulf is the cigar-shaped, art-deco attack vessel of Big Guy! Where Rusty failed, the raw power of Big Guy—a giant robot with a human pilot inside—might yet succeed. "All his awesome armament—his naked military might," ponders a lieutenant while observing the launch. "Against the monster, will it be enough?"

Not without a struggle. Big Guy throws anything he can get his hands on at the monster, before drawing him out over the ocean and firing a well-aimed nuclear missile that finally quiets the creature's rage.

And where was Rusty? The clockwork kid was being cleaned up so as to be presented to Big Guy as a gift from a grateful nation. Not that Big Guy's pilot appreciates the gift, thinking, "It would have been undiplomatic to turn the Prime Minister down—but the Big Guy works alone!"

As Big Guy rockets back to the United States to quell an alien invasion in the heartland, Rusty flies determinedly behind him. "I'm really strong and really fast!" he shouts at the speeding vehicle. "I've got a whole lot of super powers! I'll make a great kid sidekick!"

"Kid sidekick??" thinks Big Guy's pilot from the confines of the cockpit. "That's the last thing I need."

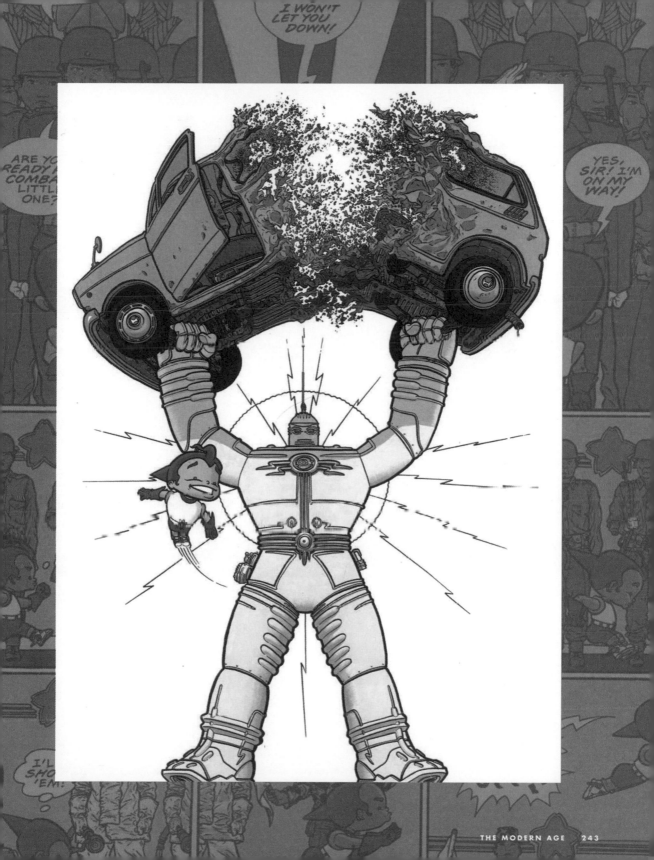

MORE FUN WITH ERNIE BATES AND HIS ROBOT PAL!

STEEL COMMANDO

HURRY UP! GET DUG IN BEFORE...

AARGH!

WE'LL **NEVER** HOLD THIS PLACE, SIR! THE TREES ARE FULL OF JAP SNIPERS... AND WE CAN'T SPOT 'EM IN THIS DENSE JUNGLE!

DURING WORLD WAR II A SMALL AIRBORNE FORCE HAD BEEN DROPPED AT A DESERTED VILLAGE IN THE BURMESE JUNGLE, WITH THE TASK OF FINDING AND DESTROYING A JAPANESE SUPPLY BASE! BUT THEY WERE SOON IN TROUBLE!

THEY'RE SUPPOSED TO BE SENDING US A **SECRET WEAPON** TO DEAL WITH SNIPERS, ON THIS NEXT SUPPLY PLANE! SOMETHING CALLED THE **STEEL COMMANDO** — WHATEVER THAT MAY BE!

THE STEEL COMMANDO CLIMBED OUT OF THE PLANE, ACCOMPANIED BY LANCE-CORPORAL ERNIE "EXCUSED BOOTS" BATES, THE ONLY MAN IN THE BRITISH ARMY IT WOULD OBEY...

REPORTING FOR SPECIAL DUTY, SIR!

GOOD GRIEF! WHICH OF YOU TWO PECULIAR-LOOKING OBJECTS IS THE SECRET WEAPON?

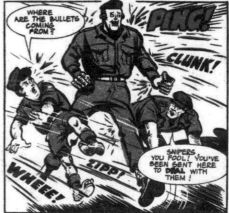

WHERE ARE THE BULLETS COMING FROM?

PING!

CLUNK!

WHEEE!

ZIPP!

SNIPERS, YOU FOOL! YOU'VE BEEN SENT HERE TO DEAL WITH THEM!

IRONSIDES FIND THEM JAPS AND **DEAL** WITH 'EM!

YES, ERNIE!

A DIRECTION-FINDING AERIAL SPROUTED FROM THE STEEL COMMANDO'S METAL SKULL...

HE'S ON THE SCENT, SIR!

STEEL COMMANDO
"Yes, Ernie."

HE DOES ALL THE HARD WORK, performs all the acts of heroism, and even has his name in the title of the recurring feature in *Thunder Comics*. Yet he remains the sidekick. Why? Because the Steel Commando can't do anything without direct commands.

Developed as "the British Army's Number One Secret Weapon," the Mark 1 Indestructible Robot proved to be an impressive but uncontrollable powerhouse. Wildly strong, almost impervious to damage, and loaded with a rotating array of specialized weapons, the British army android had one notable flaw: he wouldn't take orders.

Not from his creators or superiors, that is. For some unknown reason, the Steel Commando, "Ol' Tin-Bonce" to his friends, instantly obeyed the directives of soft-hearted slacker Ernie "Excused Boots" Bates. A perpetual whinger with aching arches, Bates is suitable for only the softest assignments. "I'm not fit for active service," he complained to his commanding officer. "I'm medical category C3 on account of I'm *excused boots*!"

Put in command of the Steel Commando, Ernie was forced to undertake exceptionally dangerous missions in increasingly rough environments alongside his iron-plated pal. At least the automaton remained an agreeable associate. While Ernie bellowed about his "perishing feet" or the imminent danger of enemy fire, the commando would respond with a calm, agreeable, "Yes, Ernie."

In their adventures, Ernie and the Steel Commando routed Nazi attacks by land, sea, and air, exploiting technological advances in the robot's equipment. Rocket jets allowed him to fly, a finger-mounted flamethrower could cut through solid steel, spy cameras in his eyes could capture secret recordings, and he even boasted a refrigeration unit capable of producing ice cubes.

Steel Commando seemed to do all the work, but Ernie's role in the relationship was essential. Whereas the military higher-ups looked at the commando only as a weapon of war, Ernie acknowledged the android's feelings. Ernie—a creature of comfort himself—also provided for the commando's rest and relaxation. Whether a warm mug of motor oil or a lie-down between missions, Lance Corporal Bates was there to provide.

Evidently the British military never got around to building additional models. This is probably for the best, as far as Ernie is concerned. An entire platoon of Steel Commandos under his command would probably be, in Ernie's words, "a diabolical liberty!"

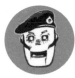

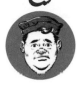

Created by:
Frank S. Pepper and Alex Henderson

Debuted in:
Thunder #1 (IPC Magazines, October 1970)

Partnered with:
Lance Cpl. Ernie Bates

How he takes his tea:
With a quart of motor oil

© 1970 by IPC Magazines

STOGIE AND HOAGY

"Sure thing, Sam! Yup!"

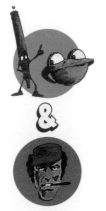

Created by:
John Wagner,
Jose Ferrer, and
Ian Gibson

Debuted in:
2000 AD #76
(IPC Media, August
1978)

Partnered with:
Sam Slade,
Robo-Hunter

**How to tell them
apart:**
One seems to serve
no useful purpose,
the other is a robot
cigar.

© 1978 by IPC Media

AUTOMATION SUGGESTS THAT the world of the future will be a utopia for humanity. In a world where robots uncomplainingly indulge in all the hard, necessary labor, increased leisure time and prosperity are all but guaranteed for human beings.

Unfortunately, it turns out that a world full of robots will also result in the breeding of *bad robots*. These must be decommissioned, and that responsibility falls to Sam Slade, Robo-Hunter.

Not all robots are bad in the off-kilter future of Robo-Hunter, but enough exist for Sam's services to be in high demand. He is stretched so thin—and so frequently found in the line of fire—that he ultimately requires reliable backup. But what he ends up with are Stogie and Hoagy.

Slade's signature look was that of a disheveled, hard-boiled, pulp detective. A necessary part of any tough-guy sleuth is, naturally, a well-chewed cigar clenched between his teeth. However, a company-wide crackdown on depictions of smoking in IPC's range of comics led the powers that be to replace Sam's cheroots with: Carlos Sanchez, Robostogie.

That's right. A robotic cigar.

Stogie was fiercely devoted to and openly admiring of the man who held him between his teeth all day. This—for better or for worse—was all expressed in Stogie's intentionally exaggerated Spanish accent. "You geev soch an importan' job to Hoagy!" he blurts during one mission, adding, "Ay-yi-yi! Are you sure thees is wise, *señor*?"

Who's Hoagy, you ask? Less enthusiastic but highly devoted—not to mention dumb as a post—Hoagy was built from a kit, as reliable and useful as an assembly-required robot possibly could be. In fact, his antics were more likely to hinder Sam's plans than to help.

When Sam decides to relocate his business to Brit-Cit—a nation run by robots—Hoagy quickly begins screwing up even simple requests. He prints Sam's name backward on their storefront window, lands on his boss's head when they jump out a window in pursuit of a crook, and generally interjects all sorts of inanities at inopportune times. And when Sam manages to strike it rich and retire in comfort, both Stogie and Hoagy bring their beloved boss back to the robo-hunting business. Specifically, they spend all of his money when he's not looking. Broke and left without options, Sam returns to his former career, his trusty sidekicks always remaining by his side and clenched between his teeth.

THE T-FORCE
"Yo, Mr. T . . . wha's up?"

PITYING FOOLS IS HARDER WORK than you might imagine. This is probably why iconic '80s celebrity Mr. T chose to assemble a squad of helpful young assistants, operating under the name of the T-Force. With them around, no fool goes unpitied!

Keeping in line with his self-professed status as a positive, non-violent role model, Mr. T recruited his T-Force from underprivileged kids and juvenile street toughs. Giving these kids important lessons in self-confidence and civic responsibility ends up saving most of them from lives of crime, turning them into productive members of these embattled communities.

Membership requires the personal intervention of the iconic muscleman and a possible face-to-face confrontation. Once Mr. T has extricated his potential helpers from whatever problem or poor life choices plagued them, they were given a two-way wrist-mounted communicator (shades of Dick Tracy!) that connected them directly with Mr. T. This was useful whenever T needed to summon his team or share video footage from the shock-resistant video camera he carried around in order to record crimes in progress.

A former drug dealer named Justice ("Because I don't get none!" he announces bitterly) is the first recruit depicted. He's nowhere near the first to join, however. Delivering an abandoned infant ("It's a crack baby, fool!" Mr. T helpfully acknowledges) to a nearby hospital introduces Justice to other members of the T-Force. Like him, they had begun in lowly circumstances but had become vital members of the community.

Additional T-Forcers included truant and cat burglar Lester, young scrappers Dionne and Drake, and assorted others. Most had been troubled teens, but a few were inducted in order to protect them from the kind of imminent danger that only a television weightlifter could prevent.

Frankly, Mr. T did almost all of the hard work himself. The T-Force was good for intelligence gathering and keeping an ear to the ground, but T took care of all the crook-bashing. After all, Mr. T promoted nonviolence and responsibility. Sending a gang of teenagers into a warehouse to unseat a drug cartel would have been . . . foolish.

EDITOR'S NOTE

The T-Force was Mr. T's *second* group of fictional assistants. A mid-1980s Saturday morning cartoon cast him as the coach of an international gymnastics team that helped him solve mysteries.

Created by:
Neal Adams and Pete Stone

Debuted in:
Mr. T and the T-Force (Now, June 1993)

Sidekicks to:
Mr. T

Targets:
Fools

Weapon:
Pity

© 1993 by Now Comics

URTH-4

"We bow only to the Earth!"

Created by:
Neal Adams

Debuted in:
Ms. Mystic #2
(Pacific Comics,
February 1984)

Partnered with:
Ms. Mystic

Favorite band:
Earth, Wind and
Fire (sorry, Watr)

© 1984 by Pacific Comics

IF ONE HAPPENS TO BE a seventeenth-century witch who recently escaped to the present day, only to end up in a firefight between giant robots and well-armed environmentalists . . . well, it might be time to get some sidekicks.

This is what happens to eco-friendly superheroine Ms. Mystic. The victim of superstitious villagers in rural, colonial Massachusetts, Ms. Mystic had been condemned as a witch to burn at the stake. Rather than go up in smoke, she uses her powers of elemental magic, which leaves her "trapped and helpless" for three centuries within a strange, nearly psychedelic universe.

She eventually escapes thanks to the power of radical environmentalism. This begins with the passionate and brilliant Dr. Raas and his congressionally appointed eco-watchdogs. Dubbed the S.I.A.—that's the Science Investigation Agency—the team takes on entities that exceed federal guidelines for environmental safety. That doesn't sound like the most exciting premise for a comic book, but lasers, killer robots, and menacing supervillains abound.

Tackling a pollution-producing factory in the middle of the Arizona desert, Dr. Raas has an occasion to use his Psionic Converter against a deadly security robot. But an unexpected side effect occurs—Ms. Mystic is freed! In a pitched battle with alien polluters, Ms. Mystic pleads with the spirit of the Earth itself, and four members of Raas's team are transformed into elemental warriors.

Daring Baron Cotter becomes the high-flying **Ayre**. Physicist Dwight Good is transformed into the redoubtable **Urth**. Dr. Kelly Kane and Dennis Swan become the heroes **Fyre** and **Watr**. Despite names that sound like a social media apps, the four elemental superheroes possess all the tremendous powers of their phonetic namesakes. They aid Ms. Mystic against any number of threats, up to and including a temporarily maddened Ms. Mystic herself. (A subordinate superhero forced to battle their senior partner is practically a sidekick rite of passage.)

The quartet eventually calls themselves Urth-4, which seems like a confusing choice given that one of their members was also named Urth (on the other hand, it worked for the Dave Clark 5). Later, graduating to their own ongoing series, the group re-spelled their name as Earth-4, which at least made things less confusing in print.

They had also considered "The Elementals" and "The Elementalists." Legal issues prohibited the first option—another comic got there first. Taste surely must have had something to do with kiboshing the second.

WALTER THE WOBOT

"Nice Judge Dwedd will appweciate a twansistor wadio—even if it did once wob banks!"

THE SATIRICALLY DYSTOPIAN FUTURE of Judge Dredd has grown less absurd and more serious in recent years. Though the strip began as a hyperviolent extrapolation of consumerism, authoritarianism, and urban life, much of the grim silliness that once punctuated the storylines has run its course. The stories still have room for comic relief and gallows humor. But, appearently, not much room for poor, loyal Walter the Wobot.

A pleasant, lisping service droid, Walter was butler to the stern, uncompromising lawman Judge Dredd—much to Dredd's distaste. Perhaps it was Walter pronouncing his *r*s like *w*s, perhaps it was his tireless praise of the grimacing lawman, or perhaps it was just a general dislike for any lifelike, talking thing, but Judge Dredd seemed to resent his loyal servant.

In fact, Walter was quite heroic. He provided vital assistance during the Great Robot Revolt and was even responsible for forming the loyalist robot army that battled the forces of deranged carpentry robot Call-Me-Kenneth. His acts of bravery and sacrifice granted him the singular distinction of being the only robot in Mega City One to have earned full status as a free human being! Nonetheless, his heroism and loyalty only ever seem to engender Dredd's resentment.

Walter was effectively written out of the Dredd comics in the early 1980s, as the series' tone began to shift. The poor thankless servant all but vanished for the following decade.

When Walter comes back, he once again attempts to inveigle himself into Dredd's good graces by assisting him in dangerous missions. The result remains the same, with Dredd refusing to give Walter appreciable credit or commendation. This poor treatment finally wears on Walter's good nature, and he attempts to launch his own insurrection; he even takes a potshot at his former master, wounding him in the shoulder.

Rather than imprisonment (or destruction, the usual fate for misbehaving robots), Walter is assigned as house robot to one of the series' other comic relief characters. It's a happy ending, but Walter should also probably serve as a cautionary tale urging heroes to treat their sidekicks with more respect. Or wespect.

&

Created by:
John Wagner and
Carlos Ezquerra

Debuted in:
2000 AD #10 (IPC
Magazines, April
1977)

Sidekick to:
Judge Dredd

Make and model:
Type D-2000-A1
walking water
cooler

© 1977 by IPC Magazines

ACKNOWLEDGMENTS

Thanks as always to the contributors and
organizers of the Grand Comics Database
(comics.org) and the Digital Comic Museum
(digitalcomicmuseum.com). Also, many thanks
to Chris Sims, Benito Cereno, Steve Engelhart,
and the audience over at *Gone & Forgotten*.

TIME TO VAMOOSE AND SWITCHEROO BACK, STRIPESY!

REMEMBER...WHEN-I-LEAVE-YOU, ONLY-YOUR-INCREDIBLE STEEL-SMASHING-STRENGTH... AND-YOUR-WITS...WILL STAND-BETWEEN-HUMANS AND-THE-EVIL-ROBOTS!

HERE'S MY STAMP OF DISAPPROVAL!

YIPE!

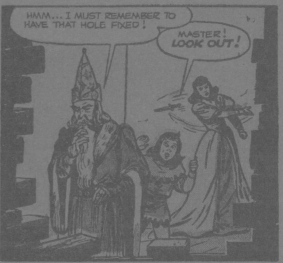

HMM...I MUST REMEMBER TO HAVE THAT HOLE FIXED!

MASTER! LOOK OUT!

AND MINUTES LATER, AN OFT-RE-PEATED SCENE TAKES PLACE---

NEXT TIME YOU HANG UP MEAT--!

SEE THAT IT'S DEAD INSTEAD OF ALIVE--

BIFF!!